DATE			
AUG 2 5 2004			
SE 0 4 '07			

BAKER & TAYLOR

Close-ups of History

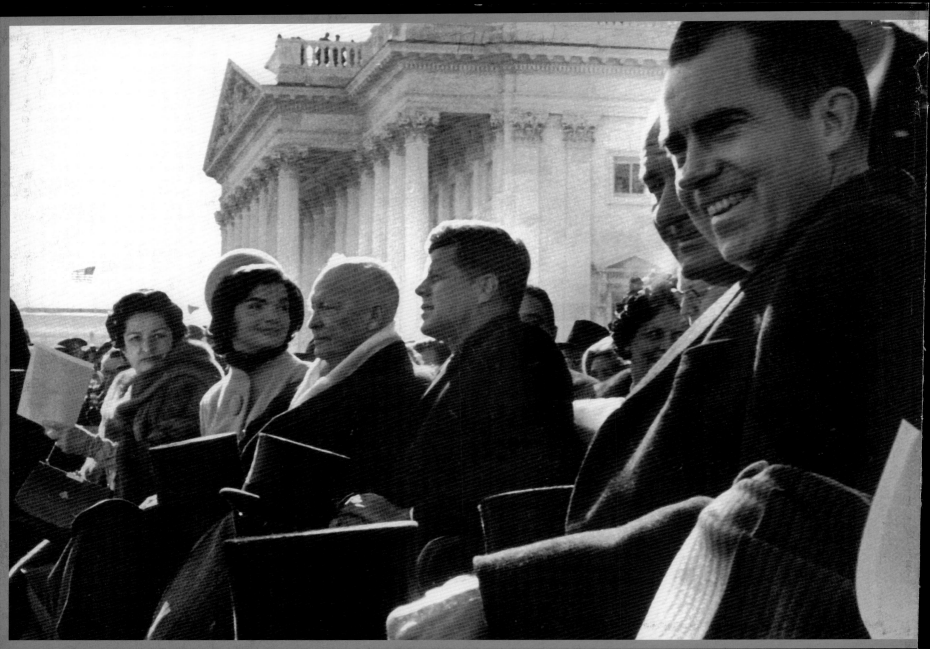

Close-ups of History

Three Decades through the Lens
of an AP Photographer

EDITED WITH AN
INTRODUCTION BY

MARGARET
WOHLGEMUTH
BURROUGHS

HENRY D. BURROUGHS

University of Missouri Press
COLUMBIA AND LONDON

Copyright © 2007 by
The Curators of the University of Missouri
University of Missouri Press, Columbia, Missouri 65201
Printed in China
5 4 3 2 1 11 10 09 08 07

Library of Congress Cataloging-in-Publication Data
Burroughs, Henry Dashiel.
 Close-ups of history: three decades through the lens of an AP pho-
tographer / Henry D. Burroughs / edited and with an introduction by
Margaret Wohlgemuth Burroughs.
 p. cm.
 Summary: "The professional memoir of Henry Burroughs—former
president of the White House Press Photographers Association, chair-
man of the Senate Standing Committee for Photographers, and "shooter"
for the Associated Press for thirty-three years—whose career docu-
mented Germany during WWII and other world events, including the
U.S. presidencies from Ford to Roosevelt"—Provided by publisher.
 Includes index.
 ISBN 978-0-8262-1725-7 (hard cover : alk. paper)
 1. Burroughs, Henry Dashiel. 2. Photojournalists—United States
—Biography. 3. Photojournalism—History—20th century. I. Bur-
roughs, Margaret Wohlgemuth, 1928– II. Title.
 TR140.B8736A3 2007
 770.92—dc22
 [B]

 2006036214

♾™ This paper meets the requirements of the American National Stan-
dard for Permanence of Paper for Printed Library Materials, Z39.48, 1984.
Designer: Jennifer Cropp
Typesetter: The Composing Room of Michigan, Inc.
Printer and binder: Everbest Printing Co. through Four Color Imports,
 Louisville, KY.
Typefaces: Palatino and Schneidler

To the friends and family of Henry D. Burroughs,

as well as businesses and organizations that have

generously contributed to the Scholarship Foundation

in his name at Anne Arundel Community College.

Contents

Foreword

Henry "Hank" Burroughs was a man of elegance and dignity in a very competitive profession: news photography. He was a legendary gentleman, always in coat and tie, who could also join his peers in jostling to the front of camera lines in the White House and at many of the major historical events of the twentieth century. An Associated Press photographer for thirty-three years who covered seven presidents of the United States, Henry Burroughs presents his life in pictures in this personal memoir of a great photographer. His camera was ready, and he was there, in an era when one click of the shutter was all you got.

There is a picture in this book that says it all for me. It shows Hank wearing a World War II army cap with U.S. insignia, balancing one foot on what was left of Hitler's desk in his bombed office in the Reichschancellory. Hank was there: curious and reflective, proud of America, documenting history, and giving us his own private view of the war's aftermath.

It's that private, even refreshingly objective, view of his world that gives us pictures from a different perspective. They also made him a revered and admired figure in the world of photojournalism. He viewed the White House Christmas decorations with an expectation of seeing President Kennedy, but it was a picture of a wide-eyed daughter, Caroline, that was published around the world. He rejoiced at covering our first six Gemini astronauts in space. He attended the Nuremberg trials. He saw the growing Russian threat in Berlin. He was a personal friend of Nixon and Ford and all the rest. His pictures were on the cover of *Life* and virtually every other magazine and newspaper in America.

The White House photos, ranging from Franklin Roosevelt to Gerald Ford, present these presidents with a remarkable clear focus. It's the style of the man, Hank Burroughs, to show the private

and searing moments of assassination, or resignation from office, or war, and yet write about these scenes with the warm glow of respect. His words are direct; his sentences brief. And his sense of irony and humor is shining especially as he observes the daily trials of what Harry Truman called the "One More Club." Mr. President, one more picture please.

Finally, for me this is also a book about how the White House operates. Hank Burroughs was there when we started having "photo opportunities" and "photo releases" and other kinds of White House control. He knew the freedom of waiting in the lobby for dignitaries. He dined and joked with presidents. He knew their wives and families. I knew him only at the end of his life, but he was still curious, excited about his work, and proud of the dramatic flow of history that passed through his lens. Through this book, we can all share it. And we thank his wife, Peg Burroughs, for assembling this illuminating memoir.

MARLIN FITZWATER
Press Secretary to President Ronald W. Reagan
and President George H. W. Bush

Preface

Henry D. Burroughs, who died January 14, 2000, was a prize-winning Associated Press photo-journalist for thirty-three years. He covered seven presidents from Roosevelt to Ford and many history-making events during those years. In the four-year tour he had in postwar Germany from 1945 to 1949 he witnessed the sentencing of Marshal Henri Philippe Pétain, the Nuremberg war crimes trials, and the Berlin blockade.

Everyone urged Henry to write about his works. He left his notes, articles, and tapes, and in the last year of his life began to write of his career and the stories behind the photographs—many of them world famous.

The book has been compiled and edited by Margaret W. Burroughs with the cooperation of the Associated Press.

Acknowledgments

Many people have contributed to the completion and success of this book.

Personal aid and guidance came from Hal Buell, former executive film editor for AP, now a writer and lecturer. He mentored me through the process of writing a book; he critiqued and supported my efforts.

The AP film librarian, Chuck Zoeller, diligently searched for photographs that illustrate the events of the narrative for each president and the postwar years in Germany. Without his cooperation there would not be a book.

David Hume Kennedy, formerly President Ford's White House photographer, now working for *Newsweek,* has been a staunch booster for me. He was enthusiastic about the memoirs I was writing. He pragmatically advised me that getting a book published is difficult and offered help.

An enormous debt is owed to my editors and proofers. As a novice in these endeavors I relied heavily on friends who offered to read and proof my written book. Mary and Dave Boak and Helen and Don White generously and carefully proofed the manuscript. Joan and Tom Kelly were tireless and ruthless editors in making this a more readable document. They both urged me not to give up, because this was a story to be told. I appreciated my taskmasters.

Moral support and advice was given by people who had faith in the project I was pursuing. Fred Rassmussen of the *Baltimore Sun* buoyed me with his enthusiasm when I became discouraged. John Eisenhower, a writer himself, encouraged me to continue to pursue publication even if disappointed on several occasions. My three brothers, George, Tom, and Bill Wohlgemuth, and Hank's sisters, Jane Burroughs Dollins and Rosemary Burroughs Schulte, are my biggest cheerleaders.

Awards

1951	First Place, Sports—White House News Photographers Association
1953	First Place, Personality—White House News Photographers Association
1960	Seventeenth Annual news pictures of the year selected for National Exhibition sponsored by National Press Photographers Association; School of Journalism, University of Missouri; and Encyclopaedia Britannica
1962	Nineteenth Annual Pictures of the Year competition, sponsored by National Press Photographers Association
1964	First to be given an AP Managing Editors Award—it was written up in *Who's Who*
1964	Certificate of Honor certifies that the photo of Henry Burroughs exhibited in the Municipal Museum of the Hague from December 17, 1964, to January 31, 1965
1972	Second Place, News—White House News Photographers Association
1973	First Place, News—White House News Photographers Association and Pictorial—White House News Photographers Association
1973	Selected Photographer of the Year—White House News Photographers Association
1993	Kodak Achievement Award

Close-ups of History

Henry Dashiel Burroughs, a resourceful, talented, career photojournalist, worked for the Associated Press (AP) for thirty-three years. He covered seven presidents, from Franklin D. Roosevelt to Gerald Ford. He always said he had a front-row seat to history, covering presidents as well as the events of postwar Germany from 1945 to 1949. This book offers you his seat and his unique perspective. You will revisit those special and historic moments and learn how he photographed them.

Covering seven presidents from 1944 to 1974 as a still photographer, he witnessed many changes in photojournalism technology, style, and accessibility. Cameras used in the early administrations were Speed Graphics, large, cumbersome, and slow. Fortunately the presidents realized this and allowed for the time it took to change a film holder. Photographers trained to use the Speed Graphic were very careful about not squandering shots. The introduction of the Rolleiflex, a more compact camera that could take twelve pictures on one roll of film, made it easier. This had been a great era for still photographers; newsreels came out weekly at the movie theater, but TV was not yet available. Therefore photographers were in the papers daily, and some newspapers were almost exclusively made up of photographs. The photographer was in the premier position in the press. By the 1960s, though, a shift in the presentation of the news to the public was under way. The new thirty-five-

millimeter camera had advantages for the photojournalist; however, TV coverage was introduced during the Kennedy administration and the photographer took second place to the network anchors.

TV had taken over coverage from the still photographer with fleeting pictures and action during the nightly news shows. Many evening papers folded. Yet the still photographer continues to capture moments in history that will remain with us forever: Marshal Pétain receiving the death sentence in Paris for his part in leading the Vichy government that collaborated with the Nazis; President Eisenhower at the periscope of a nuclear submarine; presidential candidate George McGovern at Mt. Rushmore; President Nixon in the Oval Office looking out the window as the Watergate scandal broke.

Someone said that photographers are the blue-collar workers of the press corps. Did this imply that they are not as intelligent as the rest or that their work is more physical? We see photographers sitting on the floor in a hearing room, moving in a crouching walk at a meeting, or running backwards with their cameras, lenses, and bags in front of an important person. They are always on the front line in every story where the action is. The Secret Service knows the White House photo corps and allows them to be close to the president. They may even be considered a front-line shield for the Chief Executive.

When on an assignment, the photographers must quickly size up the situation from a news standpoint when they arrive on the scene. Who are the players? Will there be much movement? Will it be an affable situation or one of conflict? Will it be casual or formal? Is this a story of national importance or global interest? Knowing the answers is a tall order. A conscientious photographer will often make a picture immediately, capturing all of the participants if there are more than one. This is to ensure that his office will get at least one good shot. Then he has time to size up the actions of the newsmakers. Timing is more often than not the key to the exclusive picture of the day. The high moment, the peak of the action, must be captured and frozen in time forever. Several seconds later may totally change the character of the story. To capture the spontaneous moment is a special skill. You must know your camera well, its drawbacks and all of its capabilities. You must have an instinct to anticipate pictures, along with some luck. Although a reporter may be under pressure with a deadline, he can rewrite copy. This is not a luxury a photographer enjoys. Henry measured up to all of these criteria. He was truly a gifted artist.

How did Henry make a classic historic picture? He had a highly cultivated sense of news for the occasion. He caught a lineup of four presidents on the south portico of the Capitol at JFK's inaugural. At the time one was a past president (Eisenhower), one was being sworn in (Kennedy), and two others were outstanding politicians who would not rest until they also became presidents (Johnson and Nixon).

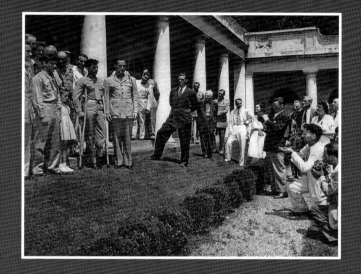

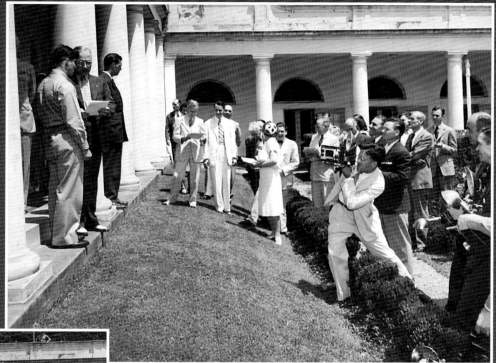

How to make a perfect picture of President Truman with Congressional Medal of Honor winners: 1. Size up the situation. 2. Move in to focus on the principals. 3. Get closer and wait for the perfect expression that captures the moment.

A great international picture is the photograph of Pétain dressed in his formal uniform at the moment he heard his death sentence from the French Tribunal for betraying his country in World War II. Photographers were not allowed in the courtroom. Henry broke the rule and got the shot. He took his Speed Graphic from under his bulky raincoat and shot one frame, then vanished. It was a stunning picture. It played around the world.

Then there were special pictures taken when a photographer follows his instincts for news and finds a special angle. He or she must take a chance and be sure to be in the right place at the right time. A perfect example of this is Henry's picture of Jackie Kennedy congratulating her husband after his inaugural speech. He followed the Kennedys back into the Capitol like he was part of the official party and caught a spontaneous intimate moment with the new president and his wife.

When asked, "What makes a good picture?" Henry said, "A good photographer with lots of luck and perfect timing. Instinct and a keen sense for the news play a great part also to capture the moment." All of these characteristics are honed through years of practice and coping with unusual situations. He measured up with the finest.

What was his working style? He was often described as a photographer and a gentleman with a keen intellect—two characteristics that are not normally found in one person. The nature of a news photographer's work is to be where the ac-tion is, and trying to capture the essence of the event often led to pushing and jockeying for the best position with language that matched the aggressive actions. This was not Henry's working style. He respected his colleagues and they in turn respected him. He also treated his subjects with dignity. Walter Meers, an AP columnist, said, "Henry was a thinking photographer. He looked like a kindly professor but toughness was there too—he always came back with the picture."

Hal Buell* said that when Henry talked about his life as a photographer with the AP, he always said how much he loved his job. Where else would this happen? He had a front row seat in history.

Buell said in his eulogy, "Even when Henry was eighty years old, he would recall events he covered with the enthusiasm of a man who understood the importance, the relevance, and the responsibility of what he was doing."

* Formerly AP's executive newsphoto editor, now an author and writer.

The Mission of AP's Washington, D.C., Photo Department

The mission of the Associated Press's Washington photo bureau is to photograph the heartbeat of the national government: the president in Washington and when he travels, the House, the Senate, the courts, the cabinet, the vice president and his travels, the first lady and her travels, and foreign visitors. This is the task of ten photographers. One person is on permanent assignment to the Senate and another is permanently assigned to the House. The White House and the president are always covered, often on a rotating basis. When the president travels there are usually two photographers on the trip.

As a new member of the Washington staff I had sometimes to work the dreaded split shift; that is, three days nine to six, plus Saturday and Sunday nights. Working nights sometimes had special advantages, like covering major-league baseball. The Senators played out at old Griffith Stadium in those days, and AP covered every game. Not so much for the Senators—the local newspapers were all doing that—but for the papers in the opposing team's home town.

The photographer's stand was just under the first tier along the first-base line. Best seats in the house. We would use "Big Bertha," a huge 5x7 Graflex custom-built to carry a large telephoto lens.* You could cover all the bases and the outfield with that rig. It even had a

* Big Bertha was used at the Nuremberg trials.

5

gearshift for quick focus change. You could preset the gearshift to focus on any base, then when the play occurred you just shifted to that position and shot. No focusing. All the wire services had Big Berthas. They were also used for special occasions such as inaugurations and speeches before joint sessions of the Congress.

The night photo editor was Max Desfor. He was a superb editor and ran the photo desk in a very professional manner. I was impressed. But I was even more impressed when he threw some strong advice in my direction. Max dropped this one on me: "Henry, don't ever let them talk you into becoming a photo editor. The title sounds good, but the perks and fun of shooting far outweigh the title." I never forgot, and years later had occasion to be grateful for that advice.

There are many special assignments that might take a staff photographer out of Washington for days. For example: I covered all of the Mercury astronauts when they "splashed down." I followed Soviet Premier Nikita Khrushchev on a trip across the United States. I traveled with a group of nine U.S. governors who toured for three and a half weeks in the Soviet Union. We were often assigned to feature picture stories of human interest. Every four years we covered the political conventions and campaigns.

Washington is the most interesting and exciting place to work as an AP photographer. It is the hub of national and international news. The photographer graphically brings current events to the public. It is a daily challenge to make the best picture and get it back to the office as soon as possible.

Chapter I *How I Got Started*

Little did I realize what destiny had in store for me as I stepped onto that busy wharf on the Potomac River at Indian Head, Maryland, on a hot summer day. I was ten years old and coming to visit my Grandfather Burroughs for the entire summer. What joy!

I didn't know it, nor did my grandfather, but that summer was to set me on the path to becoming a professional photographer, making pictures of presidents, princes, ministers, emperors, sports heroes, and a world-famous chimpanzee.

There waiting on the dock was the familiar figure of my grandfather with his jaunty fedora, black ebony walking cane, full gray mustache, and a big smile. I loved my grandfather, and he loved me. I was the first-born in my generation. Both sets of grandparents lived in Indian Head, and they all spoiled me with attention, and I enjoyed every minute of it.

The two of us walked up the hill toward his house chatting away, for I had many stories to tell. I had come over from Baltimore to Washington on the old Baltimore-Washington and Annapolis Railroad. Then I had walked to the Navy Yard in time to catch the boat to Indian Head. The boat ride was exhilarating. The boat was an old converted submarine chaser named the *Porpoise*. The captain was a friend of my grandfather and was anticipating my arrival. He took me under his wing and showed me around. He even let me come into the pilothouse as he maneuvered the throbbing ship out of the Navy Yard and down the Potomac River to our destination.

What excitement for me! But there was more excitement, of a different kind, to come. For it was during this visit that Grandfather, just to entertain me, introduced me to the wonders of photography. He set up a camera on a tripod and put a hood over his head and then focused on the picture. Of course everything appeared upside down through the camera lens. He demonstrated the magic of the darkroom, where emerging images and the acrid aroma of fresh hypo cast their spell. Unbeknownst to me or Grandfather, the die was cast. I was destined to be a photographer.

Years later when I needed to find a job, I would recall those happy childhood days. Those were depression times, 1935. I had just graduated from Baltimore Polytechnic High School, a very fine engineering high school, and I needed a job. College was out of the question; my folks couldn't afford it. An ad in the *Baltimore Sun* for a photographer's assistant led me to the studio of Edgar Schaefer. He had a reputation as Baltimore's finest commercial photographer, and he offered me a temporary job because he had just granted his regular assistant a year's leave of absence to try his hand at news photography, but with a promise that his old position would be waiting if things didn't work out.

I jumped at the chance. Eight dollars a week! I had been making only two or three on my paper route.

Mr. Schaefer was a master technician and a great teacher. I can still remember the cleanliness and order of his studio and the fastidious way he maintained the pristine darkrooms. When he went on an assignment I would carry his cases and help set up the camera. I soon found out why he was so highly regarded as a master photographer. One day we set out to photograph a statue of Johns Hopkins. It was a bright, sunny day, great for photos, I thought.

But when we arrived at the location Schaefer shook his head. "Light's not right," he said. "We'll have to come back on a slightly overcast day when the light is softer." That's the way he was about everything. It had to be just right or not at all. In the darkroom I was only allowed at first to move prints from hypo to wash water. He was meticulous about the proper washing of all prints so they wouldn't ever fade. There was a mechanical washer for small prints but the large ones had to be washed by hand; that involved moving them around in the water and changing them from tray to fresh tray. That was my job, and I hated it. After many months I was allowed to make contact prints of the large 8x10 negatives, but I was never allowed to use the camera. Working for Edgar Schaefer was an unforgettable experience. I especially enjoyed going on location with him. He used an 8x10 view camera, and we would go to Bethlehem Steel Company or Black and Decker or one of the other large corporations loaded down with lighting equipment and other special paraphernalia.

He knew all the tricks of lighting, dodging,* backgrounding, and long-time exposure techniques. A master. I was fascinated. But with all his talent he did not like to photograph

* To increase density on certain areas of the photograph by giving extra exposure during the enlarging process.

people. When he ducked his head under that black focusing cloth he didn't want to confront homo sapiens on the ground glass. He absolutely refused to make portraits, and when he had to use models in an advertising scene he worked under protest. He avoided people but he was truly superb at photographing things.

I was learning. But it was a very short year indeed, for alas the regular assistant returned, and I was once again looking for a job.

It didn't take long though. Good luck! I found one rather quickly with the young, vibrant public relations firm of Blakeslee and Lane. When they discovered I had worked for the famous Edgar Schaefer they hired me right away as a junior member of their staff. I thoroughly enjoyed working for them; they had an exceptionally good rapport with their employees and everyone was friendly. However, they were expanding, and when they opened a small studio in Washington, D.C., I was moved to our nation's capital.

I worked there a brief time, but then I discovered I could double my salary by taking a government job at the Agriculture Adjustment Administration. Again, it was only temporary—printing and checking aerial maps for crop planting acreage. Our offices and darkrooms were in the old Post Office Building on Pennsylvania Avenue. The salary was very good, $1,440 per year, and I was able to save a fair amount of money. But after about one year the job ran out and I was once again looking for employment, pounding the pavement with my small portfolio of photographs.

One day I wandered into the *Washington Post.* The timing was perfect. Hugh Miller, head of the photo department, looked over my prints and allowed as how he didn't have an opening on his news staff, but the photographer who did the fashions, advertising, and promotion for the paper was leaving to open a business of his own.

Miller asked, "Would I be interested?" Holy Smoke, would I be interested? You bet!

The position was under the direction of Don Bernard, the advertising manager. Miller introduced me. Mr. Bernard looked over my portfolio of photos. He liked what he saw and hired me. I was ecstatic. I loved working at the *Post.* Eugene Myer had bought the paper just a few years before my arrival, and there was a vibrancy and enthusiasm everywhere.

I couldn't believe the new job. I had my own studio and darkroom. The studio was next to the news photography ready room and office, and my darkrooms were in an area shared with the news darkrooms. I quickly made friends with the news staff. They were a great bunch.

I did all the fashion, promotion, and advertising photography for the *Post.* Occasionally, I'd do a little news story, usually if they got into a scheduling jam.

Hugh Miller, the boss of the photo department, was an unforgettable character. He was a Scotsman and successfully upheld the reputation of his clan. He would parcel out film to his staff as though he were paying for it out of his own pocket. Hugh was a very affable fellow, well liked by all, but

this stinginess about film was the cause of periodic mumbling and grumbling among that proud group of talented artists. But the problem was easily solved, for I was an easy mark for extra film. I could draw supplies that were charged to the advertising department, and the advertising department was very generous. Miller was quite aware of this and I'm sure that fact figured heavily in his parsimonious strategy. Naturally this largesse on my part made me very popular with my fellow photographers.

Miller also hated to spend money on camera repairs, so when a photographer came in with a malfunctioning camera or lens Miller would put on his green eyeshade, get out his box of small screwdrivers, and proceed to dismantle the offending equipment. One day I watched him take apart a lens shutter and work on it for about an hour, mainly trying to put it back together, then in disgust dump the whole kit and caboodle, springs, shutter leaves and washers, into a brown paper bag. Then he called Irvin Schlossenburg, the copy boy, over, handed him the bag, and ordered him to "take this over to AP and have Henry Jenkins fix it."

Henry Jenkins was the best camera repairman in town. He was a master printer in the AP darkroom. He was also a superb camera technician and he was used to receiving brown paper bags from Hugh Miller. "Jenks," as he was called, could fix anything. He had a complete machine shop in his basement at home. He not only repaired cameras for most of the professional photographers in Washington but also could make parts and modify cameras to suit the cameraman's shooting style. He was in great demand.

Hugh Miller walked into the studio as I was photographing a bunch of whiskey bottles for advertising. "How would you like to be a war correspondent?" he asked in a friendly mumble. "Sounds interesting," I replied, trying to control my excitement.

Hugh said that his old friend, Lou Johrdan, the Associated Press's chief photographer in New York, had told him that AP was looking for a photographer as a war correspondent. Some of their war-weary photographers needed replacing. This was 1944.

"Who do I call?" I asked.

"I'll find out if they're interested." Miller replied.

The next day I was over in the AP bureau looking for Howard Kany, their Washington photo editor. AP occupied the entire third floor of the old Evening Star Building on Pennsylvania Avenue. A cacophony of sounds greeted me as I entered the newsroom; mainly there was the urgency of clattering teleprinters and voices raised to a pitch that could be heard over the clatter and the ringing bells. A sense of high excitement overcame me as I asked directions to the photo department.

All the way in the back, a friendly editor directed me with a wave of his hand toward an open doorway.

As I entered the photo department the sounds changed perceptively. Now there was the clacking of just two tele-

printers, but accompanied by the distinctively high-pitched "beep-beep" of wire photo transmitters sending their photographs around the world. This sound was to haunt me for the rest of my working career.

Howard Kany greeted me with encouraging warmth and enthusiasm. They must be desperate, I thought. After a short interview he took me in to see Paul Miller, the bureau chief and assistant general manager of the AP. My God, I thought. What did Hugh Miller tell these guys? At any rate, Paul Miller offered me a staff position in the Washington bureau with the stipulation that I would be accredited as a war correspondent and replace a photographer who was due to return from Europe or the Pacific.

I put on my best cool, laid-back demeanor as I accepted the job, but inside my guts were churning with more excitement than I can express. Thank you, Hugh Miller.

Back at the *Post,* my boss, Don Bernard, the advertising director, was very unhappy and I had to promise to find a good replacement, which I did. Working for Don Bernard at the *Post* had been a happy time for me. He was a pleasant boss and rewarded me with generous raises. I had to take a small cut to start out with the AP, but that was a minor consideration.

My lifestyle changed dramatically. Suddenly, I went from an easygoing, nine-to-five job at the *Post* to an exciting, high-tension, fascinating life with the AP. The transition from photographing merchandise and fashions to covering fast-breaking hard news stories was, to say the least, a shock to my psyche. Now, speed was of primary concern. On my first assignments for AP, I was as nervous and excited as a kid in a candy store.

The AP was to be my career for more than thirty-three years. It is a marvelous organization. I was most fortunate to work for it, the largest newsgathering organization in the world. AP just celebrated its 150th birthday. Working for them was like being part of a big family. Everywhere I went in the world, I was always welcomed warmly by the AP bureau chief or a staffer or correspondent. It was an absolutely marvelous experience. I had a front-row seat at many historic occasions.

CHAPTER II *The End of World War II*
Franklin Delano Roosevelt, 1944-1945

I pledge you—I pledge myself—a new deal for the American people.

—Franklin Delano Roosevelt, National Democratic Convention, Chicago, July 1932

Shortly after I had joined the Associated Press, the assignment editor, Joe Jamieson, greeted me with a bombshell: "Henry, I want you to cover the White House the rest of the week. I know you don't know your way around over there yet, but I cleared you to get into our press room. Our correspondent, Doug Cornell, will be there to show you the ropes."

I nervously checked my camera, carefully loaded enough holders in my Speed Graphic to cover a revolution, and set off quivering with anxiety and excitement. The White House! I'd never been there. Franklin Delano Roosevelt! He was the only president we'd had since I was twelve years old. Now maybe I'd actually get a chance to see and photograph him.

Just a few weeks before this I had learned that the Associated Press was hiring war correspondents to cover Europe. It was an opportunity to participate in a great world adventure instead of continuing to take fashion shots and commercial pictures for the *Washington Post*. I was interviewed, hired, and accredited. I thought that I would be working with the army overseas. However, the arrangements were not completed before I was assigned to cover the White House for the Washington bureau of the Associated Press. My heart was

pounding with anticipation, euphoria mixing with dread as I walked up the driveway to the White House gate. The sun was shining brightly and my adrenaline carried me along to the West Wing. It was a rare privilege to enter the White House. It was wartime and only a few people were authorized to enter. I was so nervous—"Please, God, don't let me foul up." The guard was friendly. "You're from the Associated Press?" he asked. "Yes sir," I answered. "You're new aren't you?" He checked the list. "First time," I replied. "Well, go to it," he replied, "and don't make any fuzzy pictures."

At that time the press room was at the extreme northwest corner of the West Executive wing of the White House. It was a fairly large room with windows facing Pennsylvania Avenue and West Executive Street. It was early morning and people were still arriving. There were several reporters and photographers milling around. I found Doug Cornell, the Associated Press White House correspondent, and introduced myself. Doug was most cordial and introduced me around the room. One of the people I met that morning was Maurice Lannigan of Acme News Pictures. He turned out to be a very important person on my first day at the White House. Lannigan was an old-timer who knew the ropes and very generously took me under his wing. I was a grateful and enthusiastic student.

We photographers represented the three wire services at that time. On occasion, photographers from the *Washington Star,* the *Washington Post,* and *Life* magazine might show up.

But day in and day out, it was the "three wires"—Associated Press (AP), Acme News Pictures, and International News Photos. (Acme and INP later merged to form the United Press International [UPI].) Lannigan told me the ground rules: unless we were called into the Oval Office for a picture, we were not to make photographs inside the lobby or foyer. All photos of visitors had to be made outside, usually at the door. And, most important, no photos ever of President Roosevelt getting in or out of an automobile or into his wheelchair. No one ever broke the rules. It was a gentlemen's agreement, accepted by us all. Whenever we went into the Oval Office, FDR was already seated behind the desk and ready to greet visitors. This is where we usually made our photographs.

The first day was quiet. Several senators came in to see the president and that's about all that happened. We caught them at the door as they arrived and made their pictures. The senators seemed happy about the whole thing, and I was not displeased. Lannigan quipped, "This is the most photographed door in Washington." I laughed, and so did the senators. After writing a quick caption, I called the photo desk on our direct line from the press room. Jamison answered the call and told me a courier would be over to pick up the film holder. "Well, that wasn't so bad," I thought to myself. "But when do I get to see the president?"

I was like a child on his first day at kindergarten. I could hardly wait to get back into the office to see my negatives. They were sharp! I quickly discovered that AP placed great

emphasis on good-quality negatives. No problem there for me. I had plenty of experience in that department during my apprenticeship with taskmaster Edgar Shaefer in Baltimore. The editors were pleased with my work so far. I breathed a sigh of relief. It was a strange feeling, however, not to be able to develop and print my own pictures as I had done at the *Washington Post.* But I quickly accommodated the AP's Washington bureau procedures. Photographers shot the pictures, editors picked the negatives, and the darkroom professionals printed them. We used Speed Graphic cameras in those days and we would shoot a couple of 4x5 holders, then hand them to a motorcycle courier who would rush them to the photo desk. I could look at the results the next time I went into the office, which might be days later.

The Washington photo department for AP had a great collection of photographers, editors, darkroom technicians, and wire photo operators. I was most fortunate to be working with such talented colleagues. We were a team and we worked well together. Another crucial part of the team (how could I ever forget them?) were the motorcycle couriers. These guys knew their way around town better than any traffic policeman. They usually wore uniforms and could talk their way through any situation anywhere. When a big story was breaking they would be right at my side waiting to pick up the film holders. I think they knew every policeman, building guard, and White House guard in town. They could go into any government building without stopping to show

a pass—they were that well known. In my time, the best of the AP couriers was a guy named Fred Griffin. He was of incalculable help to photographers. He not only dispatched my film with the speed of light but also was a font of knowledge. He would report on anything he saw as he motorcycled to and fro, and he was extremely observant. Many times he steered me to a good news picture. Fred was eventually promoted to AP photographer in Memphis, Tennessee, and then joined the *Memphis Commercial Appeal,* an AP member paper.

The president didn't make many public appearances. Remember, it was 1944 and wartime. Contact with the press was also rather rare. There weren't too many picture opportunities in those days. Most of the White House coverage consisted of interviewing presidential visitors and attending the daily press briefings by Steve Early, FDR's press secretary. But after several days of this routine the big moment came. Early announced a photo session during which the president would present the Distinguished Service Medal to Admiral Richard Byrd, the famous explorer. Byrd was the first man to fly over the North Pole and the South Pole and had just completed a secret mission in the Pacific theater.

At the appointed hour the press corps crowded into the hall outside the Oval Office waiting for the door to open. Tension was high, especially for me. Photographers were nervously checking their cameras with much shifting around and small talk. As for me, my excitement reached a high plateau. I constantly checked my Speed Graphic. Had I

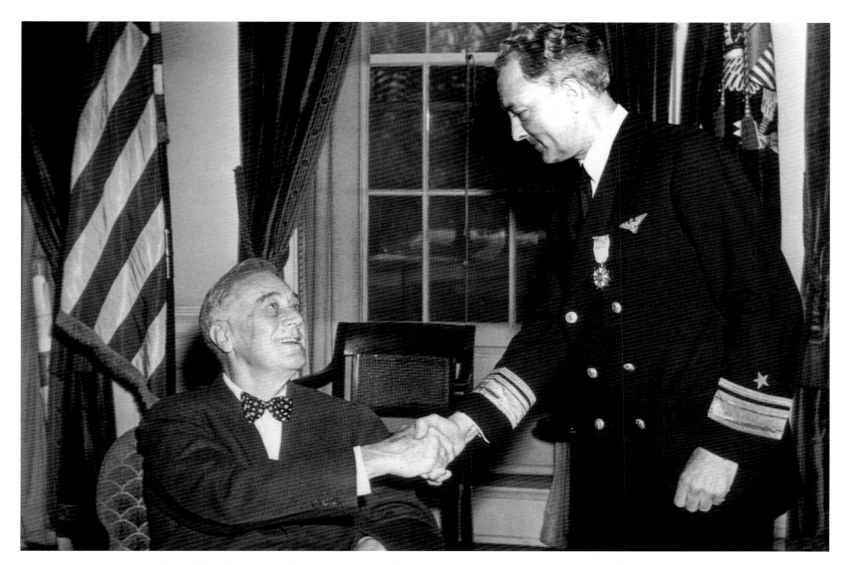

Admiral Byrd received the Distinguished Service Medal from the president in the Oval Office.

cocked the shutter? Was the back shutter open? Was the flash firmly inserted? Had I pulled the slide on the holder? I was a nervous wreck. Finally the big white door opened and we all charged into the Oval Office to take positions in front of the president's desk. And there he was. As the thundering herd of newsmen jostled for position around the huge desk, the president greeted us with a big smile and a humorous welcoming comment. I have no idea what he said but his personality seemed to fill the whole room.

In a moment Admiral Byrd entered the room and approached the president. I was in a good position. The two men shook hands. Bang! Three flashbulbs fired within split seconds of each other. The three wire services were on the job. Next came the critical moment—preparing for the next shot. In those days, if you were really fast, it would take seven seconds to replace the slide, turn the 4x5 holder, pull the slide, cock the shutter, and remove and replace the flashbulb. On a hot story those seven seconds could seem like a lifetime. The president made a few remarks as he removed the Distinguished Service Medal from its box. I had the feeling he knew about the problem because he stalled a bit before pinning the medal on the admiral's uniform. Bam! Another shot! God, I hoped they were sharp. After this very brief ceremony we were ushered out of the great oval room. I ran to the northwest lobby where our AP courier was standing by. The courier zoomed off on his Harley-Davidson and I phoned the caption to the photo desk. I felt like I'd played a small part in history that day and I loved it.

There were several more of these Oval Office encounters—Admiral Leahy and Admiral King and other World War II military figures. Admiral William F. "Bull" Halsey and his wife came to pay their respects to the president. Halsey commanded our fleet in the Pacific, and General MacArthur called him the "greatest fighting Admiral of World War II." He retired as admiral of the fleet in November 1945.

It was some time before I saw the president again. Then one day we were told that he was to make an address to the nation via newsreel cameras and radio that evening. Before TV was common in every home, the newsreels recorded the action in black and white for movie theaters. The still photographers would not be able to shoot during the address, but we had a couple of minutes before the speech to make our shots. The White House library was to be used as a makeshift studio and a special lighting expert had been flown in from Hollywood to light the set. At the appointed hour the "newsreels" set up their tripods and cameras in the library, then the "stills" were allowed in. There were just the three of us wires, AP, Acme, and INP. I remember taking in two cameras—my regular Speed Graphic with flash, and a second Graphic with a twelve-inch-long focal-length lens mounted on a tripod. We set up our tripods in front of the president's library desk and waited.

The light in the room was very soft with large diffusers in front of the lights—portrait quality. The Hollywood man had done a superb job. Pretty soon a Secret Service man wheeled the president into position behind the desk. Roosevelt stayed in his wheelchair and greeted us with an affable but serious

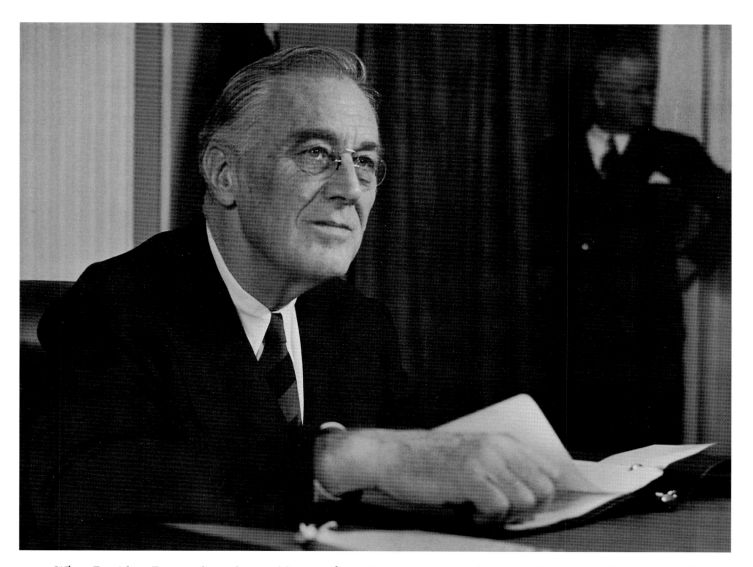

When President Roosevelt made an address to the nation, newsreels, radio, and still photographers covered it.

demeanor. He was going to talk about the war. I was quite anxious as I carefully focused the twelve-inch lens because we knew we had only a short time to shoot. It was shorter than I'd anticipated. I had time to make just two exposures, and then we were escorted out. Both pictures were well received. The lighting had been excellent. I got front-page play in both the morning and afternoon papers. The president looked quite good in these photographs. He was ill at the time but we surely didn't realize it.

On Armistice Day (today Veterans Day) that year the White House announced that the president would make one of his rare public appearances at the Tomb of the Unknown Soldier in Arlington Cemetery. We photographers hustled over to the tomb to stake out positions on camera stands erected for the purpose. The three wire services plus cameramen from all the local papers and news magazines were set up and of course all of the newsreels as well. Steve Early again laid out the ground rules for us. No picture of the president getting out of the limousine or getting back in. Everyone agreed.

It was a crisp November day. The sun bouncing off the white marble tomb provided perfect lighting for the solemn proceedings that were about to begin. A special honor guard was in place on both sides of the Tomb of the Unknown Soldier as the presidential car rolled up. I soon realized why Steve Early had said no photos of the president getting into or out of the car. The next scene was unforgettable. I had photographed the president in the Oval Office many times but he

had always been seated at his desk. Now I watched with riveted attention as two strapping Secret Service agents gently lifted him from the back seat as though he were a baby and carefully placed him by the limousine door. It was a vivid and poignant sight. Then an agent locked his leg braces and he stood hanging onto the open car door for support. It suddenly hit home! How terribly handicapped was our courageous president. My heart went out to him. He was now put in the care of the two military aides, General Watson and Admiral Brown, who stood dutifully on either side of their boss. Only then did Early give us the OK to start shooting. Those were the rules. I can't imagine that ever happening today, but everyone adhered to them in 1945.

The ceremony proceeded. Standing with the president were James Forrestal, the secretary of the navy, and Henry R. Stimson, the secretary of war. Forrestal would later become our first secretary of defense.* The commanding officer of the

* Forrestal worked extremely hard and tragically ended his career in a suicidal leap from the top floor of the Bethesda Naval Hospital. Apparently, he was plagued with depression. A whole class of aircraft carriers were named for him. The secretary of war, Stimson, was certainly the most incredible member of the Roosevelt cabinet. At the time he was truly a distinguished elder statesman, and the lone Republican in the cabinet. He had been made secretary of war by President William Howard Taft, then he served as governor of the Philippines under Calvin Coolidge, and Herbert Hoover made him secretary of state. What a great man. He was seventy years old at the time and still serving his country. He stayed on with Truman as an adviser.

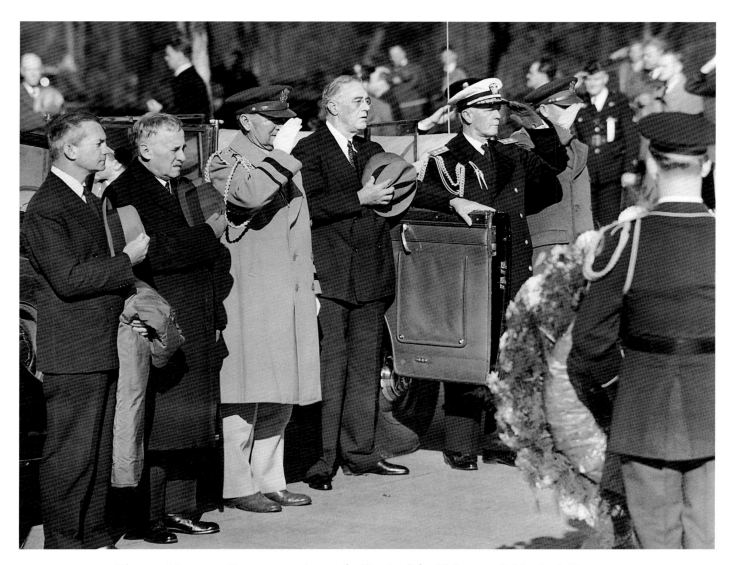

The president standing at attention at the Tomb of the Unknown Solder in Arlington
National Cemetery after a wreath had been placed at the site on Armistice Day in 1944.

honor guard placed the presidential wreath at the base of the tomb, and all stood as the bugler's haunting "Taps" resounded throughout the hills and valleys of Arlington Cemetery. The many spectators were solemnly quiet as the Secret Service agents carefully placed Roosevelt back in the limousine. As the car pulled away the crowd cheered for their president and the good old AP courier was at the ready at the camera stands. He had talked his way through army security and managed to get his motorcycle to a spot only several hundred yards away. The courier, the final and critical link of the team on the spot, again performed admirably.

Later, when I had time to look at the picture I had made that day in Arlington, I noticed a rather peculiar thing. President Roosevelt's naval aide, Admiral Brown, was saluting with his left hand. After examining the photo carefully, the reason became clear. Whenever the president was required to stand, as he was in this case, the admiral's job was to support him with his right arm. The puzzling part of this was that the open limousine door provided a good support and the military aide, General Watson, had a firm grip on the president's other arm. Admiral Brown was so used to this routine that he just saluted with his left hand automatically.

We didn't see the president for a long time after this. We were unaware of the reason but later found out that he was en route to talks with Churchill and Stalin at Yalta. But absences from the White House were not unusual and quite often, unbeknownst to the press corps, the president would drive to his Catoctin Mountain hideaway, "Shangri-la," for a few days. One time he spent two weeks there without our knowing about it. Life went on in the White House and the press room as though he were there: Secret Service agents going through their routines, pretending. They sure fooled us!

Shortly after Roosevelt returned from Yalta he scheduled a dramatic address to a special joint session of Congress. It was a big news event. Everyone of importance in Washington was there. The galleries were packed. I staked out a position in the press gallery behind the speaker's podium and on the Democratic side of the aisle. It was noon on March 1, 1945. This was the last time I would photograph President Roosevelt.

A hush came over the chamber as "Fishbait" Miller, doorkeeper of the House of Representatives, announced in his unmistakable style, "The President of the United States of America." Then as the president was wheeled down the aisle by a Secret Service agent, all rose to their feet with loud cheers and applause. I thought the room would explode. This was the first time he had allowed himself to be wheeled in. He usually walked with aides on both sides.

"No pictures in the wheelchair" ran through my mind. FDR was beaming and waving to old friends from his wheelchair halfway down the aisle. I saw a flash go off from the gallery on the opposite side. Not to be outdone by a competitor, I instinctively made one shot as the president waved from his wheelchair. News photography is very competitive. He was passing members of the cabinet: there was Harold

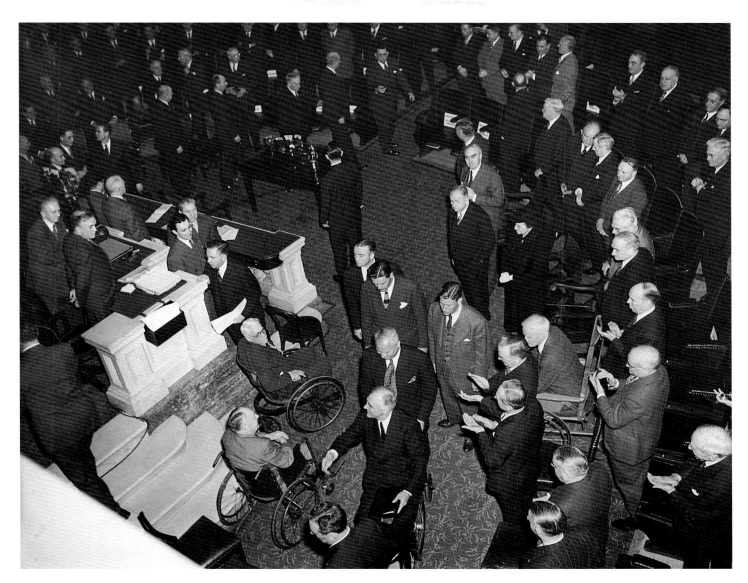

An unpublished picture of President Roosevelt in a wheelchair. He reported
to a joint session of Congress on his meeting with Stalin and Churchill in Yalta.

Ickes, whom they called the "Old Curmudgeon," the secretary of the interior, next to him was Frances Perkins, secretary of labor, and there were also a few members of Congress in wheelchairs.

The president was placed in his chair behind the lectern and then the flashbulbs popped all over the place. He apologized for remaining seated. It was the first time he did not stand to make an address to a joint session. He said that it was too difficult to stand when he turned around to acknowledge the introduction by Speaker Sam Rayburn. He said his journey from Yalta was extremely tiring. This was the first time Roosevelt made any references to his health or endurance. I took another shot.

I shipped out those first few shots quickly. Our courier ran them down to the portable darkroom we had set up in Fishbait Miller's office just off the House floor. AP had a full staff working there—an editor, a darkroom printer, and a wire photo operator with a portable wire photo transmitter. Time was of the essence.

I found out later that the photographer who had made the first shot of the president being wheeled onto the House floor was from New York and didn't know about the ground rules. Alert Secret Service men saw his flash, but didn't see mine. The agents took his film, while mine went in to the photo desk with the first shipment. Howard Kany, chief AP photo editor for Washington, spotted the negative and put it aside. Late that night after the session he called me over and said, "I know you made this just to protect us but there is no way we will use it and get in trouble with the White House. Save this for your memoirs."

In the future days, which we seek to make secure, we look forward to a world founded upon four essential human freedoms. The first is freedom of speech and expression everywhere in the world. The second is freedom of every person to worship God in his own way—everywhere in the world. The third is freedom from want. The fourth is freedom from fear.

—*FDR's address to Congress, January 1941*

CHAPTER III *Four Years in Postwar Germany, 1945-1949*

ASSIGNMENT AS A WAR CORRESPONDENT IN GERMANY

Wartime Washington was a busy city, filled with an air of excitement. Men and women in uniform were everywhere.

Wire service photographers had credentials admitting us to the Pentagon and we made frequent trips there to photograph news conferences with visiting brass. But more often we were called to the Public Relations Department to pick up the latest combat pictures released by the censors. In order to speed up this important link with the news media, Pentagon officials arranged for us to drive inside the building and park temporarily long enough to make the pickup. Photographs came in from all over the world: from the European theater, the Pacific theater, China-Burma-India, and from all branches of the military. The Pentagon released them as soon as the censors cleared them. The three wire services were always alert for these picture releases and competed with each other in selecting and transmitting them on their networks.

During this time I applied through the Associated Press and was accredited as an AP war correspondent. The AP had photographers in all theaters of operation. AP photos came into the Pentagon via Army Signal Corps or Navy Communications along with the official Army, Navy, Marine Corps, and Air Force pictures.

I was on the replacement list waiting for an overseas assignment. We had a superb staff of cameramen covering all fronts. Bede Irwin was in North Africa; Bill Allen was with General Mark Clark in Italy; Henry L. "Griff" Griffin was with George Patton and the Third Army; Peter Carroll was somewhere in Europe; Byron H. "Beano" Rollins covered the Battle of the Bulge; Charles P. Gorry was with MacArthur's forces in the Pacific, and Joe Rosenthal was with the Marines in Okinawa. Their pictures were all funneled into the Pentagon for release to the media.

Finally I received the word from AP headquarters at 50 Rockefeller Plaza, New York, that I was to replace Peter Carroll in the European theater. Carroll was a top-notch photographer from the Boston bureau who had been covering European operations and was due to return to the United States.

What an exciting prospect! After checking in at the Pentagon to make sure my papers were in order, I bought a uniform and waited for my marching orders. During this waiting period, the war in Europe ended. I was assigned to the Twelfth Army headquarters, wherever they were. My orders got me into Paris, where I checked into the Scribe Hotel, which was then the press headquarters. I was a babe in the woods and I didn't have a clue as to what was going on. I headed for the bar, and sure enough there was my guardian angel with a big smile on his face: Henry L. "Griff" Griffin, just returned from Potsdam where he had photographed Truman's meeting with Churchill and Stalin. He took me under

his wing. He knew the ropes and I quickly got the impression that he was running the whole press camp there. The first thing Griff said was, "Let's get that stupid insignia off your uniform." He was referring to the triangular insignia that had been issued by the Pentagon. "Gimme your jacket and hat," Griff insisted. "You don't want anybody to think you just got here. I've got some real patches that I'll sew on for you." In about ten minutes we were back in the bar and I was sporting "real" patches—of round green felt with "War Correspondent" in gold. Griff could sew a mean stitch.

That was lesson number one. Lesson number two was how to order a drink. All you had to say was "Finea low"; that was a brandy and water. Brandy was about the only thing available, and it was good.

The next morning, bravely suffering a hangover, I tried to locate the 12th Army Headquarters. It might be anywhere, I was told. They're on the move. Then I met Wes Gallagher, AP's chief war correspondent in the European theater. He solved my problem. "You stay here and work out of the Paris Bureau for the time being until we can make assignments," he said.

The big story in Paris was the trial of Marshal Henri Philippe Pétain. The old marshal, who had been the hero of the Battle of Verdun during World War I, was on trial for his life. He had served as head of the Vichy government during Hitler's occupation of France. He collaborated with the Nazis by setting up a puppet government that was strictly under

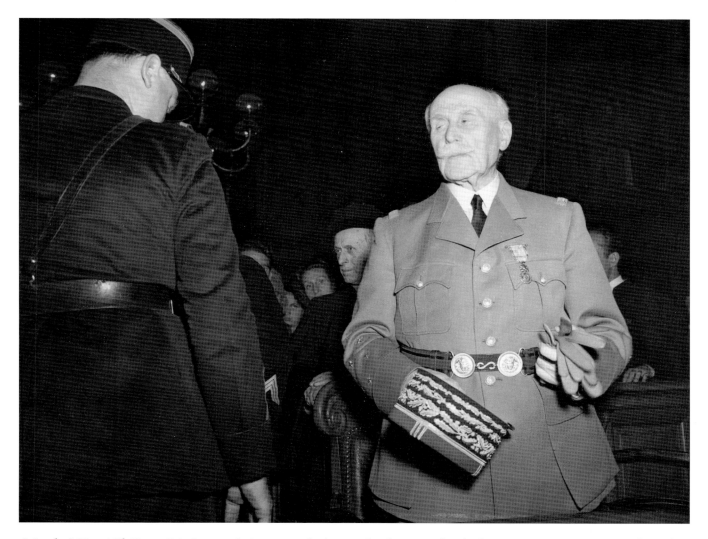

Marshal Henri Philippe Pétain stands in stunned silence after hearing that he has been sentenced to death for his role in heading the Vichy government in France during World War II. The only recourse left to Pétain is the executive clemency of General Charles DeGaulle, onetime admirer who later became Pétain's chief antagonist.

German control. He moved the capital to Vichy and the government was called the Vichy government. I believe that he thought he was doing the best for France to try to save what was left. It was very controversial, and many called him a traitor. Emotions in the new French government were running very hot and heavy. On the final night of his long trial the courtroom was packed. It was tense and dramatic, with judges in their robes and the distinguished old soldier in dress uniform, standing in the dock, awaiting his fate, along with the overflowing galleries and photographers with cameras on tripods and long lenses, jammed inside a roped-off area. The trial was in French and I couldn't understand a word. To me it seemed like a French Opera Tragique.

Louis Nevin, an AP correspondent who spoke fluent French and knew his way around the court, got us into the courtroom and into the press section. We were both in uniform so we got special treatment. I smuggled my Speed Graphic camera under my raincoat. We settled down to watch the windup of the trial. After what seemed like a very long time, Nevin whispered, "They're going to sentence him now."

I waited until the old marshal rose slowly to his feet and I walked out onto the floor in front of him. Pétain was holding his gold-braided hat and white gloves when he heard the court's decision, the death sentence. He paled noticeably and turned his head slightly to the side. It was a highly dramatic moment. I made just one flash picture that caught his tragic expression and left the courtroom. His countrymen sentenced the eighty-nine-year-old legend, hero of World War I, to death. It was a stunning picture, published around the world.

General Charles DeGaulle reduced the sentence to life imprisonment. All Pétain's honors and rights of citizenship were taken away. He died in prison at ninety-five.

I was in Paris on V-J Day and with all the celebrating going on around me I decided learning French had to be a top priority in my new assignment, so I enrolled in the Berlitz School. My French was coming along fine, but after my second lesson, just when I thought I was getting the hang of the stuff, Gallagher assigned me to Berlin. Ach de lieber!

ASSIGNMENT: BERLIN

With my orders in hand to report to Berlin in August 1945, I hurriedly packed my standard Army footlocker and left the Scribe Hotel in Paris in the AP's Citroen, a large black sedan with a driver. I hoped to catch an Air Force flight to Berlin.

I arrived at Orly in good time and found my bucket seat in a C-47, affectionately called a "Gooney Bird" by the GIs. We were on our way to Tempelhof Airport in Berlin. Flying in to Tempelhof was quite an experience. It was a unique airport right in the heart of the huge, sprawling city. As we circled for landing I could see an enormous area of bombed-out build-

ings and rubble heaps. "Unbelievable, what complete devastation. How awful," I thought. Then suddenly the Brandenburg Gate came into view. It was damaged but still standing. Many of the buildings along Unter Den Linden, the broad avenue leading east from the old gate, were somewhat intact. Had our bombers deliberately avoided these grand old structures, or was it just luck?

As the pilot circled we had a marvelous view of the historic monuments of this famous German capital, or rather what was left of them. It was an exciting moment, but I didn't know what I was seeing. Later, I discovered that the huge building on the west side of the Brandenburg Gate was the old Reichstag, or parliament building. It was severely damaged. Hitler's Reichschancellory, a large complex not far from the big gate, was also heavily damaged. The wide boulevards leading up to the famous gate had been cleared of rubble. The Charlottenburg Chaussee was on one side and Unter Den Linden on the other. The side streets in the area were still blocked with rubble from the bomb damage. Here and there you could see a path cleared wide enough for a jeep to get through. Bombed-out buildings and heaps and heaps of rubble surrounded the airport. The plane came in low over building skeletons that looked like they may have been apartments in their day and landed smoothly on the huge runway.

A jeep met me; the ride through the city was even more mind-boggling as we got a close-up of the incredible damage inflicted by our bombs and Soviet tanks to this magnificent old capital. Berlin was a target for Allied forces from 1941 to 1945. In the culminating Battle of Berlin during the last ten days in April, the Russians increased the devastation with a barrage of tank and artillery fire.

The jeep took me to the U.S. Berlin Press Camp in Zehlendorf-West. This stylish suburban area looked a lot better. Most of the houses were intact; there were a few broken windows here and there, but most of these comfortable-looking residences were in good shape.

The 82nd Airborne Division was occupying Berlin, and they had set up a press camp in a large house on the Argentinische Allee. There I met Colonel Barney Oldfield and Major Ted Coleman, public relations officers for the 82nd Airborne. They greeted me warmly, gave me a quick briefing, and assigned me a billet with a German family nearby. It was getting close to cocktail time and Oldfield invited me to come to the press club for a drink as soon as I checked into my room. He sent a young lieutenant with me to meet my German landlord.

The house was of moderate size on a quiet cobblestone street. The owner of the house, a doctor, I think he'd been a professor at the Kaiser-Wilhelm Institute, was still living there with his wife and grown daughter. All three of them came into the dining room to meet me. They were obsequious and nervous. The Army had requisitioned their dining room as my billet, and I had a feeling they were terrified their entire home would be taken over and they'd be out on the street.

So far, they'd had much better luck than most Berliners. They were very accommodating to me, and especially deferential to the young lieutenant billeting officer. This was my first encounter with Germans, and all I could think of was my old high school German teacher, Mr. Gminder. How embarrassed he would be at my stumbling at German conversation.

When I attended "Poly," Baltimore Polytechnic Institute, we had to take four years of foreign language. It could be either French or German. Everybody said German was easier, so I chose it. Now here was my big moment, a chance to speak the German language to Germans.

In my faltering high school "Hoch Deitch" I tried to relieve what I sensed to be an uncomfortable atmosphere. After a "Guten Tag" and a "Wie geht es Ihnen," my mind went blank.

Suddenly, one of my teacher's poems popped into my head. Mr. Gminder told us it was the most perfect poem ever written, and I had remembered it, sort of. It was Goethe's "The Wanderer's Night Song."

I started out, "Uber allen Gipfeln-ist rue."

The old professor's eyes lit up. "Ach! Goethe," he exclaimed. My God, he recognized it, I thought. Things were moving right along. The strange warmth of self-satisfaction was beginning to flow. In a gesture of friendliness I broke out a bottle of Chartreuse, my liquor supply from the press center for one month. The professor's wife produced five crystal liqueur glasses and we drank a toast. The professor seemed to loosen up a bit and started telling me something in German. I wasn't sure what he was talking about, but picked up the gist of it. I nodded approvingly, and he continued in a rambling fashion. I was able to pick up an occasional word, but it was painful. I left as gracefully as possible and headed for the press club.

The press club was in an old mansion on the corner of Forst Strasse and Sven Hedin Strasse. It had been the home of the German finance minister Walter Funk and was a perfect setting for our press club. The entrance led into a large foyer with an ample cloakroom. Several rooms opened to the foyer—a large ballroom with a crystal chandelier, followed by two smaller rooms; one served as a bar, the other a music room. A wide stairway went up to the second floor where, among other large rooms, was a billiard room, which played an important part in my first night in Berlin.

After a quick tour of the premises I settled in at the bar. An exciting place! Here were people whose newspaper byline names I'd read about for years and now I was rubbing elbows with them. I met just about everybody in the club that night. The bar was a congenial place with much conversation and many toasts. The popular drink at the time was what the French correspondents called the "Bomb Atomique," a double martini served in a champagne glass. Wow. A killer, all right.

It wasn't long before my head was swimming. I met and talked with American, British, and French war correspondents who told fascinating stories. As the evening wore on the revelers began peeling off. Suddenly, I realized that I was

pretty tipsy and I'd better go home. It was the darkest night I'd ever seen. Not a street lamp in sight. It didn't take long to realize that it would be foolish even to think about trying to find my way back to the professor's house, so I stumbled back to the press club. I sneaked up the stairs to the billiard room, stretched out on the billiard table, and fell sound asleep.

I awoke at dawn with an indescribable "Bomb Atomique" hangover. The old house was as quiet as a funeral. Not a creature was stirring. I softly descended the stairs, sneaked out the front door, and found my way back to my bed in the professor's dining room. Double martinis had found their mark.

Life in Berlin was interesting and exciting. Berliners spent most of their time coping, trying to find enough food to stave off starvation and enough fuel to keep them warm. The occupying military governments of the United States, Britain, France, and the Soviet Union rationed food. Nobody starved, but there were sure a lot of hungry Berliners. Being on the winning side certainly made a big difference. The Army supplied us with plenty of food and heat for our billets and offices.

Living around the press center complex could be quite pleasant. The Army had requisitioned a fine old Zehlendorf-West home for the press center mess hall. The old ballroom of the house was used as the main dining room with a balcony for an orchestra overlooking the dining room. During my first meal there I couldn't believe what I saw and heard. A string quintet was on the balcony playing Beethoven and Schubert for our dining pleasure. Schubert's "Trout Quintette" was one of the selections, and I'll never forget it. The mess hall food didn't quite match the music, but there was plenty of peanut butter and that was OK with me.

Another pleasant memory was walking back to the press center. During lunch I made friends with *Stars and Stripes* correspondents Ernie Leiser and Joe Fleming. It was a typical late summer Berlin day, gorgeous weather, just the right temperature. Our woolen uniforms were very comfortable. Walking along, we spontaneously broke out in song, a magnificent version of "I've Been Working on the Railroad." It was that kind of day and sticks in my memory. I asked Joe how they got the German musicians who played at meals. "Those guys are more than happy to play for their meals. Our Army food looks pretty good to them," Joe told me. It didn't take me very long to discover that any Germans who could work for the Army were lucky ones. Food was the imperative on every German's list, and the best jobs were working for one of the civilians with the Army. They kindly shared with the Germans.

Shortly after my arrival in Berlin, Louis Lochner, who had been AP bureau chief in Berlin before the war, offered to show me around. I jumped at the opportunity. Louis knew the city like no other correspondent. He had lived there for many years, covering the Nazis and their rise to power. When the United States and Germany declared war on each other,

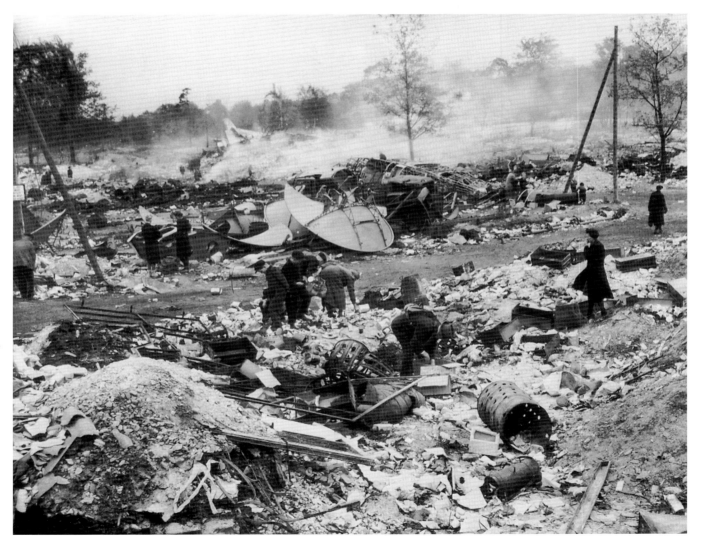

Residents of Berlin hunt through a dumping ground near Tempelhof Airport in search for food and fuel.

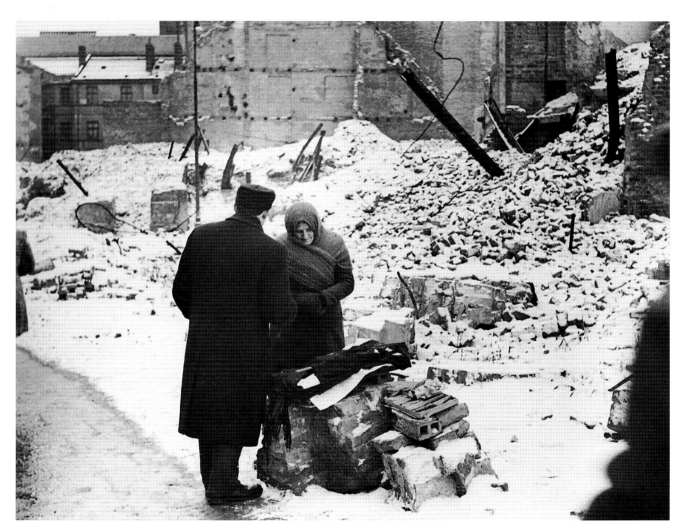

A desperate widow is selling a few meager clothes for money to buy food.

Louis spent some time, along with other members of the American community in Berlin, in a German internment camp. He was eventually released and returned to New York by way of Lisbon. He was undoubtedly one of the best-informed journalists on the inner workings of the Third Reich.

We ordered a jeep from the press center motor pool and set out on the grand tour. Lochner was amazing. Louis knew the history of every street and building in devastated downtown Berlin. He pointed out all the landmarks and reminisced poignantly about how beautiful they used to be. I remember passing the shattered façade of what had been a grand old townhouse that belonged to one of Germany's greatest mathematicians. We drove down the Charlottenburg Chaussee, the wide boulevard leading up to the Brandenburg Gate. It is near the Reichschancellory, and Louis pointed out that small planes landed and took off there in the final days of the war. As we approached the Brandenburg Gate we passed through the famous Tiergarten, a park in the city. Some of the statues were still standing, but most were toppled over or badly damaged and just about all the trees were destroyed. We saw the Soviet Victory Memorial, still under construction. It was an imposing structure of gleaming white marble. The Soviets were not wasting any time.

Soviet soldiers and American GIs were milling around the Tiergarten. We soon discovered the attraction. The GIs were selling watches to the Soviets. A Mickey Mouse watch or any model with a sweep second hand was going for one thousand dollars. The exchange was all in occupation money. The Soviet Army used the new currency to pay their troops five years' back pay, and the GIs could convert it into U.S. money orders and send it home.

Just behind the Soviet Memorial hovered the gaunt remains of the Reichstag Building where Hitler came to power. We worked our way through the debris up the main stairway and entered what must have been the great hall. Here were remnants of huge marble and granite sculptures, with chunks knocked out of them and bullet holes everywhere. What a grim mess.

Then we went through the famous Brandenburg Gate, down Unter Den Linden, past what was left of the world-famous Adler Hotel and the Opera; everything was in shambles. Hitler's Reichschancellory was to be the grand finale of our tour. Near the Brandenburg Gate we drove on a single-lane path through the rubble until we came to the front of the massive building that had once been Hitler's office. Louis pointed out the balcony where Hitler stood as he addressed the German people amassed in the plaza below. Russian and German tanks fought it out right in the Reichschancellory courtyard, leaving an impressive pile of debris.

Lochner, in his quiet story-telling style, painted a picture of the old Reichschancellory and of how Hitler, who was always aware of the importance of staging, insisted on having a magnificent entrance to his office. In spite of the destruction and debris one could imagine a foreign distinguished visitor as he

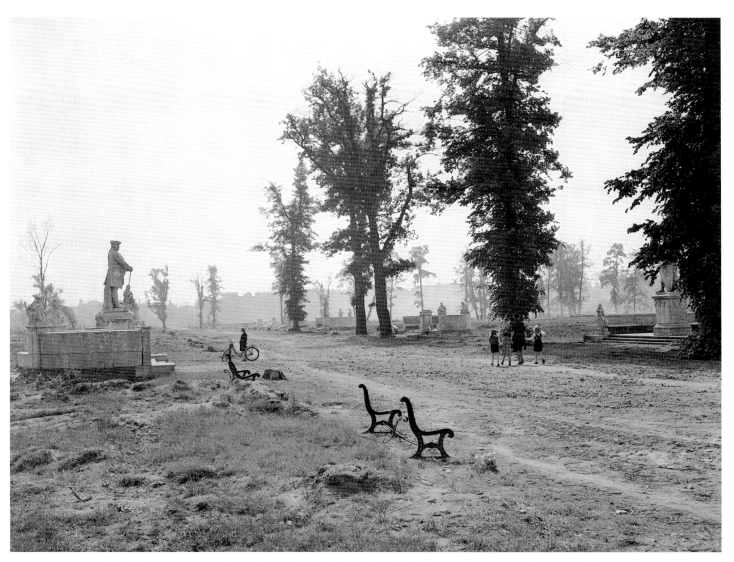

The Tiergarten—a showplace park in Berlin, bordered by monuments of Prussian kings.
The grounds were devastated during the war, and park benches were stripped of wood for fuel.

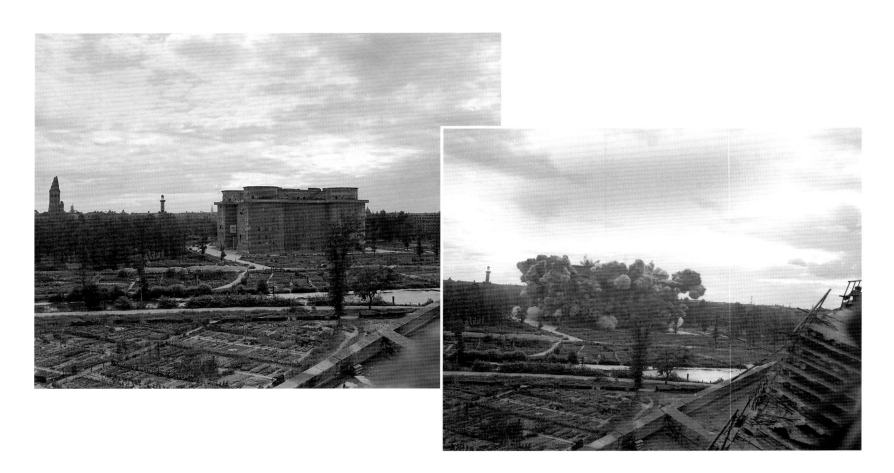

This building stored artwork confiscated by the conquering German Army. It housed many fortunes in gold bullion bars as well as gold inlays from teeth and many treasures taken from the Jews who were sent to concentration camps. In 1947 the British Army demolition experts attempted to demolish the building—it was also used as an air raid shelter. Fifty thousand pounds of high explosive was used, but the demolition was a failure: only the heavy iron shutters from the windows were blown off.

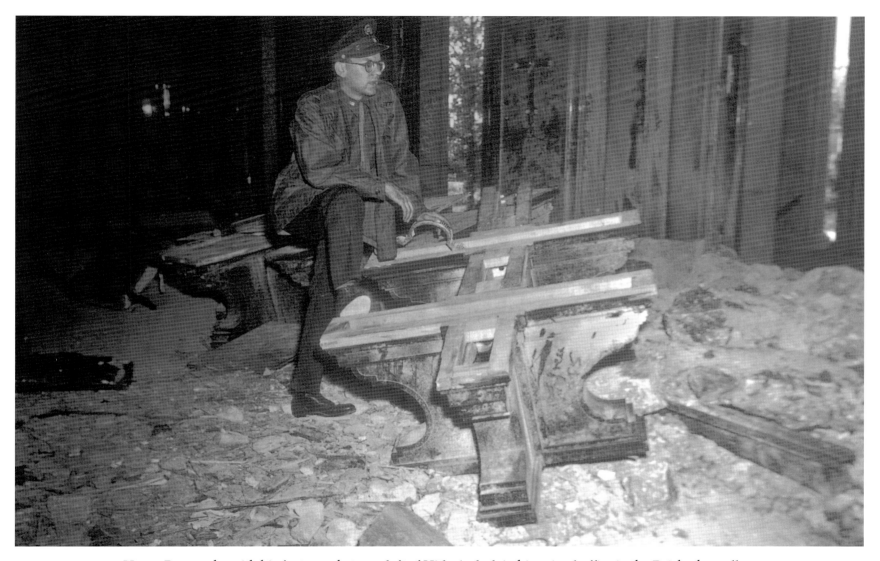

Henry Burroughs with his foot on what was left of Hitler's desk in his ruined office in the Reichschancellory.

approached the inner office of Der Fuhrer. The foyer must have been an eye-opener. Huge. There was a very long palatial hallway leading to the inner sanctum. The office was immense, with large windows overlooking a garden. Hitler's desk, a heavy, hand-carved beauty, was knocked over and damaged. Soviet soldiers, who were the first ones in after the battle, must have had a field day gathering souvenirs.

Across the garden from Hitler's office was the entrance to his famous bunker. The bunker was flooded, but later, when it had been pumped out, I had a chance to inspect the rooms. They were small and rather miserable-looking—not at all like the Hollywood version. The bunker was in the Soviet section of Berlin and when they finally blew it up, large chunks of concrete were all that was left.

I made several tours with Louis Lochner. One I'll never forget. We looked up an old acquaintance of his, a scientist who had been with the Keiser Wilhelm Institute. The old doctor told Louis that the Soviets had captured a group of prominent scientists who had been working on atomic fusion. They were being held somewhere in the Soviet Union. He ticked off the names and predicted that the Soviets would have an atomic bomb in four years. His guess was in the ballpark.

On the way back to the press center my head was buzzing with images of Hitler and Eva Braun, and of their last days in the bunker; the final days of the Battle of Berlin with courier planes taking off from the boulevard near the bunker; the Charlottenburg Chaussee and Soviet tanks moving through the downtown streets. It all had a nightmarish quality.

But as the days wore on, I began to accept rubble heaps, shells of destroyed buildings, and homeless people as normal in this sad city.

There was a not-to-be-forgotten victory parade in Berlin in September 1945, at the end of the war. Standing in the reviewing stand was General George S. Patton, Jr. He wore a gold helmet liner and his "pearl-handled" pistols, which were really ivory-handled. Next to him stood the famous Marshal Georgi Zhukov. Patton was center stage until Zhukov arrived, his chest covered with medals. His uniform was bright pool-table green. Zhukov was the hero of Moscow and Stalingrad. His tanks took Berlin. This was a sore point with Patton, and it was an ironic moment with the two standing next to each other. Patton had really wanted to take Berlin; he was right outside the city limits but was put on hold by the U.S. Command. A deal had been made between Stalin and Roosevelt in Yalta that the Russians would enter Berlin first. The German forces were fighting desperately because they knew what they were in for if the Russians took the city. There were stories of pillaging and rape by the Russian soldiers after the surrender of Berlin. In the victory parade, the capital echoed to the sound of four thousand infantrymen and two hundred armored crews representing the four powers: Britain, the United States, Russia, and France. They paraded in the Tiergarten, Berlin's Hyde Park.

Military advisers came to Berlin, and many others visited. Marlene Dietrich came to see her mother, who was living there. Later that month in 1945, the first Jewish New Year's

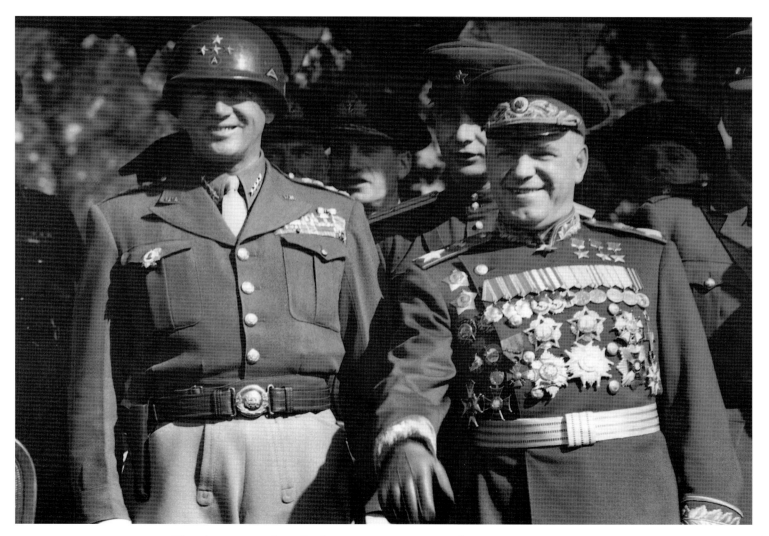

The victory parade in Berlin in 1945. Reviewing the troops were General
George Patton and Marshal Georgi Zhukov of the Soviet Union.

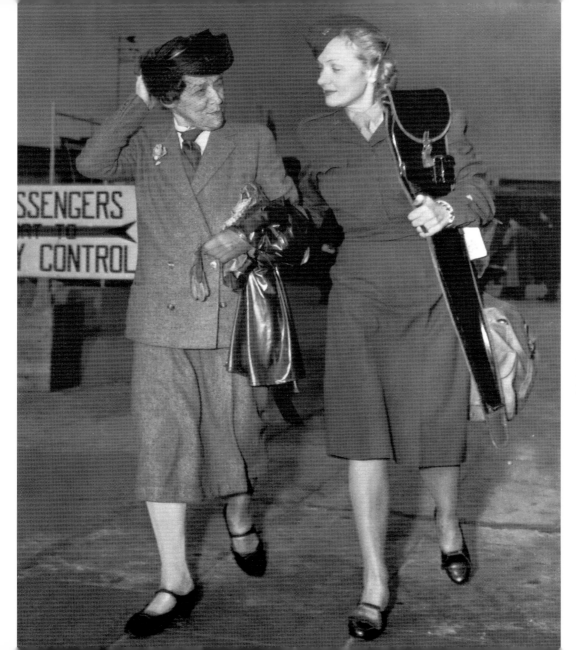

Marlene Dietrich walks with her mother, Josefine von Losch, who met the actress upon her arrival at Tempelhof Airport, September 19, 1945.

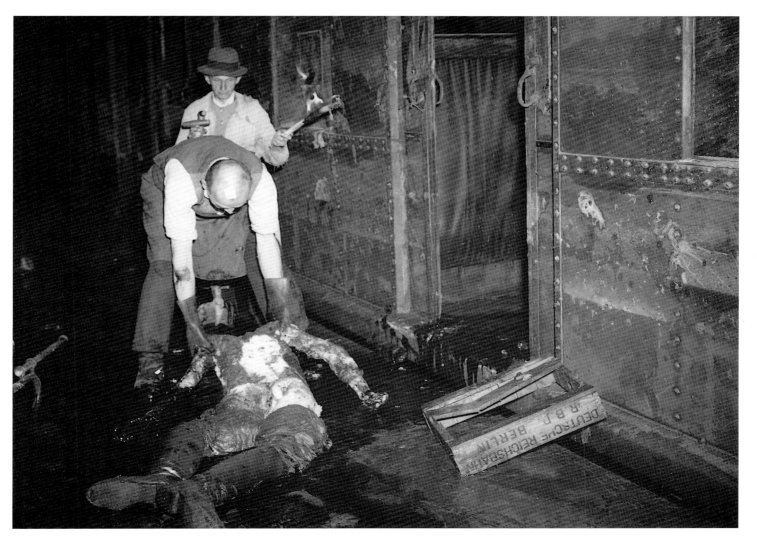

The Nazis flooded the major underground transportation system in the last days of the battle for Berlin. The engineers had pumped out the station; we found several cars filled with dead passengers. Civilian workers wear rubber gloves as they remove a semi-decomposed body.

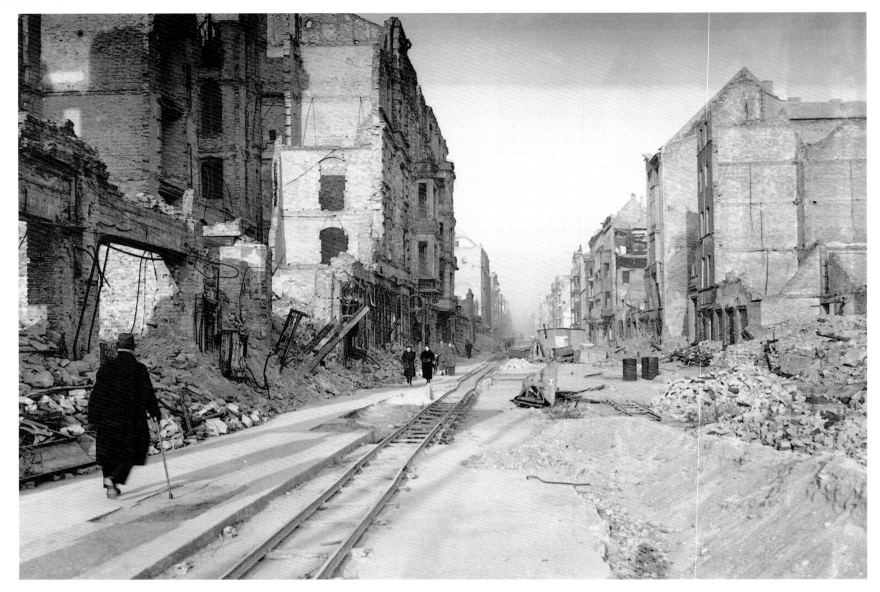

Driving through Berlin on streets that were merely paths cleared through the rubble.

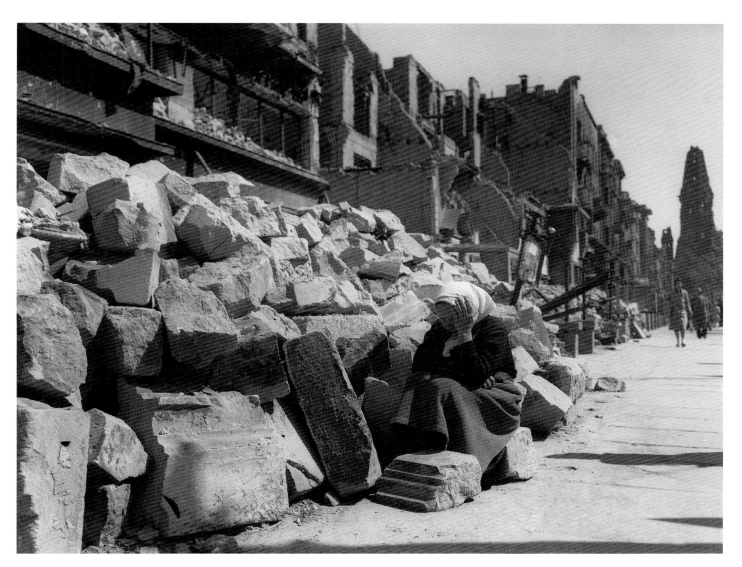

An exhausted woman who had been working all day to clear the rubble.

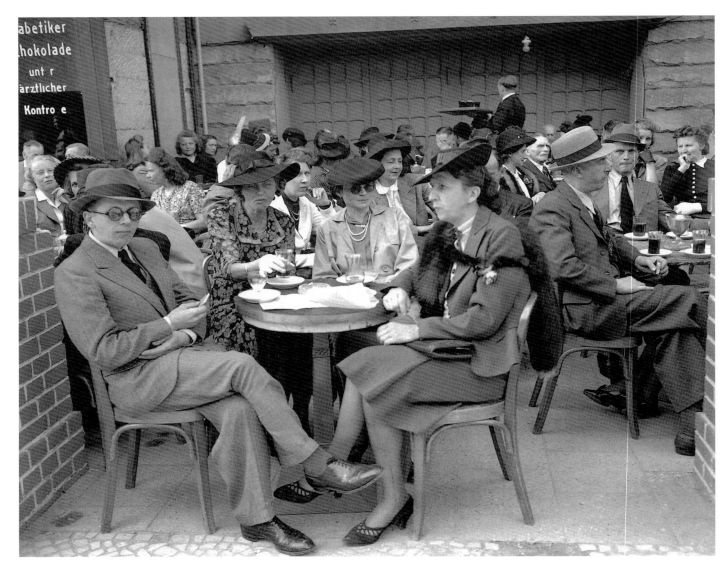

The Kurfürstendamm sidewalk cafés prove to be very popular on any sunny Sunday.
Drinks are lemonade or watery beer. Food can be had for those valuable food ration chits.

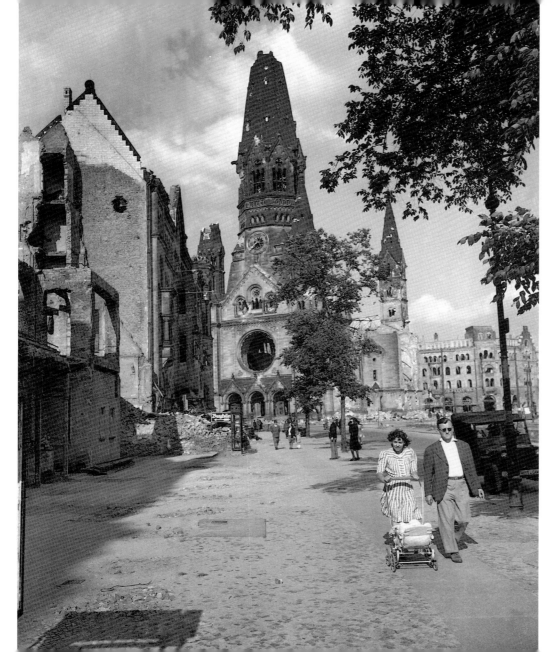

A church on the Kurfustendamm will not be repaired. The Kaiser Wilhelm church will continue to stand as a memorial of the war.

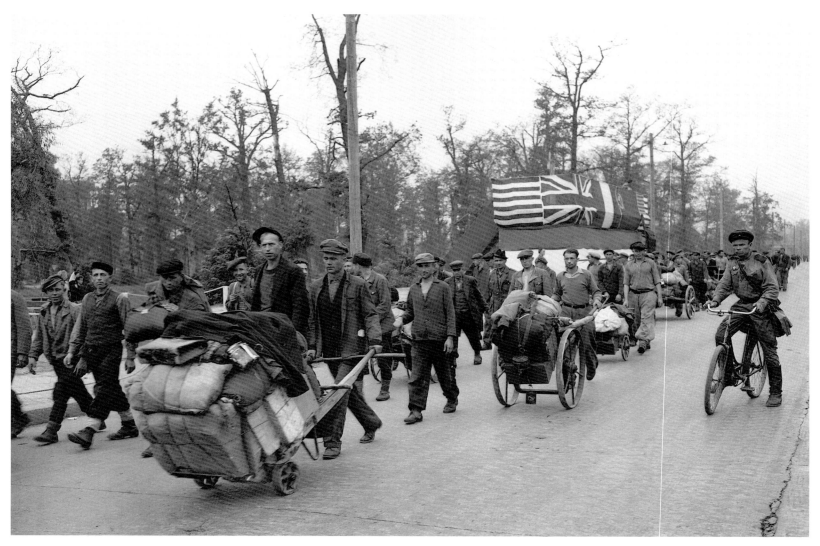

Liberated Russian prisoners from the West with their belongings loaded onto all sorts of handcarts seen as they pass along the Charlottenburg Chaussee in Berlin on their long trip home on foot. No transportation was provided by the Soviet Union.

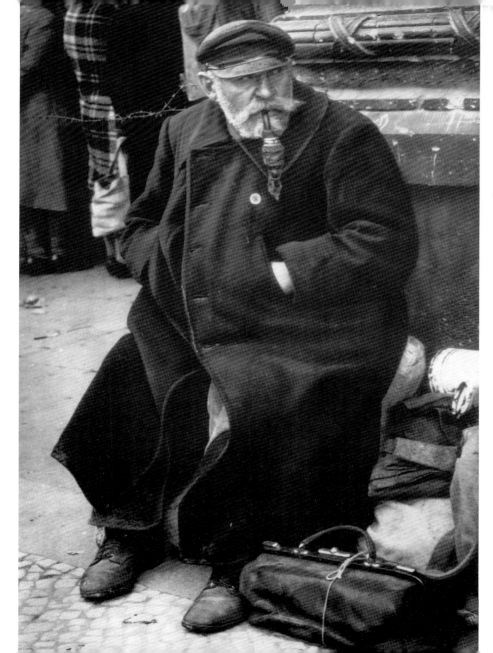

An old bewhiskered German puffs on his ornate pipe and sits atop his meager belongings. He waits patiently at the Anhalter Station for a train, which will take him and other displaced persons out of the capital city and back to their homes.

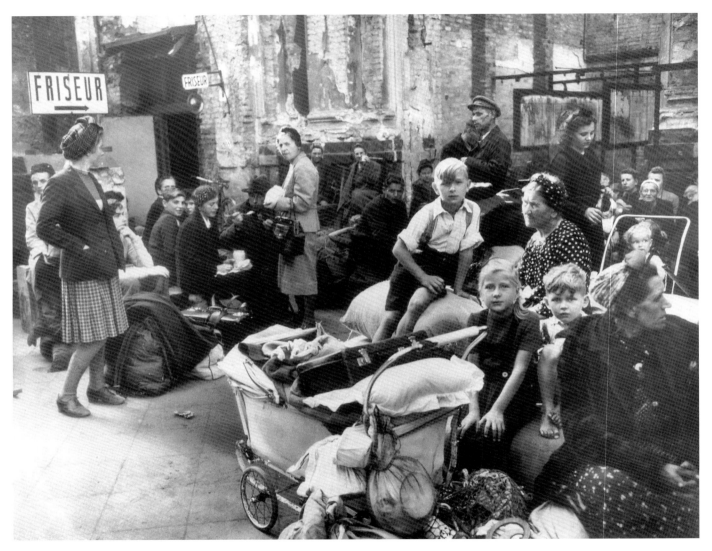

Countless German people uprooted by the war are seen in groups at Lehrter Strasse
Transient Refugee Camp—formerly a military prison—waiting for trains.

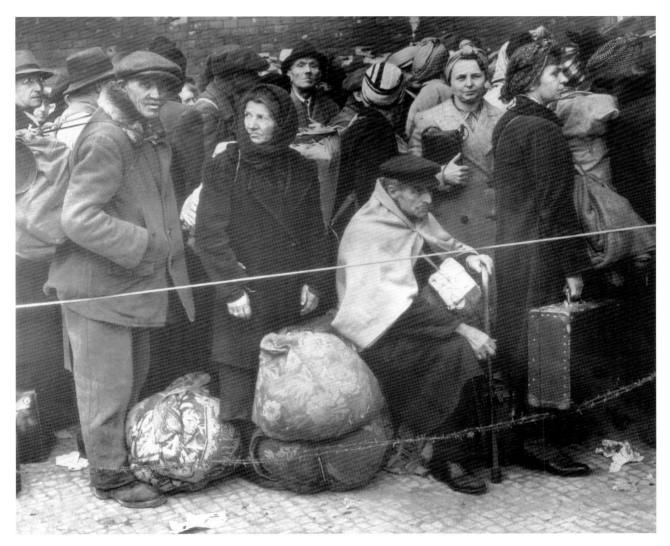

Displaced persons with their scant belongings wait several days for trains because of the shortage of German transportation facilities to take them out of Berlin.

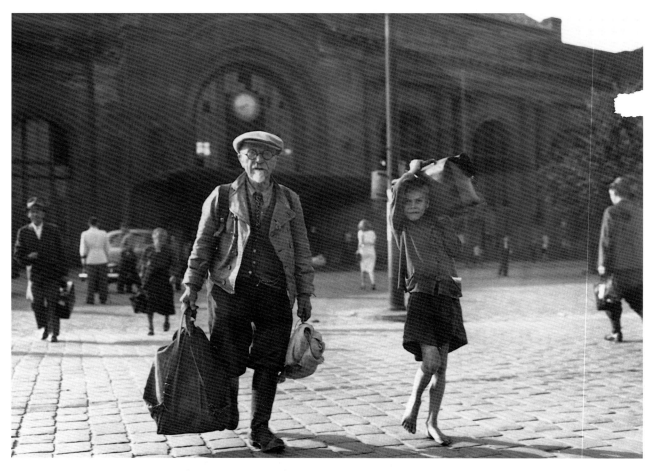

A German general is met by his small son at the train station. A hired auto will carry them to the general's ancestral home, a farm near the university town of Giessen. He and his family now occupy only four rooms of the large estate. The rest of the space is taken up by fifty evacuees from the eastern part of Germany.

service was held in the reconstructed Berlin Synagogue. The Nazis had burned the original building to the ground in 1938. Only the Torah, the Sacred Scroll of Jewish laws that was hidden in a waterproof safe, survived destruction. Allied troops in Berlin attended and participated in the service. It was a highly charged emotional day.

Before the war crimes trials began in November, the daily routine would be to try to find human-interest stories amid the rubble and the devastation. In looking back, one thing sticks in my memory above all others. The smell. The odor of decomposed bodies mingling with the dust of the debris.

The worst experience I had was the day I went into one of the major U-Bahn (underground rail system) stations with the engineers. The Nazis had flooded the underground during the last days of the Berlin battle. The engineers had just pumped out the water and we went down to take a look. A train with several cars filled with dead passengers was at the platform. The stench was beyond description as workers began removing the bodies.

We had Army jeeps for transportation from the press center. We rode through Berlin looking for unusual shots through the jeep-wide paths on the streets. A typical scene of the whole downtown area was women cleaning up the city, stacking bricks, shoveling debris, and forming bucket brigades to remove the shattered ruins of buildings. Women were the main workforce.

One Sunday I did a picture story of Berliners. Germans love to walk and to stop for a drink of lemonade or watery beer. Because food was so scarce there, the Germans picked berries, searching for them near the airport or growing their own. Barter markets were set up for civilians by the Berlin city administrators. They were established to curb the black market. A small admission payment was required. Military personnel were not allowed in this area. All kinds of used articles were sold or bartered.

The first year I was in Berlin, many people were on the move. Transients passed through Germany and Europe trying to get home. First there were the prisoners of war who had been held in the east and were coming back to the west. The POWs held in the west were headed back to their homes in the east. There was a marked difference in the two groups. Those leaving the west seemed to be carrying everything they could scavenge on the way and looked healthy. The group coming from the eastern front looked thin and hungry.

Other transients were displaced persons. The Nazi government moved people as they needed them to work in factories or on farms. Some had moved on their own, to avoid the fighting. Now trying to return to their homes was tedious and tiring. Many didn't know what they would find, if anything. The German transportation system was badly battered. People went to the railroad stations and waited pa-

tiently in line to board a train. They were all ages, children, mothers, and old people with their meager possessions. They would wait for several days for a train. The trains left every fifteen hours. This was true all over Europe.

The press club was a life-saving haven. After a day of rubble dust and observing forlorn, war-devastated people, it was like finding an oasis to sit in comfortable chairs and have a drink and a sandwich and congenial conversation. You might even get in a game of tennis on the old clay court. Herr Teshke, a pro from prewar days, carefully tended the courts. He was in his sixties, but could probably beat any of us. He gave lessons to anyone who asked.

In the early days, the 82nd Airborne occupied Berlin. They didn't have much time to think about recreation, but one day I discovered that General "Slim Jim" Gavin, commander of the 82nd, and his men were planning to jump at Tempelhof Airport just for fun. It turned out to be a good picture story. Ground crews put out targets on the field for the soldiers to try to hit. What a sight as they came gliding downward. A joyous occasion. Nobody injured. These guys were all pros.

Talking about recreation—Berlin provided me with one of the most unique golf games I've had the pleasure of suffering through. Army Special Services had taken over an old golf course out by the Wansee Lake. It had once been a beautiful course—the Nazis knew how to live. I joined a foursome of correspondents to try out the newly refurbished course, way out in the western suburbs, far from the damaged city. We were all excited about playing a strange new course. Strange indeed. On the third hole a rusty German tank sat right in the middle of the fairway. I hit a magnificent drive right down the middle. The ball hit the tank on the fly and careened off into the woods. "That's a free drop, right?" I exclaimed, anticipating a generous and favorable reply. "Play it where it lies," said Tom Reedy with authority. The other two guys chimed in: "Yeah, the tank is a hazard, just like a sand trap." The ball was hopelessly lost in the dense underbrush of the Wansee woods. The next time we played on the course, several weeks later, the tank was gone. I really expected to see a sand trap, but the area was seeded, with a temporary fence in place. The Army Engineers had come to the rescue.

Summers in Berlin are glorious: long, sunny days and short, cool nights. Daylights last until almost eleven o'clock in the evening. How pleasant it was, after a day's work, to sit on the press club lawn sipping a drink and listening to the correspondents rehash their stories. A great bunch of reporters was gathering there that first summer: Louis Lochner, Dave Nichol, and Dick Kasischke of the Associated Press; Ted Meltzer of International News Service; John McDermott and Charlie Bernard of United Press; Kathleen McLaughlin of the *New York Times;* Maggie Higgins of the *New York Herald Tribune;* Judy Barden of the *Chicago Daily News;* Hal Faust of the *Chicago Tribune;* Lyfford Moore of Reuters, who later joined ABC; Ed Haaker of NBC; Joe Fleming and Ernie Lieser of *Stars and Stripes,* as well as many others.

Probably the most fascinating reporter was Wes Gallagher. I met him in Paris during the Pétain trial. He was then the best war correspondent in the European theater and operated out of the press office in Frankfurt. He assigned me to Berlin and later he moved there. We became very close friends. Working together closely on stories, we got along well. He was my boss; great, but demanding. He had been named one of the ten most successful young men of the year by a business poll several years before. He ran a tough, tight ship, but he also had a heart of gold. Even he used to make jokes about his very sour demeanor. However, he had a smile if you knew how to talk to him.

He was legendary for his poker and gin rummy games. While I was in Paris as a war correspondent, Don Whitehead and Wes were into a big gin rummy game in the press office in the Scribe Hotel. I still remember it. Don said, "I've got to go out and buy my wife a gift. If I come home from Paris without a gift she's going to kill me." Wes said, "Deal." Then he called his secretary and told her to buy Don's wife a gift. They played until it was time for Don to leave Orly airport to catch his plane home. Gallagher rode with him and they played gin rummy on the back seat all the way out to the airport. Gallagher did not like to lose. When they got to the airport Wes wrote a check for what I considered an astronomical sum.

While Wes and I were in Berlin he went to New York on home leave. He was a bachelor when he left and he returned with his new bride, Betty. Everyone remarked how he had mellowed. If he had, I didn't notice. He and Betty lived in Berlin very happily. They had a couple of children there.

Gallagher had a superior news sense. He knew exactly where and how he wanted to go with a story. He was excellent in assigning and organizing staff for the best coverage. He loved a challenge, especially if it was a complicated situation. His greatest asset was that he intuitively knew what was going to be the top story. This talent took him to the presidency of the Associated Press Association worldwide.

SETTING UP AP'S PHOTO DEPARTMENT

Setting up AP's photo department in Berlin after the war in 1945 was imperative for me.

I had to rebuild the photo staff. A lot of former AP employees came back looking for jobs. I hired many who had worked in the dark room, which we set up right away. Several former librarians were hired. The finest photographer of the wartime staff wanted to return, but he had been a member of the Nazi Party. The de-Nazification program was going on and I could not put him back on staff. But a former retired major from the Wehrmacht came in looking for a job and I hired him as a dispatcher of photographs.

The photo department in Berlin was given many assignments throughout Germany and elsewhere in Europe. Some were of international interest, while others were local stories

describing the recovery of the people, their cities, and how they coped with severe shortages and the disruption of their lives. AP pictures out of Berlin went to London, Paris, or New York. They were transmitted by radio or press wireless, or you got them on the fastest plane possible to London or New York.

We now had many of the old photo staffers back.* Since they recognized authority, our Wehrmacht major was an asset. Wolfgang was a brilliant guy. He learned English in six months and was able to write captions and send them to London or New York, a task I disliked. He really took charge and I was delighted because I wanted to take the pictures, not edit them. It allowed me the opportunity to cover the biggest events of the times. I made him the photo editor at AP until he was hired away by the German equivalent of *Life.* He was a fine editor.

We were also trying to reestablish a photo service into Berlin to the German papers and rebuild that part of the photo department. I hired a German salesman who was trying to get local papers to subscribe to our service. Many of these papers were surviving but wanted expanded service. Our job was to get them the pictures as soon as we could. In order for our Berlin bureau to have a complete service to sell to the Ger-

* After the war some of the staffers who had hidden and secreted AP picture files brought them back. There are pictures of Goering, Hitler, and others but no captions. There were several copies of the Gestapo black list for Berlin.

man papers, we had to receive pictures from around the world. The package came in from London, the base of our international service. Our salesman was successful because we delivered what the German papers wanted.

The photo department in Berlin was well established by 1946.

■ THE FRANKFURT PARK HOTEL AND GENERAL GEORGE S. PATTON

I reported back to AP headquarters in Frankfurt after the opening of the trial in Nuremberg. This was always a pleasant change. War correspondents covering postwar Germany found solace and comfort in the grand old Park Hotel in Frankfurt. The hotel was elegantly appointed with graciously balustraded stairways and an excellent bar and dining room. Whenever I came to Frankfurt I would stay at the Park and operate from there, making many trips into the U.S., French, and British zones of occupied Germany.

A few correspondents had permanent rooms with a bath. We transients had to take what was left over. Nice rooms, with wash basins and running water, but the bath was down the hall. The communal baths were impressively spacious with large, old-fashioned tubs and elegant fixtures.

During the refurbishing of the plumbing system, the bathroom on my floor presented an unusual challenge. There was only hot water. When you filled the tub with steaming hot

water you wouldn't dare get in the tub. You waited at least half an hour for it to cool down to a reasonable temperature. Then you had a choice: you could wait in the bathroom, or go back to your room to wait and take your chances that some unscrupulous felon would take over your hot bath. It got to be a big joke: "Guard the hot water!"

Another popular sport at the Park was "looking for Martin Bormann!" Bormann was one of the highest-ranking Nazi officials, a confidant of Adolf Hitler, who dropped out of sight as the war ended. Many expense-account trips in Switzerland, Rome, Paris, and Lisbon—all the best places—were titled "looking for Martin Bormann." No one ever found Martin Bormann; he was pronounced guilty in absentia at the Nuremberg trials.

One night in the Park bar I was having a drink with my old friend and AP colleague, Tom Reedy, when Tom got a call from a friend in the military police. The MPs were going to raid a house of prostitution. The two of us left the bar and hightailed it to the Bahnhof neighborhood where the raid was to take place. When we got there the area was cordoned off with many MP jeeps and flashing lights. There was lots of shouting but the action was pretty much over. We were standing outside the police lines, watching with great interest, when a young reporter from Agence France-Presse (AFP) came running up out of breath. "What happened?" she gasped. Without flinching, Reedy replied, "They found Martin Bormann." By this time the troops had begun to disperse,

so we sauntered back to the Park, and Tom checked with the MPs to see how many girls had been rounded up. We chuckled about the young woman reporter from AFP. About 3 a.m. the next morning, Tom was awakened with an alert from his New York office. "AFP has story Martin Bormann found. How, please?" Tom guessed what had happened, but being a good newsman he knew what he had to do. He had to get on the phone and check all his sources to make doubly and triply sure it wasn't true. The next day he moaned and groaned about how it served him right, and how he was hoisted by his own petard.

Another day at the Park Hotel, AP got a tip from our friends on the *Stars and Stripes* at Pfungstadt that General George S. Patton was involved in an automobile accident. AP correspondent Godfrey Anderson and I took off to investigate. Our information was that Patton, famous general of the Third Army, had been taken by ambulance to the new Seventh Army Hospital in Heidelberg. We arrived at the hospital but couldn't get past the reception desk. We tried to get a report on the general's condition and exactly what had happened but didn't get very far. We were told it was a minor accident, the general had suffered only minor injuries, and newsmen would positively not be permitted to enter the hospital. Godfrey filed a story and we headed off to find the scene of the accident. We found it on a roadway just outside of Mannheim, and we found the general's car, an old Cadillac limousine, at a nearby motor pool. The right front fender

AP foreign correspondent Godfrey Anderson looks over the wrecked front of the automobile in which General George S. Patton, Jr., was riding when he was injured. Patton's car was in an accident with an army truck near Mannheim, Germany.

was crumbled, and the radiator had been bashed in, but there were no broken windows. It looked like a run-of-the-mill fender-bender to us. I made a photograph of Godfrey looking at the damage and we took off for Frankfurt to process and transmit the picture. I didn't realize the news value of that photo. The next day that picture was the only one available to U.S. newspapers to illustrate the seemingly minor motor accident. Reports eventually came from the hospital that Patton had broken a vertebra in his spinal column. He was quoted as saying, "This is a damned ironical thing to happen to me."

Patton was a soldier's soldier. He is quoted as saying:

May God have mercy upon my enemies, because I won't. I'm a soldier, I fight where I am told, and I win where I fight. Yea though I walk through the valley of the shadow of death, I fear no one—for I am the meanest motherfucker in the valley.

In spite of twelve days of intensive treatment by the finest surgeons and neurosurgeons, the great George S. Patton, Jr., died in his sleep at the Heidelberg Hospital. This contentious hero of World War II, who had successfully led the Third Army across France and Germany, had just celebrated his sixtieth birthday. Beatrice Patton, his wife of thirty-three years, was with him when he died. She had flown over from New England to be at this bedside. It was December 21, 1945. He had planned to be home for Christmas.

Patton was buried the day before Christmas in the American military cemetery at Hamm in Luxembourg. He shared space in the cemetery with the heroes of his Third Army who were killed in the Battle of the Bulge.

Stories Assigned to Berlin

In August 1946 workmen began repairing the Olympic Stadium in Berlin for the International Sports Meet scheduled to be held the following month. This is the stadium where the Olympic Games had been held ten years before—and much like in 1936 there were to be teams from Belgium, Czechoslovakia, Denmark, France, Great Britain, Greece, Luxembourg, the Netherlands, Norway, Poland, the Soviet Union, and the United States. The stadium had 120,000 seats. The German public was invited. At the last minute the Russian team refused to participate in the track meet.

Soviet Zones of Saxony and Thuringia in East Germany

Apparently, the Saxony and Thuringia provinces in Soviet-occupied Germany were more prosperous than others, because these two provinces were showplaces for any Western correspondents or dignitaries on tour. I went from Berlin to tour the agricultural areas, visit factories, and observe their cultural center. I found industry booming and production humming, with no unemployment in the Russian zone. The situation was the same in every city and factory we saw: the Zeiss Optical Works in Jena, brown coal production in Halle,

The world-famous Meissen porcelain factory, for centuries the property of the state of Saxony, was taken over by the Soviet government as part of its quest to wring war reparations out of the Russian zone of occupation.

textile mills, and the synthetic rubber plant. Although there had been war damage, most of it had been repaired. However, Russia received most of the production of these factories as reparations, and little actually stayed in the local area. The most distressing part of the postwar reparations was the dismantling of plants to relocate to Russia. A German official said, "These removals are very painful, though we recognize them as inevitable. However, we hope to survive this bloodletting." In some cases, like the ancient, famous Royal Saxon china factory at Meissen, the Russians simply took the title to it by the order of the Soviet military governor.

The contrasts between East and West Germany's economies were striking in early 1946. The East's industry was booming and appeared to be prosperous. But then came the calculated and economically devastating period of reparations to the Soviets. Most of the factory production was shipped to Russia, and food production was feeding the entire Soviet zone of Germany as well as much of Russia.

By the next year the Western zones were rebuilding and manufacturing cameras, cars, radios, and leather goods. Coal production from the Ruhr Valley had reached prewar levels. Frankfurt and Hamburg were again brightly lit, and there was again night life. I not only took pictures of this but also wrote the many stories for which I received a by-line. I got a tongue-in-cheek note from Wes Gallagher, AP bureau chief in Germany, that said, "Dear Hank, now it just isn't possible that we have a literary photographer after all these years, who was your ghost writer?" Wes often tried to lure me into becoming a correspondent for the AP, but always and forever I was a "shooter."

Weimar in Thuringia was the cultural center of Soviet-occupied Germany. Bomb damage in the city had been light, except for the Old Deutsches Theatre. It was slowly being rebuilt. The young twenty-six-year-old Communist director of the theater anticipated completion by autumn of 1948. The opera *Faust* had already been chosen for the opening. In the meantime, the theater had been producing plays, even a Russian play, and operas in the smaller Stadt Theatre, which was intact. The improbable boast of the young director was that he had a 70-piece orchestra, 350 employees—a hundred more than the prewar count—and all were working to help in the theater's reconstruction. He had to remove all of the original employees, who were all Nazis. The first director of the theater had been Goethe. A huge statue of him stands in front of the building, which already had been rebuilt twice. Fire destroyed it in 1829 and then again in 1908.

These two provinces were the breadbasket of Germany. They were again producing prewar quantities of grain, potatoes, and sugar. The two land governors said the area was not quite as productive as it might be, but every way to increase food production was being explored. I felt that they were being pressured by the Soviets. It appeared that every bit of land was being used. Growing fields went right up to the factory walls and fences. The Soviet land reforms had little or no

Saxony and Thuringia provinces were the breadbaskets of Germany. The fields were extensive.

effect on production. We were taken to what had been a large farm belonging to a Pole who had disappeared into one of the Western zones. The farm had been split up into small tracts. Each landholder was given a horse, cow, ox, heifer, wagon, plow, barrow, house, and barn to start his farm. Threshing machines and tractors were used collectively.

One healthy bronzed young man told me he had just returned from America, where he had been a prisoner of war for three years. When I asked him how he liked being back home, he replied, "It's all right I guess, but I'd sure like to go back to America." "How do you like the land reforms?" I asked him. His unhesitant reply was, "They should have never taken this farm away from old Zakow, he was a good man."

On another trip, several correspondents toured Saxony and Thuringia to observe the first East German elections since the end of the war. There were five parties. The Women's Party and the Kultur Party apparently did not have a large membership. The predominant party was the Socialist Unity Party, judging from the posters, banners, and pins. They were listed number one on the ballot.

We moved about freely, looking at the polling places, watching people cast their ballots, occasionally stopping to talk with the Germans. We were immediately surrounded by large knots of people and we had to move on. It appeared that women outnumbered the men two to one. In Leipzig our American cars were surrounded by large crowds of voters in front of a polling place. They asked hundreds of questions, including the inevitable one, "Are the Americans going to take over Saxony?" This was wishful thinking.

In November 1947 I was sent to Warsaw to observe the first elections in Poland under Soviet control. The elections were touted as democratic and free and were covered by all of the Western media. We were allowed to watch the voting process. Apparently the entire operation had been rigged so that the person favored by the Soviets won.

I did have an opportunity to see some of the city. It was very downtrodden with little sign of recovery, and the people looked very thin by comparison to those in Berlin. At the airport the next day, I was waiting for my call to board the plane back to Berlin, and I seemed to be the last person in the terminal. I then heard, "Final call for Mr. Borgoose, final call." That had to be me! Burroughs certainly can be mistakenly pronounced that way.

War Crimes

Berlin was the focus of my activity in Germany, although I often went to AP press headquarters in Frankfurt as well as on other assignments. As the autumn days grew shorter, news stories began to break. The judges of the tribunal for the war crimes trials met formally in Berlin for the first time. They were: Frances J. Biddle, representing the United States; Lord Justice Lawrence, representing Great Britain; Henri

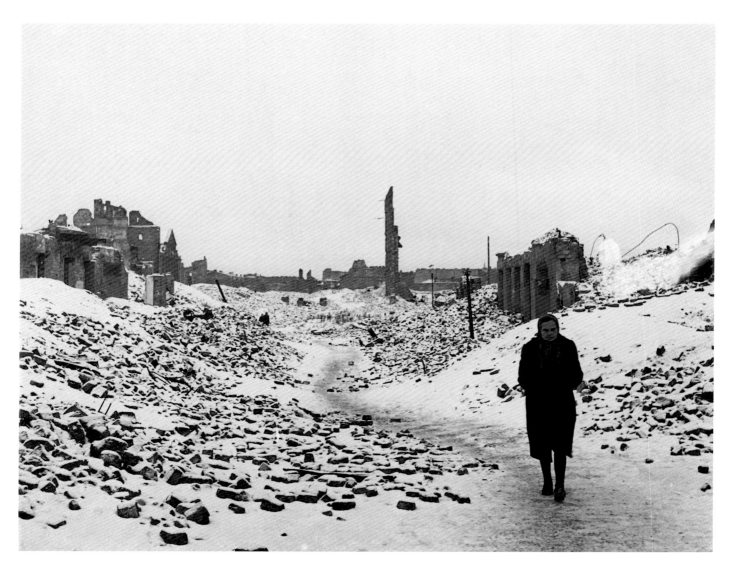

November 1947—devastated Warsaw in the winter.

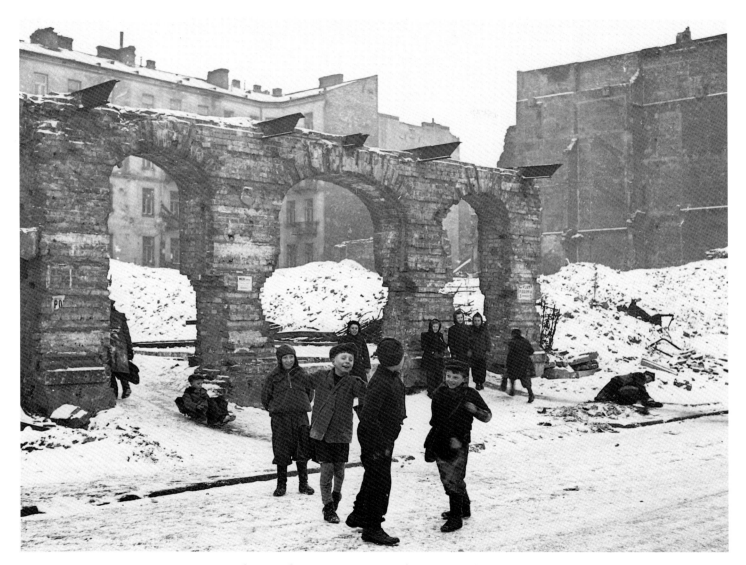

Warsaw. Children have fun no matter how bleak the environment.

Donnedieu de Vabres of France; and Major General Iona Timofeevich Nikitchenko of the Soviet Union. The upcoming trials were generating great interest in the world's newspapers. So this meeting in Berlin was a big story.

I went to Frankfurt to await orders for the opening of the trials. The overnight military train from Berlin was a pleasant ride. The train went through a corridor in the Soviet zone from Berlin west to Helmstedt on the border of the U.S. zone, then down through the American zone to Frankfurt au Main. Frankfurt's railroad station had been partially destroyed but was back in action. Most of Frankfurt had been heavily bombed, but there were two important surviving buildings. One was the I. G. Farben main office building, which became Eisenhower's staff headquarters on the Allied European Front (SHAEF).* The other but two blocks from the station was AP press headquarters, at the famous Park Hotel.

Shortly after I arrived I hurried down to Bruchsal Prison to cover the hanging of five German civilians. Bruchsal is south of Heidelberg, north of Stuttgart, and just east of the Rhine River. The five men were farmers who were convicted by a U.S. Army tribunal of murdering six Army Airmen who had parachuted from a disabled plane near Russelsheim in 1944. The farmers were protecting their homes from U.S. soldiers

* Supreme Headquarters Allied Expeditionary Forces.

with pitchforks. The executions began at dawn, November 1945. I experienced a tense and eerie feeling as the men were led out of the prison yard where gallows had been erected. I had never witnessed a hanging before. They were executed one at a time on a single wooden platform. A German cleric accompanied each man as he mounted the gallows. Three hours lapsed before the last man met his fate. The final words of the last farmer, after saying the Lord's Prayer, were "Forgive them, Father, for they know not what they do." The trap door opened. I'll never forget that moment; it was etched on my heart. Was this justice, or revenge?

President Harry S. Truman sent former Justice of the Supreme Court Robert H. Jackson to untangle such problems as what kind of proceedings the trials would take. What would the punishment be if found guilty? Where would the trials take place? There were many trials and tribunals in many cities of Germany that would follow the same format once a format was established.

Justice Jackson visited General Lucius D. Clay, the military governor of the American zone, in his quest for the best place to hold the major trials; London, Paris, Luxembourg, Wiesbaden, and Berlin were discussed. Clay suggested Nuremberg because the Palace of Justice there was almost undamaged and behind the court were four wings of cellblocks, there was plenty of office space, and the Grand Hotel next door, the best in the city, was miraculously intact. Clay said he could have General George S. Patton bring in fifteen thou-

Five German farmers were hanged for murdering six U.S. airmen with pitchforks. The final words of the last farmer were, "Forgive them Father, for they know not what they do."

sand German POWs to clear the streets of rubble within forty-eight hours. Nuremberg was selected.

Nuremberg, once a medieval walled city of arts and learning, now looked like a ghost town. Many of the old buildings were destroyed. It was 91 percent leveled. The Allies had bombed the city in retaliation for the Nazi bombing of Coventry, England. Piles of rubble were everywhere and the smell of destruction permeated the fall air. Nuremberg now was a shabby city and the people were downcast, vacant-looking, and hungry, with seemingly no desire to restore their old way of life.

The large press corps covering this historic event was billeted in a spacious building known as the Faber Castle. The Faber Schloss had been the home of the pencil king of Germany. The Faber pencil dynasty was established in 1761 by Kasper Faber and the company remained in the Faber family until 1903. Just outside of the Faber castle, an enterprising lady set up a bake shop in the old city, surrounded by rubble. She could hardly keep up with the customers' demands. Bread and potatoes were all the Germans had to keep going. The castle was a real treat; it was shabby but spacious enough to handle the herd of news people. The place bustled as correspondents and photographers checked in. They came from more than twenty nations, but mostly from the United States, Great Britain, France, and the Soviet Union.

Conditions were crowded. It looked like every correspondent in the world wanted to cover the trials. I arrived in mid-November 1945 for the opening of the trials and stayed for about one week.

My billet was in the music room of the old castle. There were about eight iron cots set up, and I laid claim to one of them. As I plopped down to test the comfort level of my new bed, my eyes were drawn to the ceiling. In bas-relief were all kinds of angels and cupids with bows and arrows. All the arrows were Faber #2 pencils. The quivers were also loaded with pencils. Faber pencils of course. My gaze dropped to a frieze. Incredibly, knights on horseback were jousting with lances of Faber pencils. Our music room was the talk of the press corps.

I couldn't wait to show off my ceiling when in came my roommate and arch competitor, Emil Reynolds of Acme News Pictures, the photo division of the United Press. "Get a load of the ceiling," I offered, after quick introductions. Emil broke into an infectious laugh and asked, "Whatever happened to Eberhard?" Emil is one of the funniest guys I've ever met, and we soon became fast friends. The friendship lasted down through the years, even through some very trying and competitive stories we worked on in Berlin.

When time permitted, Emil and I did a little research and discovered that Eberhard Faber, great-grandson of the founder, emigrated to the United States and in 1849 established the first U.S. pencil factory. Every American school child is familiar with Eberhard Faber pencils.

In Nuremberg, Emil entertained us with his sardonic and insulting sense of humor. He had nicknames for many of the

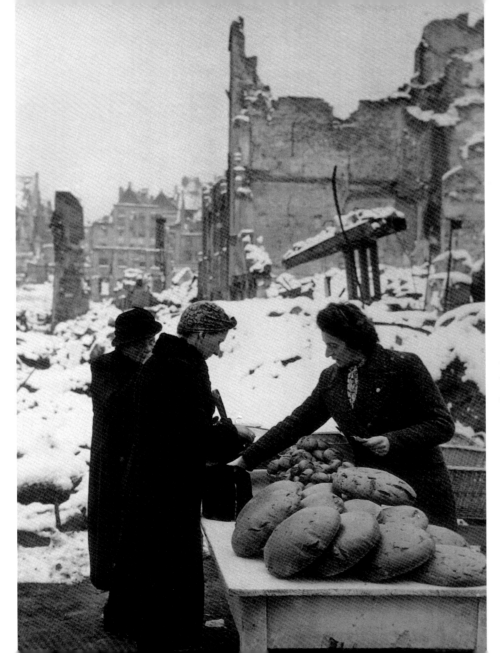

This enterprising woman is selling wheels of black bread and rolls amid the ruins in Nuremberg. She could not keep up with the demand.

correspondents: "Blacksheet" for one of the reporters, who was always asking for carbon copies of other reporters' stories. "Typhoid Mary" for a female correspondent he particularly disliked.

One day, before the trial started, a rumor hit the castle that Frau Göring was coming to visit her husband, Reichmarshal Hermann Göring, unquestionably the best known and highest ranking of all of the prisoners to be tried. This precipitated our fast exit from the castle looking for Mrs. Göring. Alas, but the Army did a good job of sneaking her into the prison. Nobody got a picture of her. Official Army photographers were allowed inside the prison from time to time, but I never found out what they did with their pictures.

The first trial in Nuremberg, the one most people remember, was for the top leaders of the Nazi Party. This trial started in November 1945 and ended in October 1946. There were many other people tried in Nuremberg; verdicts, sentencings, and punishments continued until 1949.

The Nazi leaders were tried by a quadripartite group of allies that had defeated Germany, the French, Russians, English, and Americans. The Nuremberg trials were very well organized. A courtroom had been specially designed and built for the trials in the old Palace of Justice, the former home of the German regional court. The courtroom had facilities for simultaneous translation and interpretation of the four languages to be used, with earphones for members of the court, the prisoners, and the news media. There were reserved spaces for reporters and photographers, plus a small number of visitors' seats.

Tensions had reached a fairly high level by the time the trial opened on the morning of November 20, 1945. Photographers had staked out their positions in the courtroom. My old friend and colleague from AP in Washington, D.C., B. I. (Sandy) Sanders, and I were manning the AP cameras for the opening. It was Sandy's beat and he covered the whole trial. I stayed for about one week and returned for the sentencing. Charlie Lane, our news photo editor from London, was directing the very important operations back stage where processing, selection, and transmission by radio of the photos were handled. This was a big story and the world was waiting.

On one trip to Frankfurt from Berlin, in early 1946, I shared a compartment with General Bedell Smith, who was General Eisenhower's chief of staff. I asked him if he had gone to Nuremberg to observe the war crimes trials. He said he didn't want to go near the place because he couldn't sit across the dock from his counterparts in the German Army, Generals Keitel and Jodl. He said, "There but for the Grace of God go I."

There were 240 seats reserved for journalists. The overflow listened to the trials in the pressroom via a loudspeaker system. Many big hitters of the news media were there: Wes Gallagher and Louis Lochner of the Associated Press; Walter Cronkite and John McDermott for the United Press; Kingburg Smith for Hearst's International News Service; Ray Daniell of the *New York Times*; Marguerite "Maggie" Higgins

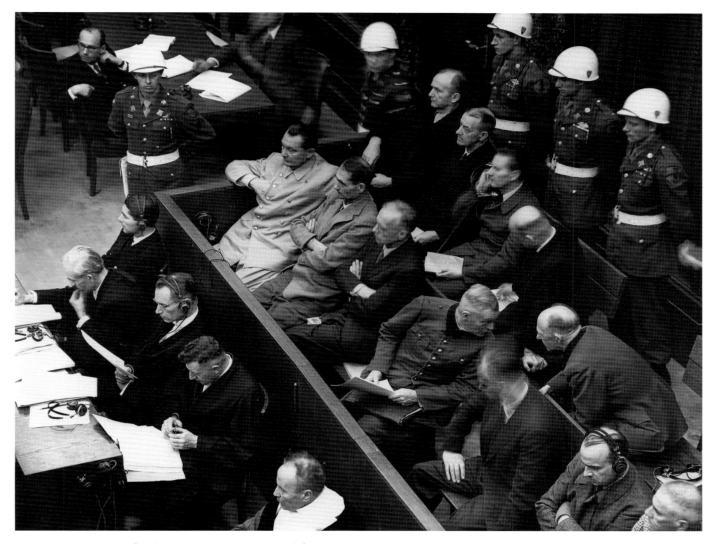

The first and most famous of the Nuremberg trials of major Nazi war criminals.

of the *New York Herald Tribune;* William L. Shirer and Howard K. Smith of CBS Radio; and many more.

Finally, the courtroom door opened. The prisoners, headed by Hermann Göring, filed out and took their places in the specially built dock. The newsreel cameras whirred and still cameras clicked away. Many of us were using the old Speed Graphics and the long lens Graflexes nicknamed "Big Berthas."* The unmistakable sound of those old focal plane shutters dropping filled the otherwise quiet courtroom. With the long lenses we could look right down on the dock and get a perfect shot. Photographers were allowed to photograph the reading of the verdicts on September 30 and the sentencing on October 1.

We were not able to make pictures of the executions on October 6. The Army photographers took pictures of the hangings and of each corpse. These photos, showing the hangman's ropes in place, were released. Kingsbury Smith of International News Service was chosen by lot to represent and report to the American press on the executions. When we received word that the condemned men were headed for the gallows in the jail yard, we all went there, or got as close as we could. We were close enough to hear the door drops on the gallows. One alert photographer counted just ten. Eleven men had been condemned to death by hanging. Who cheated the hangman's noose? We soon found that Göring had swallowed a cyanide capsule the night before the execution. There have been many theories of how he got the capsule. At the time it was thought that Frau Göring had smuggled it in.

The corpses were driven away, cremated, and the ashes strewn in a river. There was a fear that some people would erect a shrine or a memorial. Those in the military that carried out these orders were sworn to secrecy. The river was identified many years later as the Isar in Germany.*

Questions still haunt some. Were the war crimes trials a victor's revenge or the authentic pursuit of justice? Can a nation try crimes that were not defined as such until after the fact? Justice Jackson certainly wrestled with these questions.

■ ■ THE BERLIN BLOCKADE AND AIRLIFT

In early 1947, Berlin was relatively quiet. The four-power military government was supposed to be controlling the devastated former capital. An advisory commission confirmed an agreement at Yalta and Potsdam in 1944 by setting up the Allied Kammandantura, the four Allied military powers, to govern the city. The Allies called it a quadripartite government.

The Western Allies and Soviets had different economic policies in governing. The Russians dismantled East Berlin industries before handing over that section of the city to the

* "Big Bertha" was the name given to a large gun built by Friedrich Krupp. When he died the ownership went to his wife, Bertha.

* Reference: *The Nuremberg Trial* by Joe J. Heydecker and Johannes Leeh; *Nuremberg: Infamy on Trial* by Joseph Pasico.

A religious service was held for all of the men who were hanged. Their bodies had been cremated.

Berliners demonstrate against the Nuremberg decisions. Berliners carry red flags and banners calling for the death of all the Nuremberg Nazi defendants. Speakers denounced the decision of the International Military Tribunal to acquit the three Nazis: Franz von Papen, Hans Fritsche, and Hjalmar Schacht.

quadripartite government. The Soviets encouraged increased production in their zone, but took a large portion of it for war reparations.

German political parties were beginning to organize. Democracy was the new and popular slogan amongst Berliners. The new slogan was used by the Communist organizers as well as the Western-oriented parties. We didn't realize at the time that the Soviets had been planning and organizing for months to take over the quadripartite city government of Berlin, one way or another. At the time we Westerners were blithely operating under the assumption that the four powers would rule the city together. However, there was trouble in reaching consensus. The Soviets vetoed most Western measures. This may have been the beginning of the Cold War.

Picture coverage became more difficult and photographers did not have as much free access when things started to go sour with the Russians. It didn't take long for things to heat up between the Soviets and the Western sectors. The Russians put pressure on the Western photographers when they worked in East Berlin (the Soviet sector). They didn't look upon Americans coming into their sector with favor. Often we were delayed by the Soviets when we went on assignment to the east zone. One day Joe Fleming, a *Stars and Stripes* reporter, and I took an Army jeep with a driver and went to the Soviet sector looking for the Soviet barter market that they said they would start. It was to be similar to the one in West Berlin. Berliners who had little or no money could barter with

each other for the things they needed. It sounded like a good story and picture. But we never found the barter market. Apparently we were close when we were arrested by Soviet soldiers, who confiscated our jeep. Fortunately, our German driver lost himself in the crowd that surrounded the jeep, worked his way back to U.S. headquarters, and reported what happened. The AP contacted General Holly, who was the commandant of Berlin in the U.S. sector. He called his Soviet counterpart and read him the riot act, which resulted in getting us out. Joe and I were held prisoners for eight hours and were interrogated by a major in Soviet Intelligence, obviously an NKVD man, who spoke perfect English. We never got pictures of the market. My camera was in our jeep when the Soviets took it, and they returned it to me after I was released.

In a move calculated to drive the Allies out of Berlin, the Russians, claiming "technical difficulties," halted all traffic by land and by canal in or out of the Western-controlled section of Berlin in June 1948. Much tension followed when the Soviets closed off the Autobahn and rail lines from Helmstedt into Berlin. These were the lifelines into our isolated city, surrounded by Soviet German territory. All food and supplies for West Berlin came in by these two land links. The Helmstedt to Berlin corridor, which was one hundred miles long from the west, had been agreed upon when Berlin was first occupied by the four powers. (The only remaining access routes into the city were three twenty-mile-wide air corridors across the Russian zone of Germany.)

The crisis was of gigantic proportions. Many were saying that if the U.S. Armed Forces tried to break the blockade, it would start World War III. This was the first major test of the free world's will to resist Soviet aggression. General Lucius B. Clay, commander of U.S. Forces and the military governor of Germany, was faced with the choice of abandoning the city or attempting to supply the necessities of life by air. He started an immediate airlift with a few cargo planes available at Wiesbaden and Frankfurt. General Clay then flew to Washington to sell the airlift idea to President Truman and the top military commanders. General Clay had his headquarters in Berlin and didn't intend to let the Russians kick us out. The key military advisers to the president didn't think much of the plan, but President Truman did. He overruled the brass and declared, "We're going to stay in Berlin, period!"

Operation Vittles, the greatest airlift the world had seen, got started. The C-47s, the "Gooney Birds" that had started bringing supplies into the blocked city, were suddenly joined by their big brothers, the C-54s. These transport and cargo planes arrived at Rhine-Main, Frankfurt, and Wiesbaden from bases all over the world, and then began flying around-the-clock missions into Tempelhof Airport. Planes, mostly C-54s, were coming in every two or three minutes, night and day. In a show of strength and to underscore Allied determination to resist Soviet pressure, the Strategic Air Command (SAC) bomber groups were sent to Europe, placing Soviet targets well within the range of the B-2 group. The early flights carried mostly coal and potatoes, the two basics for survival. Later, cargos became more sophisticated. Dried food replaced potatoes because it was lighter. Tempelhof, in the U.S. sector, is right in the heart of Berlin. In the city's glory days there were buildings all around, but they were now all destroyed. All of the British planes landed at Gatlow, an airfield in the British sector, and the French were landing at Tegel in the French sector. The planes headed for three separate air corridors for their approach, but on their return they all used the same busy corridor.

When the airlift started there was on hand a thirty-six-day supply of food and a forty-five-day supply of coal for two and a half million people. It was a brilliant move to fly in the supplies. Without firing a shot, General Clay managed to keep the city going for a year through a bitter winter.

I remember those early days covering activities at Tempelhof. Everyone pitched in with great enthusiasm. The German people whom I talked with were ecstatic, realizing that General Clay was not going to abandon them and their city. They named one of the great boulevards in Berlin "Clay Alle" after General Clay.

During all this, life at the press community in Zehlendorf-West continued as usual. One rainy night I was invited to a small dinner party at Drew Middleton's house; Drew was the *New York Times* correspondent. One of the guests, General Charles Gailey, chief of staff to General Clay, received an urgent call. An airlift C-47 had crashed in the U.S. sector en

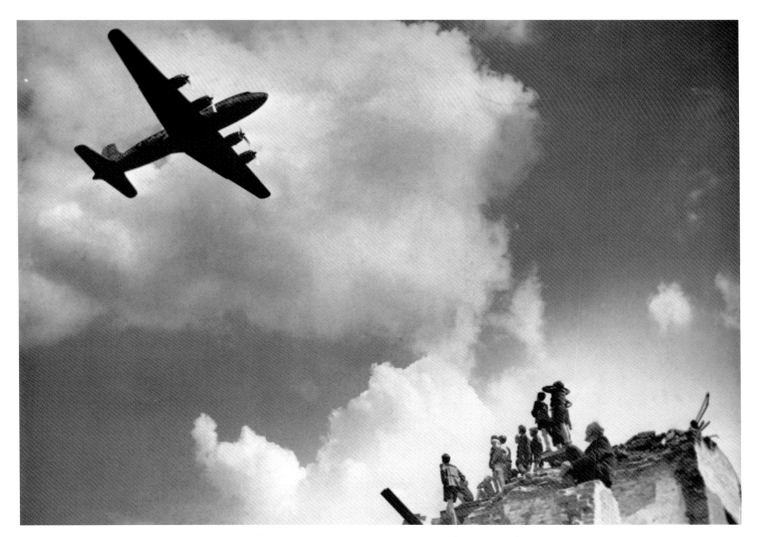

Youngsters stand on a bomb-damaged building near the Tempelhof Airport as a U.S. cargo plane, part of the Berlin Airlift, flies overhead after delivering a load of coal in 1948.

route to Tempelhof. I grabbed my camera and hitched a ride with the general. His staff car got us to the scene in minutes. The MPs were already in control. The pilot and crew had been removed from the wreckage; unfortunately there were no survivors. The plane's wreckage melded in with the bombed-out buildings along the glide path on the approach to the airport. Tempelhof used a ground approach system for talking the pilots onto the correct path. The controller with the plane on his radar would instruct the pilot: "You're too high, you're too low," etc. It had been a very successful procedure, except in this particular case.

I bought a Fiat Topaleno in Frankfurt to take to Berlin. It was a small car with a retractable roof. I could not ship the car by plane because the space was reserved for food and coal. Since the blockade was still in effect, I could not drive on the Helmstedt-West Berlin Autobahn, but Leipzig, in the Soviet zone, was having a large trade fair. They were proud and eager to display what their factories were producing, so I got press credentials to cover the fair. I picked up my new car in Frankfurt, then drove on the Autobahn from Frankfurt through Bamberg and Bayreuth in West Germany, then turned North into East Germany on the Autobahn, headed toward Leipzig. I cleared all of the checkpoints and crossed the border with my press credentials. There was no problem entering or leaving the Leipzig area. I arrived in Potsdam, the last checkpoint to be cleared into West Berlin. The Soviet police scrutinized all of my papers, and I was delayed while they discussed my press passes, passport, residence papers in Berlin, and Army orders. This was typical of the Soviets and it was very stressful for me; I was so close to success. My little car and I were finally cleared to proceed. That car was perfect in Berlin. When I left, I sold it for more than I paid for it.

A Moscow-trained German Communist named Walter Ulbricht had come to Berlin with the early Soviet troops and had already organized the political arm of the Communist Party. The new party was called the "Socialist Unity Party" (SED). At the same time, other parties were organizing throughout the occupied city. They were: the Social Democratic Party (SPD), the Christian Democratic Union (CDU), and the Free Democratic Party (FDD). The Communist SED had great difficulty signing up Berliners, who remembered well the debauchery and rape by Soviet troops when Berlin surrendered and the Russians were the only occupying force. That didn't stop the SED. Their thugs would beat up SPD speakers and organizers when they came into the Soviet sector. I covered many rallies of both parties. Fortunately, when I went into the Soviet sector on these exciting jaunts, my good friend and AP colleague, Richard O'Malley, would accompany me. O'Malley was big and tough as nails when required. He had been a cowpoke, an amateur boxer, and a nightclub comedian before he gravitated to the newspaper profession. He ended his long career with the AP as bureau chief for Germany and retired to Ireland.

The Communists were well organized and they tried to disrupt all oppositional political meetings by harassing attendees, tearing down signs, and causing fights. "I'll be your torpedo," O'Malley announced. He meant that he would be my bodyguard. The Communists didn't like Western photographers at their meetings. Thank God for O'Malley. He saved me many times from getting beat up by SED thugs. At one Communist meeting I took a couple of quick pictures with my Speed Graphic, then slipped the film holder to O'Malley. The German police in the Soviet zone came after me and demanded the film. I pulled an unexposed film holder out of the camera, removed the film, and gave it to them. Meanwhile, O'Malley had escaped with the exposed film holder.

It became obvious that the Soviet-sponsored SED could not win elections legitimately. Therefore, the Russian commandant unilaterally proclaimed that Berlin be split into an East zone and a West zone and dissolved the Kammandantura, the governing body of Berlin, agreed to in 1944. This local political crisis reached a zenith several days later when we heard through German sources that the Communists were planning to shut down the City Assembly. City Hall, where the assembly met, was in the Soviet sector. The city's ruling body was the Germans, who had been elected. The Soviets were determined that the West abandon their rights to governing the city.

I joined a small contingent of U.S. correspondents to cover the action. When we arrived at City Hall, a noisy mob of SED followers had already gathered outside. They were shouting derogatory slogans against Ernst Reuter, the elected mayor of Berlin. As the crowd got more boisterous and threatening, I went into the building to await developments just before the assembly officials ordered the building doors be closed and locked. The demonstrators were locked out of the building, and we were locked inside. The crowd surged toward the main entrance and started pounding on the door. Then several burly groups started battering the main entrance with a large log. I was standing on a stairway for height when they smashed through the doors, with the sounds of shattering glass and crumbling metal filling the entrance hall. I took one shot as the door caved in, then before I knew what was happening, I was knocked down and my camera ended up in the hands of a demonstrator. There was no O'Malley to protect me this time, but Ernie Leiser, my old friend from *Stars and Stripes,* hit the guy who had my camera. He dropped it and I grabbed it. The film was damaged as well as the camera, but the camera was repairable.

After a few minutes, the police finally cleared the building and the demonstrators left, satisfied. They had broken up the assembly meeting. The assemblymen from the West left the area scared to death. The Soviet assemblymen called a rump session and declared all of Berlin under Soviet control. The American correspondents retreated to an office on the second floor. The police announced that no one would be allowed to enter the building, and that if you left you couldn't return. So,

we all decided to stay, to see what would happen. An AP German courier was waiting outside, and I lowered my film holders to him by rope. I asked him to stop by the press club and bring us some sandwiches and coffee. We didn't know how long we would be holed up in the building. There were about seven of us, and we settled down for a long siege.

Some time after dark the messenger managed to get through the police lines with our sandwiches and coffee. We hauled up the sandwiches and feasted. We stayed overnight, until the military commandant, General Holly, who was in charge of the American sector, negotiated with the Soviet leader in Berlin to release us. We came out unharmed. The Soviets put us in trucks and took us back to the American zone.

The next day I witnessed, photographed, and wrote this story that was published in Washington, D.C., papers:

Berliners Fearless in Fighting Russians, D.C. Man Declares
AP Photographer in Midst of Battle at Brandenburg Gate

Berlin, Sept. 10. I was standing near the Reichstag building taking pictures of the great German throng streaming home from their anti-Communist meeting yesterday when I heard a great shout.

I moved closer to see what the trouble was. The crowd was closing in on a Russian jeep carrying three Soviet soldiers. The crowd was booing them as the jeep moved slowly through the massed humanity.

The jeep stopped and suddenly the crowd began throwing stones at the Russians. The soldiers jumped out of the jeep brandishing tommyguns. Those nearest them moved back. The soldiers got back into the jeep and it moved ahead toward the Soviet memorial in the British sector. The crowd taunted them, laughing and shouting.

When the jeep reached the big memorial, which is only a short distance from the Soviet Sector border, another part of the crowd surrounded it.

The Soviet soldiers left their jeep again and advanced menacingly. They held their tommyguns at the ready. The Germans faded back but continued to boo and laugh at the angry Soviet troopers. Then someone threw another rock. It crashed through the windshield of the jeep. British soldiers rushed up and forced a protective cordon around the Red memorial.

I felt the tension rise in the crowd. They seemed utterly fearless of the armed Russians. A few hundred yards away another great crowd of Germans was milling around the Brandenburg Gate, entrance to the Soviet sector.

I hurried over. As I approached I heard at least 10 shots. They sounded like pistol shots. A German near me said:

Why do the British and Americans let these Russians do their pleasure driving in the Western sector? I hurried on.

The crowd around the gate was running pell-mell into the British sector. High up on the bomb-scarred Brandenburg Gate, I saw a man working his way to the big red flag which flies there. He got near the flag, and two shots were heard. The man on the monument kept moving. He flung the flag to the ground. As it fluttered down a great cheer arose from the crowd. Some Germans rushed up to get the flag. Then a Russian jeep whirled up and five Soviet tommygunners jumped out. This time, they didn't just brandish their guns. They used them.

Within the image: Ma / von G / Haupt / Neues

Hank Burroughs behind an Iron Curtain. He went to Berlin's City Hall where the assembly met as a boisterous crowd outside was demonstrating against the elected mayor. The doors of the building were locked.

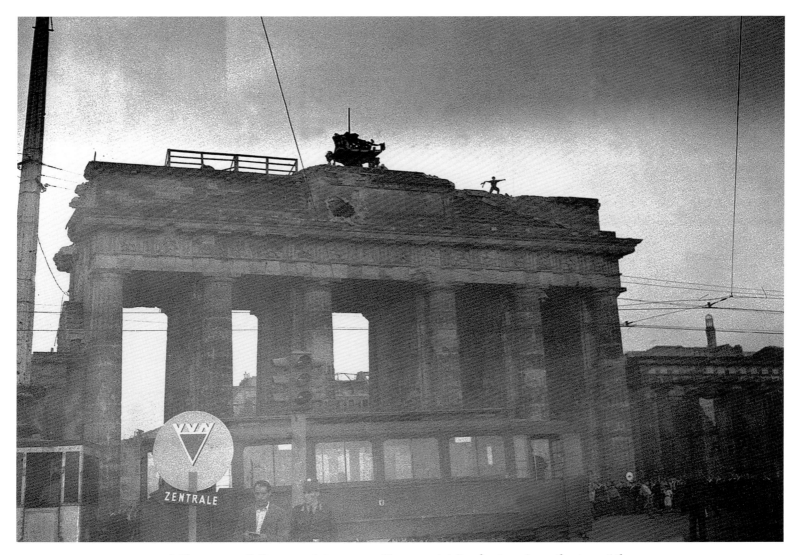

A German anti-Communist waves a Communist flag he tore from the top of the
Brandenburg Gate dividing line between Russian and British sectors in the center of the city.

I was standing in a little group and suddenly I saw a tommygun swing around. It was pointing at us. The Russians fired once. I think the shots must have been high for, as we scattered, I saw no one fall. There was too much yelling to hear the sound of the bullets.

The Germans broke up and ran in panic. The tommygunners swung toward another group. Methodically and grimly they drove the crowd away from the gate. Behind the Russians were uniformed Soviet sector policemen. I think they must have done the pistol shooting.

I heard several people were hit when the pistols were fired.

British soldiers came up the border of their sector and helped disperse the crowd. The Germans began to leave and I hurried back to the office with my pictures.

That was the beginning of the nasty stuff. It went on from there until it ended up with the Berlin Wall in 1961.

AP correspondent Dan DeLure and I were sent on an assignment to Kirkenes, Norway, in March 1949. It was my last trip out of Berlin before I returned home. Kirkenes, along with Malta in the Mediterranean, were the most heavily bombed areas during World War II. Our job was to tell about Kirkenes' place in current history, its recovery and future outlook.

We traveled north by a small coastal freighter along the west coast of Norway in the Norwegian Sea. We rounded North Cape, the northernmost point in Europe, into the Barents Sea. Finally we entered into Varanger Fjorden and Kirkenes. Although it is beyond the Arctic Circle, it is an ice-free port, approximately four miles from the Russian border, where Hitler built his "festung Kirkenes." Ships, supplies, and more than five hundred thousand German troops were sent there as a staging area to invade Russia from the north. The town of about three thousand built air raid shelters for protection and many people fled for safety. The Germans began the town's destruction and later the Russians drove the Germans out in 1944. After the war the town was found totally flattened. There was not a manmade structure standing that was built before 1944. The ore industry, fishing, farming, and reindeer herding were all destroyed.

We were put up in the only hotel in town. The rooms were comfortable and warm, but the toilet was an outhouse and it was close to -30 degrees outside. The chamber pot was a real necessity. The restaurant next door had an indoor toilet. Thank Heavens!

The local people were hoping for peace and the time to reconstruct their town and its industries. All of the buildings were new, made of wood, and construction was going on everywhere. The lifestyle of the people seemed to be thriving: stores, a beauty shop, the fishing fleets working, the Laplanders working the herds, and commerce seemed to be thriving also. However, it was hard to forget that Russian tanks were less than four miles away. The Iron Curtain had come down. Kirkenes was a Cold War town in 1949, on the Norwegian-Russian border.

The U.N. Security Council made many attempts to bring the Berlin blockade to an end. It finally ended officially on

Kirkenes, Norway, near the Russian border, in 1948. The town was almost completely destroyed during World War II by the Germans and later by the Russians when they drove the Germans out in 1944. At the height of the Cold War, Kirkenes' inhabitants could never forget that Russian tanks were less than a quarter of an hour away.

Winter ski patrols on the Norwegian-Russian border.

May 12, 1949, when the Soviets allowed movement by the Allies into Berlin by car, rail, and canal boats. However, the East German authorities continued to harass the rail communication with tiresome holdups and the imposition of bills of lading. The Autobahn was tightly controlled for the Western traveler. The Western powers imposed countermeasures—embargoes on strategic goods, previously exported to the countries of the Eastern bloc. Economics again. The airlift continued on a lesser scale until September 1949.

I had been in Germany since the summer of 1945. It was a great adventure, but now it was time to go home. In the summer of 1949 I returned to the United States and was reassigned to Washington, D.C.

Chapter IV *A Recovering Nation*
Harry S. Truman, 1949-1952

The Buck Stops Here

—Hand-lettered sign on President Truman's desk

Photographing President Harry S. Truman was a pleasure. He was my favorite and the favorite of most of the other photographers.

President Truman was a warm, down-to-earth, decisive man. He had a great fondness for the news photographers. When we came into the Oval Office for a "photo opportunity," we were a small group compared to what I see today. Early on he tagged us as the "One More Club" for we invariably asked him for "one more, please, Mr. President." He would always oblige, pulling his guests in closer for a handshake or whatever had occurred prior to the request. Today with a motorized thirty-five-millimeter camera you can go "brrr" and shoot as many pictures as you have film. In Truman's day we were still shooting Speed Graphics. There were no quick-sequence shots. It took about seven to ten seconds to prepare for the next picture. You tried to make every shot count, but if you missed one, this good-natured president always responded to our plea with a re-do and a whimsical quip. He would turn to his visitor and explain how these photographers were the most impor-

tant people in Washington, and that you have to do what they ask or they'll crop you out of the picture. Sometimes this would produce a big laugh from his visitor and we'd all shoot again, possibly making a better picture than the original pose. He really set up the picture for us. During one shooting session in the Oval Office, I shall never forget a new young photographer from New York who had quickly but not completely picked up the jargon of the "club." He asked for "one more, Mr. President." The president, with the stern look of a schoolteacher, turned to the young man and admonished him, "I don't hear the magic word." The new man on the block caught on immediately and recovered. "One more, PLEASE, Mr. President." Truman broke out in a big smile and brought the guest back for another picture.

There were not very many photographers who covered the White House permanently. The three wire services covered the White House every day; Hollywood made newsreels that were shot by five newsreel men. These newsreels were shown in movie theaters as "short subjects." Once in a while on a special occasion there would be a photographer from a local paper covering a local story, or a *Life* photographer on a special assignment. We were a tightly knit group and were well known by Truman.

I covered Truman for several months in 1945 before I left for Europe as a war correspondent. I made an interesting picture of General Eisenhower and his son, John, an Army lieutenant, who were both in Washington. Although the war was

on, Truman managed to surprise Ike and have John at the White House for a visit with his father. Truman ran on the Democratic ticket in 1948 against the governor of New York, Thomas Dewey. Miraculously, Truman won; many thought Dewey would take the election hands down. There wasn't a newspaper pundit who did not give the election to Dewey. It was a close race. In the wee hours of the morning in the Muehlebach Hotel in Kansas City, his headquarters, Truman learned that he had won the election. There is a famous picture made by two friends of mine, Beano Rollins of the AP and his competitor, Frank Cancellare of UPI. The picture shows Truman grinning and holding up the front page of the *Chicago Tribune* with a big, blazing headline: "Dewey Wins!"

When I returned from Europe in 1949 after four years in the Berlin bureau, I again covered President Truman. The war was over, the country was recovering, and the president was a healthy, vigorous man. Many guests visited the White House and many important famous people were cordially received by the president.

When George Marshall retired, the president presented him with a farewell gift, his cabinet chair with a personal plaque inscribed on the back. Marshall had served in Truman's cabinet as secretary of state and secretary of defense. As secretary of state, he proposed the European Recovery Plan, also known as the Marshall Plan. It called for the rebuilding of war-torn Western Europe. Marshall was awarded the Nobel Peace Prize in 1953 for his efforts.

When George Marshall retired, President Harry Truman presented him with his cabinet chair. A personal plaque was inscribed on the back. Looking on are (left to right) Vice President Alban Barkley, Dean Acheson, and John Snyder.

Truman hands a commemorative gavel to Sam Rayburn, the Speaker of the House. Lyndon Johnson, at that time a young congressman from Texas, and Secretary of Labor Frances Perkins enjoy the presentation.

Truman enjoyed the ceremonial aspects of his office. He presented a gavel to the famous Sam Rayburn, Speaker of the House, on his reelection. Standing with him was a young congressman from Texas, Lyndon Johnson, and the first woman in the cabinet, Frances Perkins, secretary of labor.

John Snyder, Truman's old friend, was appointed secretary of the treasury. Snyder had served in World War I in the same artillery company as Truman. He and Dean Acheson, secretary of state, often met with Truman. The president relied tremendously upon his secretary of state; Acheson was considered to be one of the best.

The president wanted a picture of a former secretary of state, Cordell Hull, on his eightieth birthday. Hull had served in Roosevelt's cabinet. I went to Hull's apartment in the Sheraton Park Apartments (it was then called the Wardman Park Hotel) and took photographs. General Clay returned to the United States in 1949. Truman awarded him a second oak leaf cluster for his Distinguished Service Medal for Clay's state-of-the-art defense of Berlin during the Soviet blockade. The city survived.

Other memorable moments with Truman included: at the Army versus Navy game in Philadelphia, he tossed the lucky coin to decide who would kick off. He entertained Winston Churchill; when photographed together, they were about the same height. Truman opened the annual White House Press Photographers Association photo show at the Library of Congress in 1951. I won first prize in sports, which he acknowledged.

Harry Truman married his childhood sweetheart from his hometown in Independence, Missouri, Elizabeth Virginia Wallace, known as "Bess." He elevated her and their only child, Margaret, to "a place somewhere above the rest of humanity," said an old friend, Bob Donovan, in his biography of Truman during his years in office. It was right on target. Truman thought the world of his wife and daughter. He would go to the mat in their defense, and did just that for Margaret on a notable occasion. Paul Hume, the theater and music critic for the *Washington Post*, criticized Margaret's singing debut at Constitution Hall. Truman fired off a blistering letter to Hume and personally dropped it in a mailbox. That letter really set the whole city on fire. Most of the time when he blew off steam in a letter, he would think about it and then put it aside. But he was extremely angry with Hume; his daughter was criticized, and he felt he had to take action.

Father and daughter were close. All Margaret had to do was ask her Dad to do something for her and he did. There was a fund-raising rally outside the *Washington Post* building on Pennsylvania Avenue. He played the piano there on her request. As I recall, he played the "Missouri Waltz" without missing a note. Truman studied classical music and as a youth he practiced the piano every morning for several hours. He had ambitions in music and loved to play, but life took him in another direction.

One sunny day, he decided to go over to the Pentagon to see his new secretary of defense, Louis Johnson, to straight-

Portrait of the first family on Easter Sunday: President Truman, Bess Truman, and their daughter, Margaret.

Truman playing the piano at Margaret's request for a fund-raiser in Washington, D.C.

en out a few things that were causing him concern. A small press pool accompanied him. Johnson greeted Truman at the main entrance and escorted him to his office. The president told us that he would likely be forty-five minutes in a private session—no pictures! As all smart newsmen do when they have a chance, I headed for the men's room. I was standing at the urinal when shortly after the next urinal was occupied by none other than the president of the United States of America. I guess all smart presidents do the same thing as all smart newsmen. I was flabbergasted as to what to say. I suppose I should have thought of some clever remark, but all I could do was to mumble "Hello, Mr. President." The president looked at me with his good-natured smile and with a whimsical voice said, "This is the only place over here where anyone knows what they are doing." The Secret Service agent, Floyd Gorman, on the other side of the room, broke into uncontrolled laughter, as did I.

Truman did not run for another term. He tried to talk General Eisenhower into running on the Democratic ticket for president. Ike chose the Republican ticket instead. Adlai Stevenson ran against him as the Democratic candidate. Of course, Eisenhower won easily; he was the great hero of World War II and everybody "liked Ike."

Truman went on a whistle-stop trip to campaign for Stevenson. Campaigning by train was a challenging experience for me. If you took too much time getting the perfect picture and delayed getting back on the train as it moved out of the station, it was tough to catch up. Running didn't always do it. Grab a cab, hire a car. The picture shows what photographers had to get—Truman speaking from the last car. Notice the hats; everyone wore one in those days.

After Ike was elected, Mrs. Truman invited Mrs. Eisenhower over for tea and for a tour of the living quarters in preparation for her move in. It was "The Changing of the Guards" for two happy women. Bess hated the White House and Washington, and she couldn't wait to get out of there and go back to Independence. Mamie, on the other hand, was delighted and couldn't wait to move into the White House. It was a happy exchange.

After Truman left Washington and the office of the presidency, he went back to Independence. Later he returned to Washington for a reunion at his favorite hotel, the Mayflower. His old friends in the capital arranged a luncheon for him. John L. Lewis, president of the United Mine Workers, attended. He was listening to a joke that Truman told and broke out into a big guffaw. I managed to get a picture of him. It was an unusual shot since he was one of the most stern, serious guys you ever met, with a notorious voice. When he spoke, everyone listened. He was a powerful person. He had organized the mine workers and when he came to Washington to testify, he attracted a lot of attention. He had a tremendous vocabulary with a marvelous choice of words—a true orator of the old style. I covered the luncheon with Ed Alley from Acme News Photos; we were the only news people there.

Truman on a whistle-stop trip, campaigning for Adlai Stevenson.

The changing of the guard: Bess Truman is happily leaving the White House to Mamie Eisenhower, who is happily moving in.

John L. Lewis, president of the United Mine Workers, at a luncheon in the Mayflower Hotel. Truman told Lewis a joke, and Lewis erupted into a great guffaw.

Truman coming out of the White House with Winston Churchill. Truman and Churchill were about the same size.

Truman greeted us warmly and invited us to join him for a drink. I shall never forget this exchange: Truman said to the bartender, "George, will you fix these gentlemen a drink?" And, of course, George said, "Sure, and what will you have, Mr. President?" "George, I'll have the usual," said Truman. Ed and I watched George. He had a large tumbler and he filled it to the top with straight bourbon and then dropped a cherry in it. He handed it to the president, who winked at us and said, "The cherry is just to fool Bess." Truman had apparently made a deal with Bess that he would have only one drink before lunch, and she was there with him. But that one drink was a lollapalooza.

Just before Truman left Washington, another group of his friends, who had worked with him in the White House, where he was revered, loved, and respected by the entire photo team, invited him to a farewell dinner. There were only about twenty still photographers in those days, plus the newsreels; there was no TV coverage at that time. The president graciously accepted our invitation. We reserved a room at the Carleton Hotel across Lafayette Square from the White House. Our only guests were the president, his press secretary, Roger Tubby, and members of the Secret Service. It was a most successful evening; lots of reminiscing and sharing stories. We all drank bourbon, of course, because that was the president's choice. It's amazing how drinkers followed the lead of each president. Washington was drinking bourbon.

When Eisenhower took office everyone switched to his choice of drink, scotch.

This evening was "off the record" and no pictures were made. One of the stories Truman told us still sticks in my mind. He told of an experience he had with Senator Robert Taft. Taft, a powerful figure on the Hill, was the leader of the Republicans in the Senate. He and Truman were dedicated political enemies. However, Truman said he had the greatest respect for Taft; he went on to tell how he had briefed the senator on a very sensitive bipartisan problem. He said Taft could have used the information to his own political advantage, but he never mentioned it. Truman was obviously touched.

There was a piano in the room and the president played four numbers, including one he said was the first one he had ever learned. The applause was thunderous. What an unusual evening for us to finally have the honor of having the president, a great friend, as our celebrated guest. A great time was had by all and we were ecstatic with the success of the party. At the end of the evening, the president rose, and in a formal, serious tone said he had an important announcement to make. That certainly got our full attention and the room became dead quiet. You could hear the proverbial pin drop. The president made this pronouncement: "I hereby dissolve the 'One More Club.'" We burst into laughter and applause. January 10, 1952, marked the end of a very elite Washington club.

The human race has been striving for peace ever since civilization started. The United Nations represents the greatest organized attempt in the history of men to solve their differences without war.

—From a collection of private letters and interviews with President Harry S. Truman by William Hillsman

Chapter V *The Cold Warrior*
Dwight D. Eisenhower, 1952-1960

I did not become engaged in the current political fight out of any desire to promote a personal candidacy for the presidency, but because I deeply and firmly believe America cannot live alone and that her form of life is threatened by Communistic dictatorship. These facts give rise to the problems we have in developing general policies that must conform to the yardstick of our enlightened self interest.

–Dwight David Eisenhower, 1952

Dwight David Eisenhower came onto the political scene like a steamroller. Everybody seemed to want "Ike" to be president of the United States. Harry Truman tried to talk him into running on the Democratic ticket, to no avail. But the Republicans persuaded him to run on their ticket, and the campaign was off and running.

I photographed Ike many times in Germany, in Berlin and Frankfurt, but I was kept on the sidelines in Washington as one of the more exciting political campaigns raged across the country. My good friend and colleague, Henry L. Griffin, was picked for the assignment. "Griff" served as a war correspondent covering Patton's Third Army primarily, but also got to know Eisenhower quite well as the supreme commander of the European front, SHAEF.

After the election, my first contact with the new administration was with an amiable, charming gentleman, Joseph M. Dodge, who had been designated by Eisenhower to be the future director of the budget. Truman was still president when Dodge moved into a temporary office in the Old Executive Office Building next to the White House. Dodge was the first man of the new administration to show up in town and I think I was the first contact he had with the Washington press corps. We chatted a few minutes. I liked him immediately. I made a few photographs and thought, "If they're all as pleasant as this guy, this will be a good administration."

Later I discovered that to be true. Covering Eisenhower and his people was a very pleasant assignment, thanks mainly to the president's press secretary, Jim Hagerty, his staff, and the orderly way they ran the White House—all very professional. Jim Hagerty had been a reporter for the *New York Times,* as was his father before him. Some said he was a hard-bitten, hard-drinking, chain-smoking journalist. He became Ike's press secretary at the Republican convention in 1952. He had been Dewey's press relations man. Jim has long been considered the best press secretary that ever came down the pike. A lot of that is certainly due to the fact that Ike was a great delegator. That was his management style. Ike put Jim in charge, expected him to do a good job, and didn't interfere. That is the way Ike operated with his entire staff and cabinet.

I always considered Eisenhower's cabinet the last true cabinet where every secretary was responsible for his agency and reported directly to the president. Eisenhower did not intrude on the operations of the departments. Each secretary handled problems and was responsible for the assigned jobs. Hagerty and Ike often golfed together, giving them a chance to be isolated in the electric cart for many discussions. They operated as a team.

A hopeful presidential candidate, Estes Kefauver, the senator from Tennessee, ran in the Democratic primaries in 1952. I went out to Kefauver's house to photograph him and his family for the AP. When I got there and before we went into the house for a family portrait, one of his children was jumping on a pogo stick. I said, "that looks like fun. Does your Daddy do that too?" She said that he was good at it. With that the senator picked up the pogo stick, and much to my amazement, he started jumping. I shot a picture with the kids watching. Then we all went inside and I made a family picture sitting at the breakfast table. Forget about the family picture. It never saw the light of day, but the pogo jumping picture was published everywhere.

He didn't run a very successful campaign but he was very affable and he ran hard. The symbol of his campaign was a coon-skin cap. Senator Fulbright from Arkansas was head of the Foreign Relations Committee. He called Kefauver "Cowfoffer" when he was running, making fun of him. However, Adlai Stevenson won the nomination and his vice presidential running mate was John Sparkman from Alabama. Four years later at the 1956 Democratic convention, Stevenson was again nominated for president and Estes Kefauver was overwhelmingly nominated for vice president on the first ballot.

Jim Hagerty, President Dwight D. Eisenhower's press secretary, was considered the best in the business.

Henry Burroughs went to the home of Senator Estes Kefauver, a hopeful presidential candidate, to take a family portrait. Kefauver's children said their dad was good at jumping on a pogo stick. The senator proved it.

An old guard conservative, Senator Joseph McCarthy of Wisconsin, headed a subcommittee looking for Communists in government. He gained national attention in 1950 when he announced that there were Communist spies in the State Department and the Army, but he gave no evidence. He returned from West Virginia where he started the whole witch hunt. Herb Block, political cartoonist for the *Washington Post,* is credited with providing a new word in the English Language, "McCarthyism." Ike refused to publicly criticize McCarthy, saying it was beneath the dignity of the presidency and he would "not get into the gutter with that guy." The Senate condemned McCarthy in December 1954 for conduct unbecoming to a senator. His influence quickly declined.

Eisenhower came to the White House Press Photographers Association dinner in 1956. Since I was the president of the association at the time, I sat on his left at the head table. Early the next morning I got a call from the AP news desk asking, "What did you guys feed the President at dinner last night?" I said that he ate what we had. He had his usual Chivas Regal scotch and his food was tested before dinner. "Don't blame us for what happened." The president had been rushed to Walter Reed Hospital at about two in the morning with a very painful ileitis attack.*

* Eisenhower had had a mild ileitis attack when he was president of Columbia University in New York. President Truman invited him to recoup in the "Winter White House" in Key West. He also was ordered to give up smoking, which he did.

I received many newspaper clippings printed Friday, June 8, 1956, the day after Ike's ileitis attack; they printed pictures of Ike coming to the White House Press Photographers Association dinner where I greeted him. There was also a news story I had dictated to the Washington news desk when they called me at 2 a.m. My favorite note came from the Chicago photo desk of the *Chicago Daily News,* which read, "Hank, It ain't too often a crummy news photographer makes the front page with a story and picture. Here's an exhibit for your collection."

Ike Seemed In the Pink at Dinner
He Ate Heartily, Says Photographer
(Henry Burroughs, AP photographer and new president of the White House News Photographers Association, sat next to President Eisenhower at Thursday night's annual dinner of the association. He tells here what he observed at the dinner.)

By Henry Burroughs
Washington (AP) President Eisenhower ate heartily a meal prepared especially for him by the Sheraton Park Hotel on orders of Dr. Howard M. Snyder, White House physician.

The meal consisted mainly of a fatless diet. For dessert he had fresh strawberries with sugar. He ate a steak, a baked potato, and some green peas. Everything was cooked without fat. The president salted his food rather heavily. At the beginning of the dinner he was quite talkative and chatted with Tony Muto of Fox Movietone News, retiring president of the Photographers Association, and me.

Senator Joseph McCarthy of Wisconsin
returning to Washington. He headed a
committee looking for Communists in
the government. It became a witch-hunt.

He sat between us.

The conversation ranged from painting to golf.

The president seemed to enjoy the stage show and appeared particularly impressed by the last performer, Pearl Bailey, the Negro singer. When she waved at him several times, he waved back at her. He applauded her vigorously.

At the end of the entertainment program, I asked the president if he would like to say a few words. He said he would like very much to do so and to thank the entertainers for the show.

Mr. Eisenhower then spoke briefly. He cracked a couple of golf jokes involving Bob Hope, the master of ceremonies.

He left the hall in good spirits. At the door where his car was waiting, the president paused for a few moments to joke with Hope. As he got into his limousine, he turned to press secretary James Hagerty and said, "Jim, are you coming with me?"

Hagerty replied, "No, Mr. President, I think I'll stay a while."

The president then said, "Can I give anyone a ride?" There were no takers. He drove off alone in the back seat with two Secret Service men in front.

Mr. Eisenhower appeared to me to be in the pink of condition. A glass of wine was poured for him, but I don't believe he drank any.

Nobody in the press corps knew what an ileum was. The president stayed at Walter Reed for about two weeks. The press corps set up camp there and reported every slash of the knife during the operation. It was covered so thoroughly that you felt like the members of the press were in the operating room. The whole world saw the drawings of the ileum as well as the whole intestinal system. We received daily briefings from General Heedon, who was the chief surgeon, including the president's bowel movements for the day. It was a big story. Now everyone knew what an ileum was. My friend Larry Burd, of the *Chicago Tribune,* used to write parodies about the current news. This one he called "The Ileitis Song." We would sing it on the press plane or just about anywhere. Dr. Snyder (General Snyder), Ike's personal physician, met the press briefly the morning after his attack. When asked about the president's condition, Dr. Snyder said, "It's nothing but a little stomach gas. He'll be good as new in a day or two." That was the story in the morning but later in the day everyone knew it was ileitis. So Larry's parody went like this to the tune of "Jesus Loves Me."

> *It's not serious that we know*
> *Because old Doc Snyder tells us so.*
> *This he says like it is true*
> *Good as new in a day or two*
> *Old Doc Snyder has he got class*
> *Can't tell ileitis from a case of stomach gas.*

We sang it to Doc Snyder and he pretended to think it was funny.

On June 19, 1956, the AP wire service put out this story:

Henry Burroughs, president of the White House Photographers Association, presents a book for President Eisenhower, recovering from intestinal surgery at Walter Reed Hospital, to James Hagerty, the president's press secretary. The book of photographs, each with a humorous caption, shows the chief executive's eight-year-old grandson, David, golfing. It was titled *A New Approach to Golf*.

Washington, June 19 (AP)—President Eisenhower, who hasn't had much to chuckle about lately, cut loose today with deep-down peals of laughter heard up and down the corridors at Walter Reed Army Hospital.

The thing that tickled the recuperating president so much, despite the tug at his surgery stitches, was a humorously captioned booklet of photographs showing his 8-year-old grandson, David Eisenhower, playing golf. It was presented to the president by the White House News Photographers Association.

The booklet was assembled by the association's president, Henry Burroughs of the Associated Press, who also wrote the captions in the first person as though they were remarks by David himself.

"I have never seen him (Eisenhower) get quite as big a kick out of any one thing since I have been with him," said White House Press Secretary, James C. Hagerty, who joined Eisenhower's staff in July 1952.

Hagerty added that, "in the opinion of everyone, including the doctors and Mrs. Eisenhower, the picture book did the president more good than anything that had happened since he came into the hospital."

Hagerty said both the president and the first lady went through the booklet several times, both of them laughing all the while. He added that the president asked him to "tell the photographers how much he appreciated their thinking of him, how much he appreciated the wonderful layouts of pictures and how much he appreciated their sense of humor.

The book was titled, A New Approach to Golf. It is an instruction manual for a beginner. The president sent Henry a thank-you note.

◼ TOURING THE SOVIET UNION

In July 1959 nine U.S. governors traveled for three and a half weeks in the Soviet Union. I had the distinct pleasure to be assigned to the trip. Secretary of State Christian Herter briefed the governors on U.S.-Soviet relations and approved their trip, which was privately funded. It was an educational and cultural venture. The mission of the governors was to make a contribution toward peace and understanding and to see that there would be an exchange of visits. President Eisenhower spent thirty minutes with them prior to their departure. He was keenly interested in their trip and asked that the delegation come back to Washington on their return to brief him. He was planning to go to Russia later that year for a summit conference, but the conference was later canceled because of the U-2 incident. The delegation was made up of five Republicans and four Democrats, members of the Institute of International Exchange, translators, and members of the press. Morris Rosenberg, an AP reporter, and I made the entire tour with the governors. We covered a large part of an enormous country including Kiev, Leningrad (now St. Petersburg), Moscow, Tashkent and Samarkand in Uzbekistan, Alma-Ata of Kazabb,* and T'bilisi in Georgia. Rarely does a news photographer have the opportunity to take such a fas-

* Kazakhstan.

cinating trip. I was the only photographer. My mission was to take pictures of the governors with the locals, visiting small farms, factories, and schools. I wish I had had more time to shoot the magnificent scenery. Throughout the trip we enjoyed the delicious Russian ice cream at state dinners as well as from vendors on the street. It was a happy gourmet surprise for all of us. Instead of coming home from Moscow I was assigned to cover Vice President Nixon's trip to Moscow. He was arriving the next day.

Covering Khrushchev

Khrushchev seemed to enjoy his historic tour of the United States in 1959. I was walking right behind as we went through the employees' cafeteria at the Mesta steel plant in Pittsburgh. He suddenly stopped and displayed great interest in a stainless steel paper napkin holder. He picked it up and I made one shot. Then he smiled knowingly and quickly tucked it under his coat as though he were stealing it. Then he really laughed and put it back on the table. I missed the good picture, but no one else got it either. I thought to myself, this guy has a great sense of humor—I was beginning to like him.

Every photographer covering Khrushchev's visit agreed that this was the roughest assignment ever. It was something like a presidential campaign trip but with overtones of a football scrimmage.

After each skirmish with unpredictable Khrushchev you could hear the moans of frustrated photographers. Even the wide-angle experts were screaming. As White House News Photographers Association's vice president Frank Cancellare of UPI put it, "As soon as he gets near the press they gobble him up and you can't even see the top of his head."

The international flavor of the photo coverage became apparent right from the start. Colorful and pithy expressions bounced back and forth in many languages. English and Russian were predominant but when the infighting got rough you could hear French, German, Japanese, and even an occasional quaint expression out of Brooklyn.

One thing you can say about the Soviet system: it produces news photographers who are just as aggressive as our capitalistic ones. The Soviet boys had a small advantage though. They did not understand English. This was a real asset because they were not inhibited by the ground rules or commands from security men and police. After witnessing several of these uninhibited moments we American cameramen decided that the best way to handle any "get behind the rope" order was to pretend you didn't understand English and just keep walking and maybe the police would think you were Russian. It didn't work.

Khrushchev left many lasting impressions on the Washington cameramen who accompanied him around the country. The men who made the trip were Frank Cancellare of UPI, Henry L. Griffin of AP, WHNPA president Ronald Weston of

This is the way Soviet Premier Khrushchev and New York Governor Rockefeller greeted each other at their meeting at the Waldorf-Astoria, September 18, 1959.

Telenews, Tom O'Halloran and Marion Trikoski of *U.S. News and World Report,* Bruce Hoertel of CBS, and Brad Krest and John Langenegger of NBC. Warren Leeffler of *U.S. News and World Report* and Stan Tretick of UPI covered the New York part and Hank Walker of *Life* showed up briefly—just long enough to make a color cover at Coon Rapids, Iowa.

I don't think any of us will forget the solid wall of police that met us head-on as we tried to follow Khrushchev into the Commodore Hotel in New York. We had been riding in the official motorcade that brought the Soviet chairman from Pennsylvania Station. We had been issued shiny white buttons, which identified us as the pool photographers. White buttons or no white buttons, we were stopped at the door of the hotel by an unyielding wall of brass buttons. A police captain explained, "Nobody gets in unless he's wearin' green or red buttons."

The button game had started. It was to plague us throughout the trip. The plaintive cry, "Who's got the buttons?" vied with, "Get behind the rope!" as the trip's classic clichés.

One morning we were all calmly sitting in the pool cars outside the Fort Des Moines Hotel. We had been waiting for forty-five minutes for Khrushchev to start his day's tour. It was a quiet morning. We were all in a relaxed frame of mind—numb, you might say. We were all wearing glistening cream-colored buttons bearing the large letters DM, our badges of admission for that day.

Suddenly, without warning, a reporter emerged from the hotel lobby wearing a bright green button with the DM prominently displayed. With ever so slight an apprehensive edge to his voice, a photographer asked, "What's the green button for?" The answer pierced through the morning haze, "It's the pool button for the day." Meanwhile another green-buttoned newsman appeared. "I guess the color doesn't matter, as long as it's got DM on it," said one of the poolers as he tried very hard to look unconcerned. "I'll ask the State Department security boys just to make sure."

In one minute he returned with the shaft that really shattered that peaceful morning. "That's right, only the green ones are good," said he.

The doors of the three pool cars flew open as if synchronized. The quiet morning sounds were suddenly drowned out by bad language and the sound of poolers running for the hotel lobby.

"Who's givin' out the green buttons?" was the defiant chant. The excited voices pitched up into the next key. The official button administrator was nowhere to be found. At any moment Chairman Khrushchev would pop out of the elevator to blow the starting whistle on the day's scrimmage, and no green buttons. The din in the lobby increased.

At last, a tall, quiet State Department security agent stepped from the elevator and announced, "It's OK, boys, the cream-colored buttons are good now. We've changed it." Our

shouting had reached receptive ears. Another crisis averted. Back to the cars.

The button game reached a climax at Gettysburg when Bob Fleming of ABC walked through the hotel lobby wearing a plain blue button. No letters, just a plain blue button. Bob would not say what the button was for. Most people were afraid to ask, but finally one guy did and within minutes ten rumors were rampant and the air was bristling with, "Where do you get the blue buttons?"—"I've gotta have one of those blue buttons." And finally a weary, "What's it for?" Only Fleming and a few confidants knew that the blue button was the center of a Pabst Blue Ribbon Beer promotion.

On Khrushchev's trip across the United States we went to the farm of Roswell Garst, an Iowa corn farmer of great renown. Mr. Garst had been to the Soviet Union where he met Khrushchev. They got along very well—two farmers sharing their experiences. Farmer Garst had his problems with newsmen. We were four hundred strong plus seventy Russians. We were crowding the farmer and his distinguished guest at every turn. Mr. Garst tried to reason with us. He threatened us. He threw things at us. All to no avail. What finally held the line was a pitchfork wielded by a farmhand in a threatening way.

Garst showed Khrushchev his corn by walking into the fields with him. Both were short men, and their heads were not visible in the corn so it was hard to tell where they were.

The corn swallowed them up. It was waving in all directions as the nervous Secret Service and the anxious press tried to find them. I parted a row of corn in my search. They were right in front of me, too close to make a shot.

Then there was the San Francisco supermarket adventure, which produced the most vivid memories of the trip. In retrospect the scenes from that supermarket are like a kaleidoscope of flashes from the Keystone Kops or Laurel and Hardy. One of my more vivid memories is of a photographer standing in the dairy products case, one size-eleven boot in the cottage cheese and the other planted in a nest of collapsed half-and-half coffee cream containers, and another is of a rather stout lady who was pushed into the potato chips section.

The big problem for photographers in the supermarket was height. Everybody was looking for something to stand on to get a shot. A display of canned soup toppled early in the melee. Several cantaloupes dropped out of the running when a two-hundred-pound photographer climbed aboard for an overhead shot.

Once, an angry voice shouted, "Get down outa my wine display," followed by a resounding crash and the tinkle of broken glass and then the aroma of wine. Shortly after came the angry voice of the butcher: "Get offa my meat." And the answer, just as angry, "I'm not the only one on your meat."

One photographer climbed up on a revolving display table. He was all set to make a shot when someone pushed

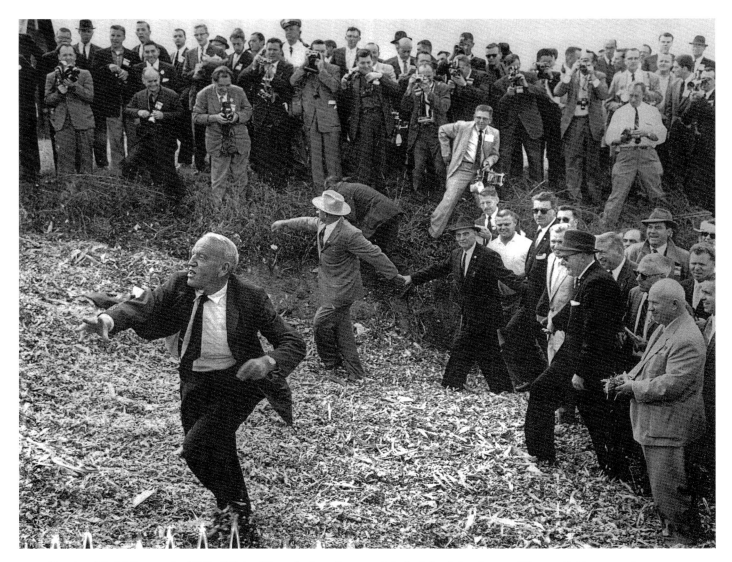

During his U.S. tour in 1959, Nikita Khrushchev (lower right) visited the farm of Roswell Garst, an Iowa corn farmer. Angry at the press for crowding around them, Garst yelled and threw silage at the photographers.

the button and the table revolved, taking him out of view by 180 degrees. Another enterprising lens man hired a teenage giant and rode the boy piggyback as he shot away at the turmoil below. At the end of the ride the boy dumped him into a bread bin. The State Department received a bill for more than two thousand dollars for supermarket damages. Cheap by today's costs.

While in California Khrushchev wanted to see how films were made. One of the major studios invited us to watch while they were shooting the famous musical *Can Can.* He entered the set very excited, met all the brass, and we were all directed to take seats and stay quiet while the cameras rolled. It was a grand-finale dancing scene.

The studio had set up a bank of bleacher seats behind the official party, who were all seated in director's chairs. Lights were off except on the set. A woman slipped into the seat beside me and said, "This is so exciting. Which one is Khrushchev?" I pointed him out, "He's the bald head with the light gray suit." We sat quietly together in the bleachers until the filming was over. When the lights came on I looked at my neighbor and went into pleasant shock. All this time I had no idea I was sitting next to Greer Garson, one of my favorite movie stars. What a thrill. We said hello and good-bye and I was off and running after Khrushchev.

One feature of the trip we will not forget is running. On the train whistle-stop tour from Los Angeles to San Francisco we dashed the length of eight cars and back again every time the train stopped. Once Frank Cancellare at Chairman Khrushchev's car waited a wee bit too long and made the dash back just in time to get aboard. It was a gamble that paid off though; he came up with a top-notch picture of the chairman waving from the door.

In the motorcade we were anywhere from car six to car twenty behind the chairman. In the constant chase of keeping up with Khrushchev we discovered muscles we didn't know we had. When it was all over we were just plain exhausted. Khrushchev ended his American visit by meeting with President Eisenhower for three days at Camp David, the presidential retreat up in the Catoctin Mountains of Maryland.

Khrushchev was a very bright guy and a tough negotiator. He tried his best to turn things around in the Soviet Union. He had turned Stalinism around 180 degrees. He was doing pretty well with the United States at the time, until the infamous U-2 incident, when the American spy plane was shot down over Russia in 1960. That sort of broke up the relationship that was being nurtured by the two superpowers.

OPERATION AMIGO

The most memorable trip I made with President Eisenhower was his tour of the South American countries of Brazil, Uruguay, Argentina, and Chile. It was unforgettable for

many reasons, but especially because I was given several souvenir bar glasses that reminded me of that exciting experience every time I used them. The glasses have all the cities we visited on them and the name of our tour, "Operation Amigo."

We set out from Andrews Air Force Base. It was one of those very early morning departure times, and I came close to missing it. For some reason my alarm clock didn't go off and I was rudely awakened fire-alarm style by a phone call from my old friend, Larry Burd, of the *Chicago Tribune:* "Where are you?" I had offered to pick Larry up for the ride to Andrews. Thank God he called. My bag was packed and I dressed running out the door. We had to drive all the way across town to get to Andrews. No traffic. It was snowing. We zoomed.

When we arrived at the terminal we both breathed a sigh of relief. There was Air Force One, the president's plane, and right next to it the Pan Am press charter plane. White House transportation folks grabbed our bags and in a couple of minutes we were safely aboard the plane. No press were aboard the plane, which was normal. Those were the days before regular press pools rode on Air Force One.

Our first stop was Roosevelt Roads in Puerto Rico, with Admiral James Holloway as our host. Next morning we took off early for Brasília. Shortly after takeoff when we'd reached cruising altitude I was jolted out of a perfectly tranquil reverie by an announcement on the public address system asking,

"will Henry Burroughs of the Associated Press please come up to the pilot's cabin." I was baffled and entered the holy of holies with trepidation. It turned out that the Pan Am pilot was the next-door neighbor of Al Resch, executive news photo editor of the AP in New York. Al found out he was to pilot the press charter and asked him to say hello to me. What a relief. We chatted for several minutes like old friends. The pilot was a very nice guy. I think he might have let me fly the plane if I had asked.

We arrived in Brasília ahead of the presidential plane and were in proper position on the ground for the greeting by Brazil's president, Juscelino Kubitschek, who was standing by for the big moment. We watched Air Force One roll up into position. A ramp was positioned and then two soldiers rolled out a huge red carpet to the foot of the ramp. The problem was that somebody had miscalculated the length—there was about a three-foot-high roll of excess carpet and nobody seemed to know what to do about it. They didn't want Eisenhower to have to jump over a three-foot hurdle so they kept him waiting inside the plane. The solution to this international dilemma came from a Brazilian officer who rushed out with a knife and cut the carpet. All was saved.

After the airport ceremony all photographers were herded onto flatbed trucks for the motorcade into the city. The ride in the photo truck to Brasília was one of the more frightening events of the trip. Two trucks loaded with screaming photographers were left behind when the president's motorcade

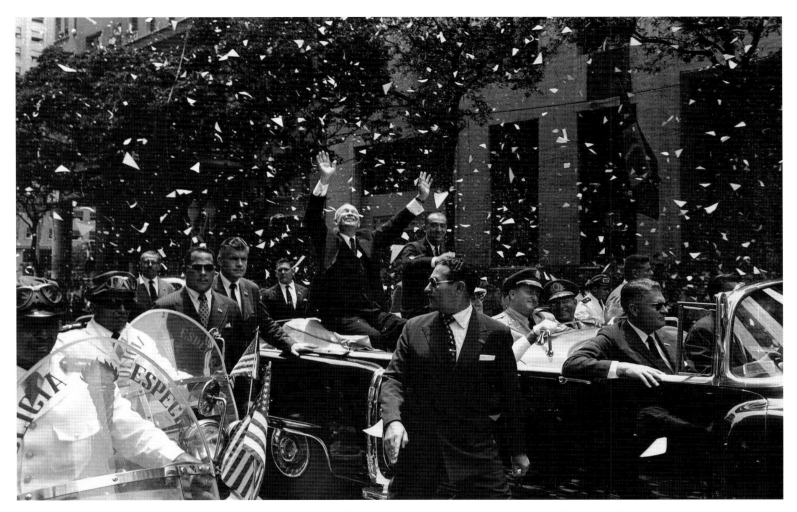

February 24, 1960—Rio greets Eisenhower. Hands raised, President Eisenhower rides in an open car with Brazilian President Juscelino Kubitschek down the main street of Rio de Janeiro.

departed from the airport for the new Brazilian capital. The screams, in all languages, became louder and louder as the trucks tried to fight their way through a gigantic traffic jam. Our driver was undaunted. When the top-heavy trucks swerved off the pavement onto the soft, red mud shoulders they would lean at a dangerously precarious angle. We photographers, like the skilled crew of a racing sloop, would rush from starboard to port to keep our "sailing ship" on an even keel. Having cleared the traffic jam, a wild ride up the highway with a dozen near disasters added just the thrill we didn't need. Once we reached Brasília it was an endless fight for position through pushing, jostling crowds and local cameramen.

The new city was still a mass of mud and construction supplies but we got a good idea of how beautiful it would become. Wide boulevards led to the town center with impressive government buildings and saplings planted everywhere. But we got the distinct impression that most of the Brazilians who were transferred to the new capital would much rather have remained in Rio de Janeiro.

President Eisenhower's reception in Rio de Janeiro was terrific. This time the photo trucks made the grade and we all got good motorcade copy. A sightseeing tour of Rio followed the motorcade thanks to our truck driver who, unbeknownst to us, was delivering a couple of his friends to their homes before taking us to our hotel, which had a leaky roof.

A pall fell on the White House contingent when we learned that twenty members of the U.S. Navy Band were killed when their plane collided with a Brazilian plane over Guanabara Bay near Rio. The band was on its way to play for a reception and dinner that President Eisenhower was giving for President Kubitschek. The reception was canceled because of the tragedy. A total of sixty-one were lost as the two planes broke into pieces and plunged into Rio's Guanabara Bay in view of horrified spectators.

Jim Hagerty said the president felt terrible about this tragic accident but went ahead with the rest of the tour. The next day President Eisenhower and President Kubitschek flew to Sao Paulo, Brazil's economic capital, and were welcomed by a crowd of five hundred thousand people.

Eisenhower addressed the luncheon hosted by Sao Paulo's industrial, business, and agricultural leaders. He alluded to the Communists' economic enticements to Latin America, and warned of their stepped-up propaganda and trade infiltration campaign in the region. The two presidents returned to Rio and hurried to the hospital to comfort the three survivors of the tragic plane crash. It was a sad farewell to Rio.

The best motorcade pictures of the tour were in Buenos Aires, Argentina, when the president, flanked by colorful cavalry, rode through surging crowds and swirling confetti on his way to the Pink Palace of President Arturo Frondizi.

We had an unscheduled day of rest at Bariloche, Argentina, the southernmost point of the trip. But it turned out to be the most hectic for us cameramen. The presidential helicopters were landing and taking off right from the front door

of the president's hotel at this idyllic mountain retreat. He eluded us easily by taking the helicopters, which landed at both the front and rear of the hotel so we never knew for sure where he would be. The high point of excitement came when a reporter suggested that the two presidents might be returning from their mountain conference by boat. At this moment a large white yacht came steaming up the lake toward the boat landing. Someone spotted an American flag flying on the boat. That clinched it! With cameras clanking we madly dashed to the dock, only to find out it was just an excursion boat.

On our way to Santiago, Chile, the three wire services were chosen to ride on Air Force One, an unusual privilege. Yes, but even the president's plane had to contend with bad weather. We had just settled down with drinks before dinner, congratulating ourselves and saying, "this is the life," when the plane hit a pocket or a downdraft or whatever and our drinks all hit the ceiling. A mess. "How can this happen on the president's plane?" we groaned. We were flying over the Andes, the longest mountain chain in South America with peaks soaring to more than twenty thousand feet. Mount Aconcagua, on the border between Argentina and Chile, is the highest mountain in the Western Hemisphere at 22,834 feet. We must have been somewhere near Aconcagua when this goofy weather showed up. We looked out the windows —nothing but deep, dark skies.

Everything went smoothly in Santiago—the airport reception, troops, gun salutes, and a mad scurry for pictures of a government housing project. The three wire services drew straws to see who would cover the state dinner at the Presidential Palace. Jack Lartz of INP was the lucky guy. All pictures were to be pooled. That left Maurice Johnson of Acme Newspictures and me free. Maurice's room in the hotel overlooked a huge plaza and the Presidential Palace so we hightailed it up there, ordered room service martinis and steaks, and sat in front of a large open window and watched the fireworks. Yes, of course, there were fireworks during the banquet. Jack Lartz was doing his job as the pooler and Maurice and I were having our own banquet.

Montevideo, Uruguay, will always be remembered by us for the tear gas. As the president's motorcade sped past the university, police used tear gas to control the demonstrators. The president probably didn't notice it in his closed limousine but in our open photo truck we all got a good dose. A two-handkerchief event. The president's speech in an outdoor arena went smoothly—no demonstrators were there. But when I climbed a fence to get a better overview for only a few seconds, damn if someone didn't steal my camera bag that I had left on the ground. Fortunately it contained only unexposed film and a small personal camera. That was a lesson sharply learned.

The South American tour was a great success, in spite of the terrible tragedy at Rio. We all returned exhilarated.

Presidents traditionally liked opportunities to leave the fishbowl atmosphere of the White House. Roosevelt went to "Shangri-La," as he called the rustic hideaway in the Catoctin Mountains in Maryland, for peace and quiet.* Harry Truman didn't go up there very often; his escape was on a boat. He would get on the presidential yacht, the *Williamsburg*, and cruise down the Potomac. Every once in a while he would go to Key West, Florida, and stay at the naval base there where he played poker with his cronies and wore loud Hawaiian shirts.

Ike went up to Camp David almost every weekend. He renamed Shangri-La after his grandson, David. The press spent a relaxed weekend in a motel in the little town of Thurmont, Maryland. It was the closest place to Camp David. We never saw the president once we got there but we had to stay nearby in case something of importance occurred.

Ike loved his grandchildren and involved himself in their activities and in setting up sporting events for them. One day at the White House after I had finished my assignment for AP, he asked me to take a picture for him off the record. He had organized a swimming contest** of some sort. The kids par-

* It was built by the Civilian Conservation Corps during the depression in 1939.
** The White House pool was built by FDR to exercise his legs.

ticipated happily and each won a competition. My picture was of them standing proudly displaying the medals their grandfather awarded each of them for their athletic feats.

The Eisenhower farm in Gettysburg, Pennsylvania, was a big attraction and a favorite for Ike and Mamie to enjoy and relax. Ike got out the pony cart and all the children went out for a ride around the farm. Sheer joy for a child.

Covering Eisenhower could be downright fun because he chose interesting locations for his "get-away-from-the-White-House" trips. Every year he spent a couple of weeks golfing at the fabulous Augusta National Golf Club in Georgia, which he joined. The press corps would cheerfully accompany him. It was a vacation for everyone. This prestigious club built a cottage right on the golf course just for Ike and Mamie, so he could enjoy his favorite game and work and never leave the club grounds. The press corps checked into the Bon Aire, an old, elegant, and comfortable hotel very close to the Augusta National. Jim Hagerty would brief us every morning at the hotel, usually releasing some information and indicating that the president was working at his desk in the cottage. Hagerty would then put a "lid" on until 5 p.m.; a "lid" was good news. It meant that there would be no pictures or interviews or announcements, therefore no stories to file. So we were free until 5 p.m. Those of us who were golfers would head for the local Augusta Country Club or the Army-Navy Golf Club nearby. Both clubs extended privileges to the White House Press.

Dwight David Eisenhower II, five year-old grand-son of the president, gets his bow necktie adjusted by his sister Barbara Anne, who is three years and ten months old, as they pose on the White House grounds in their Easter outfits. The bowtie is David's first and he is mighty proud of it.

Ike is showing the finer techniques of casting to his grandson, David.

One extraordinary day Jim Hagerty greeted us at the morning briefing with a big smile and an announcement that the president of the United States would like to invite all the golfers to be his guests for a round at his club. Such excitement you've never seen. A chance to play the famous "Home of the Masters" golf course—one of the most exclusive clubs in the world—was an opportunity of a lifetime.

We recovered from the shock and congregated at the first tee. Foursomes had been arranged by Hagerty. The rules of the club require that each foursome must include a club member, so the president had to round up several of his cronies. He called his close friends "the gang," all very successful millionaires.* They loved golf, playing bridge, and Ike. We were fortunate in our foursome to have as our host the chairman of the board of the Lipton Tea Company, a charming, affable

* Another parody by the intrepid and profound Lawrence Burd of the *Chicago Tribune*. It was sung extensively on the press plane or when the press gathered to relax at the end of a day on the road:
(Sung to the tune of "Pocketful of Dreams")
We're Ike's millionaires, we're Wall Street's Bulls and Bears
And we've got our pockets full of dough
Our bank accounts aren't light and that seems to count with Dwight
So we keep our pockets full of Dough.
We're triple A in Dun and Bradstreet,
We've got fleets of Cadillacs
And we calculate we're over weight in income tax
Ike's our cup of tea, our pal in luxury
Cause we've got our pockets full of dough.

gentleman who did not for a minute divulge what I was sure were his true feelings: that he'd much rather be playing with Ike and his pals. A good sport.

Ike kibitzed with us as we teed off and watched all of our drives. It was kind of nerve-racking to say the least. He did not play a round but retreated to an office on the second floor of the pro shop.

Hagerty had made it clear: if you were not truly a golfer, please do not embarrass the president just to try out the course. However, after all the foursomes had left the first tee, my old friend Stan Tretick, an Acme Newsphotos photographer, couldn't resist the temptation. He borrowed clubs from the pro, who also provided a caddy, and proceeded to tee up.

His first drive skewed at a 90-degree angle right into the open door of the pro shop. It did not go unnoticed. The president was watching from a second-story window, and laughing. Tretick mumbled to his caddy, "I haven't played golf very many times."

The caddy grumbled, "Thought this was your first time."

Meanwhile the White House Press foursomes romped their way around the incredible Augusta National course like true masters. It was a glorious day and we made the best of it. I think I played one of my best-ever rounds. The lush fairways were unbelievable. The ball sat up with such majesty, crying out, "Hit me!" How could you miss? Water took its toll on our scores. There is so much of it on the Masters, and it is all in the wrong places.

This fairyland day was topped off with après golf drinks with the president. An absolutely marvelous day. Wonderful weather, incredible experience, a day not one of us could ever forget. Then back to the old Bon Aire Hotel where we could rehash it and live it all over again. What a privileged bunch were we. We were living in the halcyon days of Washington journalism.

Every summer President Eisenhower would move the White House to Newport, Rhode Island, for a month. He would stay at the naval base in the admiral's house. White House offices were at the base. The press corps checked in at the Viking Hotel in downtown Newport.

The president frequently played a round of golf at the Newport Country Club, and occasionally we would take photos but when Hagerty put the lid on photos we photographers honored it. One day when the lid was on, Frank Cancellare and I played eighteen holes right behind the president's foursome, figuring we would at least have him in sight. It was very frustrating because we could see so many picture possibilities but could take no pictures. We would not think of breaking a Hagerty lid. Frank and I did skip the eighteenth hole so we could cover the president's departure.

When he came off the eighteenth green at the Newport Country Club somebody handed him a bunch of posies for Mamie. He looked like he didn't know what to do with them. He clutched them and looked confused. He finally gave them to an aide who took them to Mamie.

At the crack of dawn on September 26, 1957, I lucked into a very special assignment while in Newport. The president was scheduled to take his first cruise on a nuclear-powered submarine, the *Seawolf,* out of the naval base and I was chosen to be the pool photographer to accompany him. What a thrill. Another exciting day. As the *Seawolf* began to submerge, the president peeked into the periscope. Big smile, wide-eyed enthusiasm. He got a big charge out of that. That was the picture. I knew it. As we settled down at a reasonable depth for the quietest, smoothest ride you could imagine, the president enjoyed a tour of the *Seawolf,* visiting every nook and cranny. Pictures galore, but I knew it would be hard to beat the periscope shot. Later we had lunch with the crew, then headed back to the naval base.

The three wire services had set up darkrooms and portable wire photo machines in the Viking Hotel. The AP staff developed the film, then all three wires looked them over. Everyone agreed on the periscope shot. It was a winner. All three wires transmitted it and the picture was widely used in just about every paper around the world.

Another great Eisenhower getaway was Thomasville, Georgia. Once a year he would hop into Air Force One and fly down to go bird hunting. Ike never lost his love of hunting or fishing. He had done it since he was a youth. We were not allowed to photograph the hunting but we had to be on hand just in case. The Thomasville neighbors extended the finest Southern hospitality to us. They wined and dined the

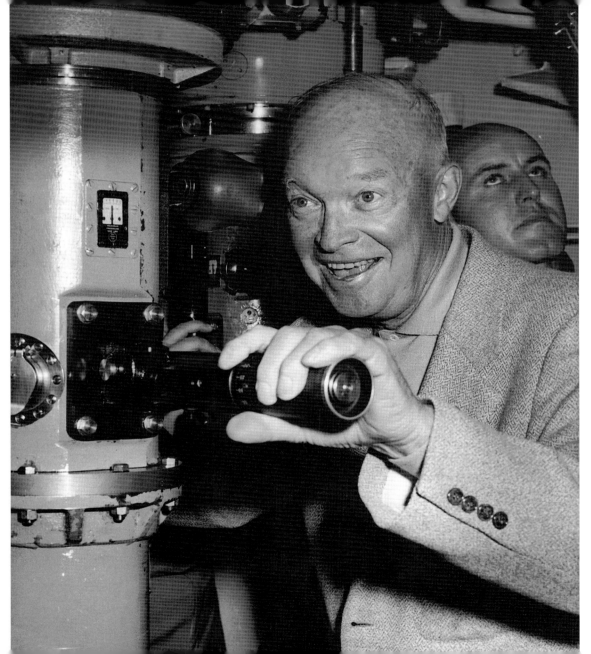

President Eisenhower in Newport aboard the nuclear submarine *Seawolf*. He enjoyed looking through the periscope.

White House press corps in elegant style at the country club. Once, after a late night at the club after the kitchen had shut down, one of the members invited several of us over to his home for bacon and eggs. We were all hanging around the kitchen with drinks while the bacon sent out some tantalizing aromas when our host announced, "My God, I'm not going to have enough eggs." The next-door neighbor came to the rescue: "Don't worry, George, I've got eggs and I'll go over and get them." The neighbor returned in a few minutes with his coat pockets full of eggs. Alas, as he entered the kitchen door someone bumped him and he leaned into the door jamb. There was a crunch of egg shells and a groan. What a mess. Undaunted, our hero rushed to a waiting bowl and dumped out the contents of his jacket pockets—cracked and not so cracked eggs. We had scrambled eggs galore and our hero exclaimed as he removed his elegant sports jacket, "Now here's a challenge for the dry cleaner."

Thomasville, Georgia, is a most charming and friendly place.

One day back in the White House press room, Jim Hagerty breezed in with an exciting invitation: "The president would like you all to be his guests for lunch in the State Dining Room. I'll be back in a half hour to escort you over to the White House."

A very upbeat group of reporters and photographers strolled into the magnificent dining room and were cordially greeted by the president. Adrenal glands were pumping at a high level. There were probably twenty-two of us. President Eisenhower sat at the center of that gorgeous oval table. As president of the White House News Photograghers Association I was seated to his left, and Larry Burd of the *Chicago Tribune,* representing the White House Correspondents Association, was seated to the president's right. The conversation was lively and the food superb. I couldn't identify the entrée, it looked like quail or something similar, so I asked the president what it was. He smiled as though he had hoped someone would ask. "These are chukars, from Thomasville," he beamed. The chukar is a grayish-brown Eurasian partridge introduced as a game bird in the United States and apparently quite plentiful where Ike hunted in Thomasville. They were delicious. They were even more delicious because of the personal presidential touch.

Eisenhower took up watercolor painting while he was in New York as president of Columbia University. He painted many bucolic scenes that were quite charming. He continued to paint throughout his lifetime and each year he gave a print to everyone in the press corps covering the White House for Christmas. We were a small group in those days. Unfortunately I only have two pictures—a red barn and a church in Bavaria. At one time I had the whole series but I gave them to members of my family. I imagine they are probably quite valuable today.

When Eisenhower was the president of Columbia University he bought a farm in Gettysburg, Pennsylvania. He had

Eisenhower at the opening game of the 1956 season between the Washington Senators and the New York Yankees in Griffith Stadium. Waving both of his arms and letting out a yell, the president enjoyed a home run by Senators center fielder Karl Olson.

the farmhouse rebuilt. It was an old cabin and the timbers had rotted and were worm-eaten. But it was now a fine house that he enjoyed on occasions as president and is where he retired.

The farm was a big attraction for Ike. He would fish, hunt, and enjoy outdoor activities that he loved. This was his first real home. He never had a home of his own during his entire career. As he moved from post to post it was always government housing, including the White House. The Eisenhower children and grandchildren loved visiting the farm. After the Kennedy Inaugural Mamie and Ike happily drove to Gettysburg by themselves.

"I come to you with a message of leave-taking and farewell and to share a few final thoughts with you, my countrymen." He warned of the danger of spending too much money on defense. He referred to the "military-industrial complex" that could use its powerful influences on over expenditure.

—Dwight David Eisenhower, at the end of his term

CHAPTER VI *The Camelot Years*

John F. Kennedy, 1960-1963

Let the word go forth from this time and place, to friend and foe alike, that the torch has passed to a new generation of America—born in this century, tempered by war, disciplined by hard and bitter peace, proud of our ancient heritage . . .

—John Fitzgerald Kennedy, Inaugural Address, January 20, 1961

THE INAUGURAL

John Fitzgerald Kennedy began working in earnest on his administrative programs as soon as he was elected in November 1960. Probably earlier. As the actual inauguration drew close, he tended to affairs from his Georgetown house on "N" Street. While making preparations for his inaugural and attendant festivities as the thirty-fifth president of the United States, JFK managed to escape the pressure and walked around the block close to home in Georgetown with his three-year-old daughter, Caroline, and her baby carriage. It was a sweet father-daughter moment. I made their picture as an exclusive for the Associated Press.

All of the inaugural activities and events with the Kennedys were magical, the beginning of Washington's Camelot. President and Mrs. Kennedy were all decked out for the in-

Prior to his inaugural, President-elect John F. Kennedy enjoys some time alone with his three-year-old daughter, Caroline, as they walk around the block close to their home in Georgetown.

JFK and Jackie in a special box at the Armory Ball the evening before his inauguration.

augural balls. They did not go into the crowds, but waved from their seats in a special box at the Armory Ball. I made a picture of JFK and Jackie in her elegant ivory satin Oleg Cassini gown. She certainly was a beautiful woman.

But what an awful night! A blizzard was swirling across the Potomac. It was snowing and cold. Oh, God how cold! It's amazing anyone got to the balls through the snow. There were five official balls and JFK went to every one of them. The motorcade, including the press car, plowed along behind the president. Afterward he attended a party at Paul Young's restaurant on Connecticut Avenue. Next Kennedy decided to drop in on Joe Alsop at two o'clock in the morning. There were two Alsop brothers—Joe and Stewart, both writers, from an aristocratic family. Joe was the famous syndicated columnist and special friend of the president. He was an influential face in Washington politics. Stewart wrote for *Look*, among other publications.

We finally said good-bye to Joe and went back to the White House. By then, it was three or four in the morning. I slept in the AP office downtown, because the blizzard had blocked most of the roads in Washington and I was assigned to cover the inauguration the next day.

■ THE BEGINNING OF THE KENNEDY ADMINISTRATION

President-elect Kennedy and retiring President Eisenhower left the White House together. They both were wearing top hats, heading for the Capitol and the inauguration ceremonies. This is the only time I saw them wearing those top hats. Kennedy did not wear his during the ceremony and the rest of the men held their hats in their laps. Some say the top hat thing may have been Jackie's idea. The picture I made of them begs for a clever caption. What did Eisenhower say that made Kennedy smile so broadly?

I came from the White House with the others of the press covering the swearing-in of the new president. My position was on the left end of the inaugural stand. A historic picture presented itself. It was a unique grouping of four men sitting together: Eisenhower, Nixon, Kennedy, and Johnson, all of whom eventually served as president of the United States, along with First Lady Jacqueline Kennedy and the future first lady, Lady Bird Johnson.

Kennedy was sworn in by Chief Justice Earl Warren on a Kennedy family Bible. Cardinal Richard Cushing of Boston, Kennedy's hometown, delivered a proud prayer for his famous parishioner. Robert Frost, one of America's leading poets, recited a poem.* Rabbi Dr. Nelson Glueck gave the benediction.

And Kennedy's speech was memorable. No one will forget those famous provocative words, "Ask not what your country can do for you, but rather ask what you can do for your

* Frost wanted to recite JFK's favorite poem. The glare of the sun off of the snow was so severe that he was not able to read, so he recited a poem he knew by heart.

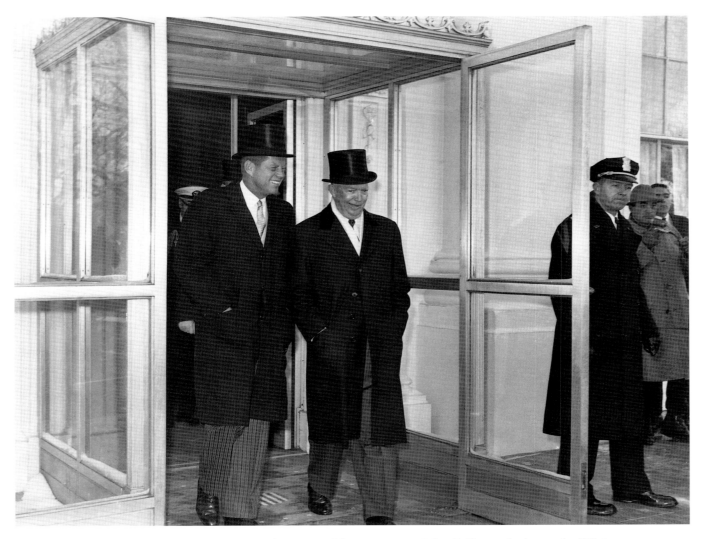

January 1961—President Eisenhower and his successor, John F. Kennedy, leave the White
House to ride together to the Capitol for Kennedy's inauguration as the thirty-fifth president.

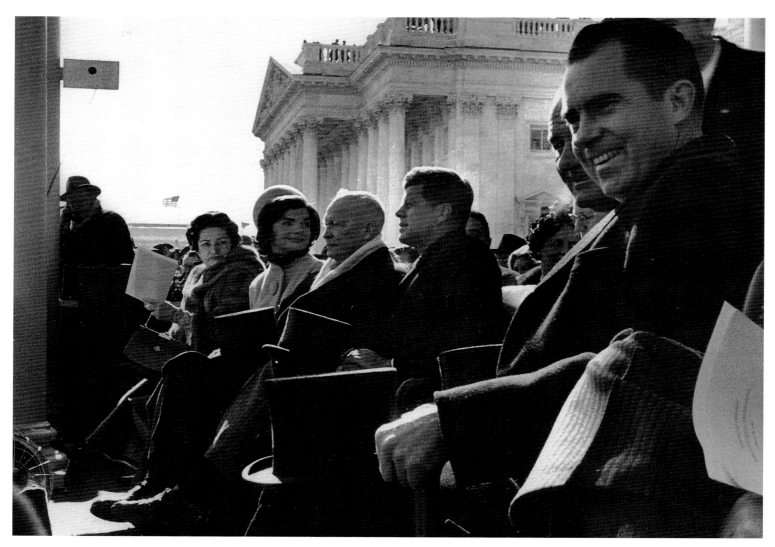

On the north portico of the Capitol, a unique grouping of four past, present,
and future presidents: Eisenhower, Kennedy, Johnson, and Nixon.

country." It grabbed the headlines everywhere and set the tone for the new administration and its charismatic young leader.

I did not cover the entire Kennedy campaign nor was I privy to events at the Kennedy compound as was Stan Tretick, who was working for *Life* to cover the campaign and lifestyle of the Kennedys. Stan had developed a personal-professional relationship with Jack Kennedy that served them both well. I knew that I must take advantage of my position on the Capitol portico for a more personal picture of the newly sworn-in president and first lady.

I was the only member of the press that followed John and Jackie Kennedy after the ceremony as they went back into the Capitol. Jackie was wearing her signature pillbox hat and Oleg Cassini suit. She congratulated John on his speech in the little rotunda right inside the building. I made one quick picture. It was a tender scene with Jackie's hands on his chin. Charming. The head of the Secret Service detail, Jerry Balsh, realized I was not in the official party and I was banished.

Much to the amazement of the whole city of Washington, the four-hour inaugural parade took place. JFK watched and the participants were exuberant even in the 20-degree weather. I hoped there was a heater in the reviewing stand.

Three thousand servicemen stationed in the area and hundreds of snow plows and trucks had been put to work through the night to remove about a foot of snow that had fallen on the parade route. It was a totally joyous day.

■ JFK's Working Style

The Kennedy team came into the White House like a storm of fresh air. Many of them were young and energetic members of the presidential campaign crew. Pierre Salinger, the new press secretary, quickly surrounded himself with a group of young, enthusiastic assistants. One of them was a perky young graduate of Barnard College, Barbara Coleman, who was assigned to "handle" photographers. That was no easy task. Barbara soon became acquainted with the confrontational nature of news photographers, but nevertheless, with cool aplomb, she quickly settled down into a most effective "handler." She was good and very popular with the press corps.

Things changed dramatically from the Eisenhower years. Eisenhower's press secretary, Jim Hagerty, ran a very efficient and orderly ship. You could count on his version of the president. But Pierre Salinger was having a rough time holding the reins.

I spoke to four hundred newspaper editors at the annual Associated Press Managing Editors Convention in Minneapolis in September of 1962. This is the news article that appeared in the *St. Paul Dispatch* by staff writer Max M. Swartz. My presentation covered the working style of the Kennedy White House for photographers.

It read as follows:

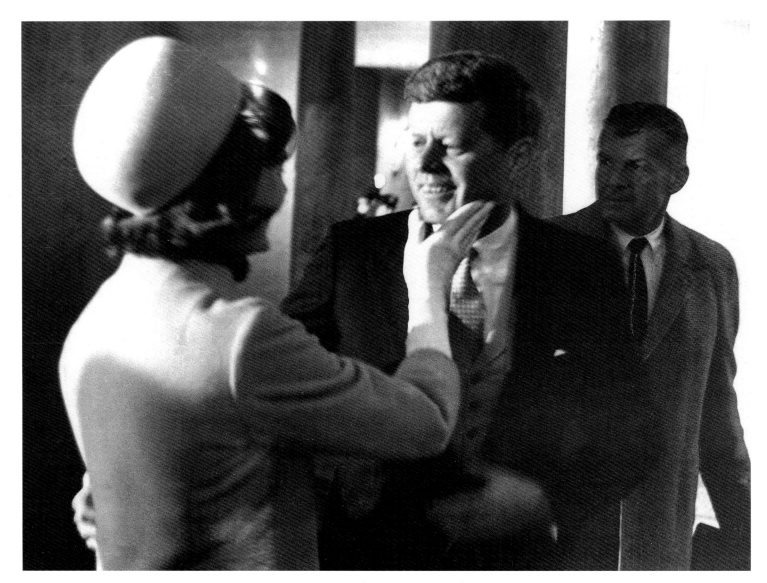

Jackie congratulates Jack inside the Capitol after the inaugural ceremony.

Shoot! It Might Be Caroline
By Max M. Swartz
Staff Writer

Press photographers shoot "everything that moves" on the White House grounds these days because it might be Caroline Kennedy.

The young daughter of the president is the "hottest piece of picture copy" for cameramen covering the presidential mansion.

"We never know where Caroline is going to pop up, and Lord help us if she is available and we don't get the picture," Henry Burroughs told the editors in a slide-illustrated talk titled, Covering the Kennedy Clan.

White House coverage has drastically changed from previous administrations, where everyone had "an equal crack" at the president when he was available for pictures, Burroughs said. "President Kennedy gives exclusive pictures" to magazines, newspapers, and "even occasionally to wire services" in a "free wheeling informality in which all the old ground rules have gone out of the window," he said.

"During previous administrations, photographers were never allowed to shoot pictures in the lobby of the White House without special permission from the press secretary. Now we are free to shoot whenever we wish as the president frequently walks through the lobby with his guests."

Unlike other former presidents, President Kennedy takes a great interest in pictures that are published and lets the photographers know when he does not like their product.

President Kennedy has increased the problems of photographers covering his activities because of his love for sailing. Whereas President Truman forced them to get up early to cover his morning walks and President Eisenhower's penchant for golf made them sports-minded, Kennedy's cruising finds photographers reaching for their longest lenses and not finding them long enough.

Mrs. Kennedy selects the photographers to take family pictures and looks the pictures over before they are released for publication.

He revealed that the president dislikes formal posing and when he thinks photographers have had enough he glances at an aide who yells "lights," and picture-taking ends for the day.

One of the first things Kennedy did was to set up exclusive opportunities for magazines—*Life, Look,* etc. We wire services were feeling left out. I kept asking for "a day with the president." I guess United Press International (UPI) was asking for the same thing, because Pierre set it up, not exclusively, but for both wire services.

The day arrived and Maurice Johnson of UPI and I were taken over to the main house and positioned by the elevator that would bring President Kennedy down from the second floor. Surprise! He emerged leading little Caroline by the hand. Good picture, but he seemed startled that we were there. I think he had forgotten about Pierre's arrangement because he was wearing a bandage on his forehead, in plain view.

A few minutes later we were ushered into the Oval Office to start our "day-with" and noticed that the bandage had dis-

A day in the life of the president—studying the plans for the day.

As though seeking "equal time," overall-togged Caroline tags along with her mother as they walk past the president's office door.

appeared. As it turned out, there had been a big Saint Patrick's Day party in the White House the night before and the president had hit his head on something. That didn't stop him one bit with our photo arrangements. He was unflappable. John Kennedy sat at his desk studying notes and preparing himself for his next meeting.

Behind the desk was a ship's model that he particularly liked. Then, I spotted Jacqueline with Caroline in tow walking past the door leading into the Rose Garden. I managed one photo through the door; it added a great deal to the series.

The president received a lot of callers that day. Among them were Secretary of Defense Robert McNamara; Secretary of Commerce Luther Hodges; Secretary of Labor Arthur Goldberg, and Vice President Lyndon Johnson. It was a steady stream of visitors. I noticed that he would stand at his desk as his personal secretary of many years, Evelyn Lincoln, brought in papers and correspondence.

When visiting dignitaries arrived he would often relax in his famous rocking chair as he did when the poet Robert Frost visited. Doctors had ordered him to use the rocker to soothe his back and comfort his problems with Addison's disease.

Our "day" with the president turned out to be an introductory look at the activities of a very busy national leader. Many key members of the new administration made almost daily visits and photographers were usually invited to capture on film the goings and comings of visitors and special meetings in the Oval Office. Many of these invitations pre-

sented good picture opportunities. President Kennedy, with his relaxed, debonair style, could appear graceful and at ease even sitting on a table.

■ Travels with the Kennedys

We traveled a lot with JFK, even though he was only in office for a little more than two and a half years. One of the earliest trips was out to Oklahoma to schmooze Senator Bob Kerr, a powerful member of the Senate Finance Committee and director of the floor fight against Kennedy's Medicare bill. The senator was a friend from Kennedy's days in the Senate and he invited the president to his ranch.

The press corps members were hospitably put up in a local motel owned by the Kerr family. The next morning we all went down to the local village where Mrs. Kerr owned a restaurant, which she ran herself. This struck us as unusual because Bob Kerr was an oil multi-millionaire. Mrs. Kerr just enjoyed running the restaurant. The ranch breakfast consisted of bacon, eggs, and steak. It would keep you going the whole day. Oklahoma ranch-style living was very impressive to us Easterners and we were a little sorry that it was just an overnight visit. Incidentally, the Medicare bill was defeated on the Senate floor by a 48 to 52 vote.

To show how parochial interests were also high on the Kennedy administration's agenda, our next stop was in Bal-

timore, a short hop by helicopter from Washington, D.C., for an official opening of a new superhighway, I-95.

My first foreign trip with the president was to Ottawa to visit Prime Minister John Diefenbaker of Canada in May of 1961. The purpose of this trip was to urge Canada to join the Organization of American States (OAS). The meeting seemed harmonious; the only significant event was that our president wrenched his back while helping to plant a tree in front of the Government House. He seemed to recover his composure quickly and we did not realize until much later that he suffered from that injured back for several months.

About a month later, in June, the president and the first lady departed on his first trip to Europe as president of the United States. We arrived at Orly Field in Paris with much fanfare and all the ceremony of diplomacy, including a welcome handshake from the tall and distinguished president of France, General Charles DeGaulle.

When I saw the general my mind raced back to an earlier day when DeGaulle first came to Washington. It was big story, this legendary character making his first visit to our nation's capital, and very important to the photographic press. There was a huge turnout of photographers and the State Department was determined to have an orderly reception at the airport. All photographers had agreed to form a line at a reasonable distance from the ramp, which we did with much shuffling and vying for position. When we finally settled down, the State Department officer was very pleased.

As the Air France plane landed the line held but tension grew. The plane taxied precisely to the designated spot. We were all about fifteen feet away. I happened to glance at the camera next to me and noticed it was set for a range of six feet not fifteen feet. He would have to move in to a six-foot range. Oh, oh! As the stately general started down the ramp, that cameraman broke ranks and the melee began. The entire gang of photographers swarmed over the general like a herd of locusts, elbowing and maneuvering. It was bedlam. As the general reviewed the honor guard, photographers were darting in and out between the soldiers to frame better pictures. Everyone got pictures, but what a mess! I feel sure the State Department officer had three martinis at the end of that day.

By contrast, everything went smoothly at Orly Field. But when I looked at the general, who was now the president of France, I couldn't avoid thinking about that chaotic day in Washington. President DeGaulle greeted President Kennedy with pomp and ceremony, than accompanied our president and the first lady on their way through the Paris streets to their apartment in Quai D'Orsey. The streets were crowded with wildly enthusiastic Parisians. They seemed especially interested in Jacqueline Kennedy and shouted her name. The recognition of Jackie was so obvious that later, during a luncheon, JFK introduced himself as "the man who accompanied Jacqueline Kennedy to Paris, and I enjoyed it."

While we were in Paris, the French provided the photographers from the two White House wire services, AP and UPI,

with a chauffeur-driven limousine in the motorcades. First class. We accompanied Kennedy to the Arc de Triomphe during a heavy rain, where he placed a wreath by the eternal flame. We lost the motorcade on the way back to Quai D'Orsey, but we arrived at Versailles for the going-away party. The French grand finale, as a tribute to the new president and his wife, was an extravaganza worthy of Cecil B. DeMille—a magnificent dinner in the Hall of Mirrors at the Palace of Versailles.

All went well for the photo pool until we arrived at the palace entrance. The official guests were quickly ushered inside while we photographers, a small group, were shunted off into a side reception hall. The first thing we noticed was that our temporary prison was dripping with crystal chandeliers and gold leaf everywhere. Our French guards told us we would be admitted for pictures at the appropriate time. We were cut off from any other communication and our French "man in charge" had to reassure us from time to time that we would be allowed in at the appropriate moment.

We all became restless and bored with our gold and crystal entrapment. As minutes became hours and the evening droned on we began not to believe our French friend. We were right. When we were finally released from our elegant prison the party was over. The president and Mrs. Kennedy were heading for their limousine and we scrambled for the motorcade cars. We had been hornswoggled by the French. Fortunately, staff photographers from our Paris bureaus had

been prepositioned in the Hall of Mirrors and made the pictures. But we didn't know that at the time, which doubled our frustrations.

Then, in June 1961, I was off to Vienna and JFK's first meeting with Nikita Khrushchev, premier of the Soviet Union and chairman of the Communist Party. It was not a very happy occasion. The two of them were testing each other and apparently exchanged some pretty strong words in this famous confrontation. They looked like a happy couple before they started talking at the beginning of the conference. Kennedy was impressed with Khrushchev and later admitted that the chairman had gotten the better of him.

This was probably going to be the most important photo opportunity of the entire tour, the two leaders of the world meeting at the U.S. Embassy in Vienna, and I came within a hair of missing the whole thing.

The airport ceremony was colorful. The Austrians turned out their best-dressed troops. But somehow there was a big foul-up. Flown in on Air Force One, the White House press pool was cut out of the action by Austrian guards after we photographed the arrival. They wouldn't let us get to our car in the motorcade and it took off without us. We panicked. We rushed off of the field looking for a ride. Good fortune hit us in the form of a pick-up truck driven by a U.S. Embassy staffer.

We jumped in the back of the truck and went careening through town to the embassy. Pierre Salinger was waiting for

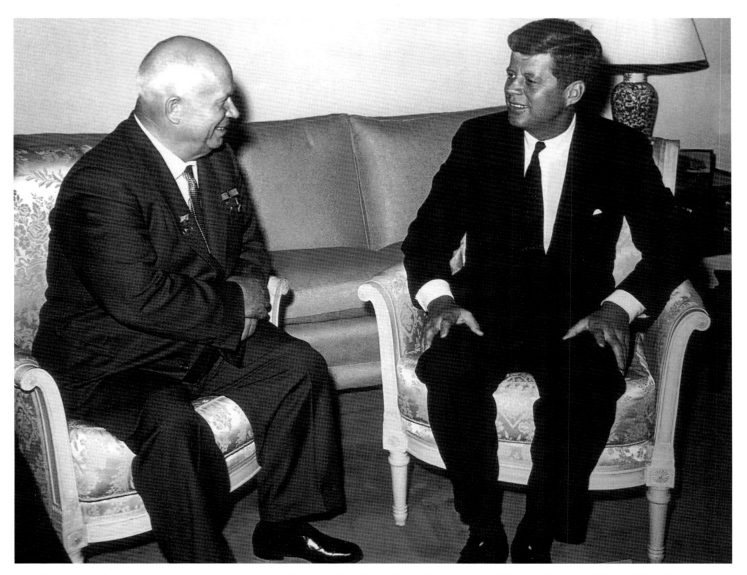

Two world leaders meet at the embassy in Vienna: U.S. President Kennedy and Soviet Premier Nikita Khrushchev.

us at the entrance and corralled a couple of Secret Service men to clear a path for us. In the nick of time we ran up the steps directly into the reception room where the two great leaders were meeting. There has never been a more grateful sigh of relief. Another front-page picture.

The plight of our Latin American neighbors was a favorite theme of John Kennedy, even before he became president. The "Alliance for Progress" was launched in March 1961 in a speech in the East Room of the White House, with ambassadors from throughout Latin America. Kennedy appealed, "Let us once again transform the Western Hemisphere into a vast crucible of revolutionary ideas and efforts."

By June 1962 Kennedy's "Alliance for Progress" initiatives had captured the imagination of Latin America. So much so that when we arrived in Mexico City shortly thereafter the welcome was overwhelming. There were seventeen million people in Mexico City and it seemed that half of them were on the streets. It was also a little dangerous for the more adventuresome cameramen.

On the ride into town disaster struck. One of the Mexican cameramen was riding alongside the motorcade on top of a large van with his television camera on a tripod. He was right in front of us, and I watched in horror as the camera clipped an overhanging electric cable. Sparks flew. The cameraman was knocked unconscious and the camera and tripod were swept off the top of the van. A sad start for what was to become a joyful celebration downtown.

Kennedy's next trip to the Southern Hemisphere was to Costa Rica in the spring of 1963 to attend a meeting of the Central American presidents. The streets of San Jose were not as crowded as those of Mexico City but the welcome was just as warm. I couldn't help thinking that only a short time before, Vice President Nixon was almost killed by demonstrators in Venezuela. My, how the atmosphere had changed. The "Alliance for Progress" had made a dramatic difference. Incredible!

Nostalgia churned up great memories for me when I was next assigned to accompany President Kennedy to Germany. After all, this was my old stompin' grounds. The president was to take an extensive tour covering Germany, Ireland, England, and Italy. The AP assigned two photographers, my old friend Henry L. "Griff" Griffon and me, to work this logistically complicated trip.

We hit many of my old haunts, and a lot of Griff's as well—Frankfurt, Bonn, and Berlin. Crowds everywhere were enthusiastic but none compared to the reception in Berlin. The president visited the infamous "wall," then made a major address at City Hall, where Berliners were packed into the square for a glimpse of this new American leader. It was here that Kennedy made his famous "ich bin ein Berliner" speech and the huge crowd went wild clapping and shouting in sheer joy.

Pierre Salinger cleared the way through security so I could make one picture peeking out from behind the backdrop of

July 1962—First Lady Jacqueline Kennedy
stands proudly beside her husband at a
reception during a state visit to Mexico.
Turning thirty-three and ending eighteen
months as first lady, she had won praise
for her support of her husband's policies
on her many diplomatic trips.

Berliners were packed into the square at City Hall to hear the young American president make his famous "Ich bin ein Berliner" speech.

flags as Kennedy spoke. It was a dramatic moment—the Kennedy charm and spirit carried the day.

There was no chance to visit my old neighborhood in Zehlendorf West where I had lived for four years. But the ride through downtown streets brought back severe memories of the rubble heaps and desolate aura of that area in 1945. It was a pleasant surprise to see the changes of the subsequent sixteen years.

We departed Germany for Ireland, where again Kennedy received wildly enthusiastic welcomes, especially in Dublin and County Wexford, where his great grandfather had been born and raised before leaving for America. There seemed to be an extraordinary number of Kennedys in Ireland and in Wexford County he found dozens of cousins. One of them came battling through the crowd to throw her arms around John and give him a big hug.

Then on to England and a visit with Prime Minister Harold MacMillan at his home, Birch Grove. It was a short and private meeting.

Rome was our next stop and was notable for having the thinnest crowds of all. We paid a call at the Vatican to see Pope Paul VI. Then the Italian president entertained the Kennedys with a colorful dinner party at the Quirinale Palace.

In contrast to Rome, Naples turned out en masse. The huge crowds there were literally bursting with excitement, whooping and hollering as the motorcade passed through the streets.

On the way home, we all decided that even though it was a whirlwind tour, the trip was exceptionally successful. The Kennedys had indeed captured the hearts of Europeans.

■ ALL'S WELL

Back at the White House, in between trips, it was day-to-day coverage, which kept us all alert. The pitter-patter of little feet would strike terror in the hearts of cameramen, because it meant that little Caroline, age four, and / or John-John, two and a half, were close to the scene, and if you missed a picture of these little tykes you would not make the front pages.

One never knew when they might show up. One day as we photographers were assembled in the Blue Room waiting for the president and first lady to pose in front of the freshly decorated Christmas tree, there was a bustle at the door. Caroline had escaped from her Aunt Eunice Kennedy Shriver, who was passing in the corridor with both children in hand. Caroline ran into the Blue Room and up to the Christmas tree, throwing her arms up in joyful surprise. This was her first glimpse of the gorgeous blue spruce and its decorations from the theme of the Nutcracker Suite.

I was really lucky on this one. I had primed my camera flash and was ready for her. I had one picture on my Rolleiflex before Caroline's Aunt Eunice grabbed her hand, saying,

Caroline Kennedy escaped from her Aunt Eunice when she spotted the White House Christmas tree. The sheer joy of a small child.

"Caroline, we're not supposed to be here," and yanked her out of sight. All the other cameramen were shouting, "lights! lights!" But it was all over before the lights appeared and I had an exclusive that would catch the imagination of editors. One headline proposed, "Have you ever seen a dream walking?" The pictures of the president and first lady from that session never saw the light of day. Editors preferred the spontaneous joy of a small child's first glimpse of Christmas.

■ DINNER WITH THE PRESIDENT

Every year the White House News Photographers Association gives a dinner in honor of the president of the United States and his official family. In 1962 the dinner was held at the Sheridan Park Hotel in Washington in April. At the president's request it was in conjunction with the White House Correspondents Association. As dinner chairman, I had the privilege of playing majordomo, greeting and escorting the president and his official family, and observing the usual protocols.

At this dinner, one sits down to a sumptuous meal and an evening filled with entertainment by illustrious performers of the American stage and screen. But far more impressive and thrilling is the aura of stateliness and majesty that is sensed in the presence of the greatest leaders of our country. The official family includes members of the president's cabinet, the chief justice of the Supreme Court and his associates, leaders of both political parties, and high-ranking officers of the armed services.

For me there was an added thrill in reading the guest list. Full of prominent names from the literary world, industry, journalism and foreign governments, the register read like a "Who's Who" of world leaders.

When the fifteen hundred or more guests are in place, the president and his entourage enter the room with the traditional "Hail to the Chief" played by the Navy Band. The entire assemblage rises to applaud. As dinner is being served and consumed, almost everyone keeps an eye on the head table to note what the president is doing, his demeanor, and whom he may engage in conversation.

After dinner the lights dim and the stage show begins. By habit, most of the audience divides its attention between the famous performers and people at the head table. When the president slips behind the chair of Chief Justice Warren, we wonder what they find to talk about with such emphatic gestures. As that conversation ends, the president takes pen in hand and scribbles something on a sheet of paper. He repeats this during lulls in the program—writing, crossing out, and writing again. Later we learned that he was organizing his speech for the evening.

Back and forth, our eyes travel up and down, watching the expressions and actions of the head table guests. Prime Minister MacMillan of Great Britain, who during most of the

evening remained stoic, was suddenly in animated conversation with Vice President Johnson to his left.

Attorney General Robert Kennedy, the president's brother, lets his face muscles curve upward in a smile as Mr. Reed, the performer on stage, jokingly alludes to the FBI getting newsmen out of bed to cover a story.

Obviously this is an annual evening of fun and ceremony as well as a grand formal affair. The photographers enjoy entertaining official Washington, the subjects of so much of their work, as well as their many personal friends.

■ THE ASTRONAUTS

"Just remember, the first astronaut was a chimpanzee," Chuck Yeager reminded us. A famous Edwards Air Force Base test pilot, Yeager, in his inimitable and competitive style, never missed a chance to rib the first American astronauts. Yeager had been at the top of the pyramid, flying supersonic jets through sound barriers and into rarefied altitudes. He didn't much cotton to calling these new test pilots "astronauts."

Well, sure enough, the first Mercury Program capsule flight out of Cape Canaveral had as its passenger a bona fide chimpanzee with a designation of #61, also known as Ham.

John Kennedy had pledged that we would have a man on the moon before 1970 and immediately pressed for an aggressive National Aeronautics and Space Administration (NASA) program. We had been upstaged by the Russians, who had beat us into space with Yury Gagarin's orbital flight around the earth, and Kennedy didn't like having the United States in second place in space. The team at NASA went to work.

I had been assigned to participate in a small NASA press pool aboard the primary capsule recovery ship, the USS *Donner*. The *Donner* was a landing ship dock (LSD) that had been specially rigged with a helicopter pad. The press pool boarded the *Donner* at Jacksonville, Florida, and we steamed toward the capsule target area out in the Atlantic.

It was a new experience for me, pleasant and exciting to be aboard a Navy ship. I just didn't know how long I'd be at sea. The crew seemed upbeat. This was not a run-of-the-mill mission. The bos'n's mate was very accommodating, getting the news pool settled in and acquainting us with the intricacies of the ship.

We didn't see much of the captain at first. He spent most of his time on the bridge. However, every evening, all hands assembled in the wardroom for the movie. There was one every night, some of them good, some bad. It didn't matter. Everyone turned out. As soon as we were all seated, the bos'n would call the bridge: "Ask the captain if he would like to see the movie." The answer was inevitably "yes," and thirty seconds later he would arrive. Then as soon as his butt hit the seat the lights went out and the movie flicked on.

One night we wallowed around in particularly heavy seas. The ship's rolling motion was especially noticeable. The

movie was running, and with each roll of the ship, the entire audience slid across the wardroom. The end chair would hit the bulkhead and the other chairs would clickety-clack in place. The audience would give a mass groan and the chairs would all slide into the opposite bulkhead. Everyone took this with good grace. In fact, it became a challenge. Nobody was willing to give up the movie.

One calm day, after we had received word that Ham's flight had been postponed, the captain invited a couple of us to the bridge, and among other things, engaged us in a bit of target practice. The cook had saved some milk cartons, which the captain would toss overboard and then try to sink using his side-arm pistol. I think it was a forty-five caliber. He invited me to try my hand. I did and discovered I was not too bad a shot. Anything to break the monotony.

Finally the big day arrived. Ham was in his capsule, the weather looked good, all systems were "go." Lift-off occurred without a hitch and a few minutes later Ham, #61, was in outer space. It was to be a short flight. In another few minutes he was on his way down and all indications were that he was off target by about 132 miles.

The helicopter buzzed off the *Donner* in search of the splash-down coordinates. We news people huddled around the radio shack anxiously awaiting word from the helicopter crew. After two hours the crew reported in. They had found the capsule bobbing up and down in seven-foot swells, had hooked on to it, and were bringing it in. However, they also said that water had seeped inside and the capsule (they referred to it as a spacecraft) was much heavier than it should have been. They had arrived in the nick of time. It was about ready to sink.

NASA technicians rushed to open the capsule as soon as it was lowered on the *Donner*'s deck. And there was our hero, the world's most famous chimp, calm as could be with his arms folded and a smug expression on his face. What a ham! And what a picture!

I was really proud when my picture made the cover of *Life* on February 10, 1961, the only time I made the magazine's cover. Two weeks of rolling and pitching on the *Donner* were all worth it for that.

As for Ham, the photo session was only long enough to refuel the helicopter, then Ham and the capsule took off for Cape Canaveral. Stories of his "debriefing" at the Cape abounded. Any time his handlers came near he went into a rage. I guess he didn't like his famous capsule space ride after all and held them responsible.

I bade farewell to the *Donner*, its captain, and crew, not realizing that this was just the first of many Navy cruises in store for me. I was later assigned to cover all the future Mercury recovery missions and I was always on the primary recovery ship—a total of seven voyages to rescue our new generation of space travelers.

The next one turned out to be very smooth and was the giant step of the U.S. space effort. When we left Pensacola

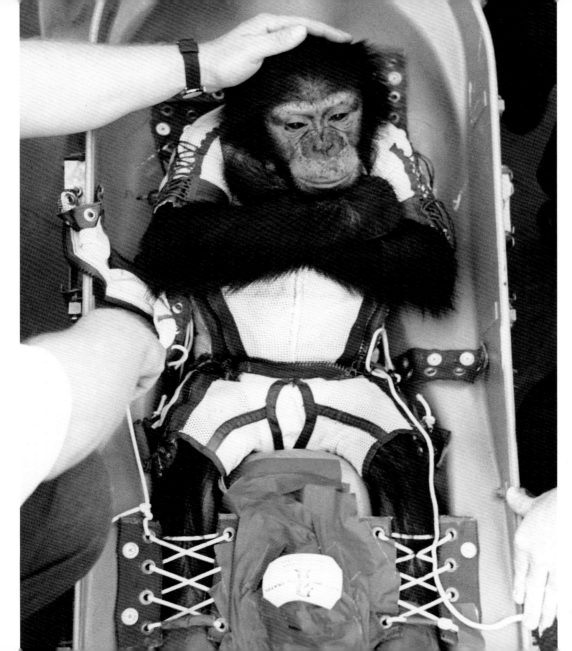

"Ham" the space chimp, America's first traveler in space. He appears very snug as the capsule is opened aboard the Navy's recovery vessel, the *Donner*.

aboard the aircraft carrier *Lake Champlain* to recover our first man in space we had no idea who that man might be. Back at Cape Canaveral NASA was keeping his identity strictly under wraps. They did not even announce that there were three finalists: John Glenn, Gus Grissom, and Alan Shepard. We learned that it was Shepard only when we reached our target area somewhere near Bermuda.

Everybody aboard the *Lake Champlain* was excited and super-ready. Then came word from Cape Canaveral that the launch had been postponed because of local weather conditions. Three days later, on May 5, 1961, *Freedom Seven* with Alan Shepard aboard was successfully launched from the Canaveral space pad. That rejuvenated our spirits and the crew of the ship went on high adrenaline.

I had the longest lens I could find, hoping to capture the spacecraft breaking through the clouds. All to no avail. Shepard's craft splashed down so far from our position that it looked like a speck on the horizon, even with a telephoto lens. But his arrival in the Marine helicopter was something else. When the doors opened, Shepard, with unabashed exuberance, jumped out of the chopper and shouted, "Man, what a ride!" Then he calmly walked over to where the spacecraft had been firmly secured to the deck and retrieved his space helmet.

Click. That was my picture.

Gus Grissom was our next astronaut to go into space, and I was on the aircraft carrier USS *Randolph* waiting for him to come home. Technology had improved. This time the trajectory was more accurately plotted and the spacecraft broke through the clouds in full view of the carrier. Through my telephoto lens, I could barely see the splashdown of *Liberty Bell,* with the helicopters hovering over the site. Within minutes, we all realized something was wrong but couldn't quite make out what it was.

Over the carrier's radio we heard that the hatch of the capsule had blown prematurely before the helicopter crew could fasten onto the spacecraft. Gus must have inadvertently hit the release while maneuvering around for a quick exit. Two helicopters were on the scene. One was trying to save Gus, the other was trying to save the capsule, which was tilted severely and taking on water. It was touch and go for both.

The crew managed to rescue Grissom but the spacecraft was not so lucky. *Liberty Bell* became so heavy with water that the chopper had to abandon it, and she sank into the ocean.

When Grissom landed on the carrier he seemed composed. At least he put on a good front. But that was one narrow escape. All of us on the USS *Randolph* gave him a rousing cheer and warm welcome and he was soon off by jet to Cape Canaveral. My pictures went with him.

I was beginning to feel right at home aboard the *Randolph.* Great crew! And hospitable. I think I never drank so much coffee in my life. I roamed all over the ship and everywhere I went I was greeted by the cordial invitation, "How about a cup of coffee?" It is a sure way to get conversation started so

America's first astronaut, Alan S. Shepard, Jr., retrieves his helmet out of his space capsule after the capsule was lowered by helicopter onto the deck of the carrier *Lake Champlain* in the Atlantic Ocean down range from Cape Canaveral.

I couldn't refuse. When I said farewell to the *Randolph* I thought I would never see her again. Wrong. Six months later, I was back on board waiting for the finale of the first orbital flight of Colonel John Glenn, USMC.

The Glenn flight was incredibly exciting and successful, especially with all its heat shield and angle-of-attack problems. But I didn't catch the splashdown. My photographer colleague and friend, Dean Conger of *National Geographic,* was the lucky one. He was cruising aboard the destroyer *Noah* when the Glenn spaceship came out of the blue and splashed down right alongside.

My anxiety abated somewhat when Glenn arrived by helicopter and was immediately catapulted off the carrier to a hero's welcome at Cape Canaveral. But to get the real picture, I had to return to Washington in time to watch the parade to Capitol Hill and catch Glenn's address to a joint session of Congress. This was a celebration of a national hero not to be missed.

My next Navy adventure was aboard the carrier USS *Intrepid,* which was designated as the primary recovery ship for the flight of Mercury astronaut Scott Carpenter. The *Intrepid* had a glorious history from World War II duty in the Pacific and was waiting at the Norfolk Naval Base when I arrived after driving down from Washington. We were told the carrier would depart promptly at 11 a.m. the next day so I asked if I might spend the night at an on-shore hotel. "Sure, no problem. Just make sure you are here by eleven o'clock."

I arrived at the dock the next morning an hour early. Something looked strange. There was one gangplank in position and one sailor standing at its base. He came running. "Are you Mr. Burroughs? Give me your bag. They're holding the carrier for you." The NASA team cheered as I ran for the gangplank. They, who knew where I was staying, had forgotten to phone the hotel and tell me that the departure time had bumped up because of high winds. The admiral was having a fit. The crew cast off the lines the second I stepped aboard.

Once we were under way, a young lieutenant found me and announced, "The admiral would like to see you in his cabin." I thought I was going to be chewed out, but the admiral was quite affable explaining how difficult it would be to pull away from dock if the winds reached a certain velocity. He went on to say, "I waited as long as I could. I didn't want to get into trouble with you NASA people." I didn't tell him that I was just part of the press pool that NASA was sponsoring, and he didn't press for details. Instead the admiral seemed to enjoy our conversation, which switched to other subjects. He was delightful and bade me welcome aboard the *Intrepid.* I left his cabin with a sigh of relief.

U.S. technology was rapidly coming of age. Scott Carpenter was successfully launched and flew three orbits around the world. He had time to conduct many experiments for NASA scientists and apparently played with the manual controls to a point where he was running out of fuel. This made

Colonel John Glenn and his wife with Vice President Johnson on their way to Capitol Hill after Glenn's successful space mission. Glenn addressed a joint session of Congress.

reentry rather dicey. Carpenter splashed down 250 miles below the target, completely out of sight of the *Intrepid.* When the helicopters found him Carpenter was floating in a life raft alongside the capsule.

It didn't seem to bother Carpenter. He arrived aboard the carrier in an exuberant frame of mind, chattering on about his adventure and experiments. The pictures of his arrival were flown to Cape Canaveral and Carpenter spent the night on board. The next morning he was catapulted off the carrier in a jet plane bound for Florida. I enjoyed the same experience later that day, only I was headed for Washington.

Adventures in space were almost becoming routine when Wally Schirra entered the scene as the sixth U.S. astronaut to explore the heavens in a Mercury flight. He flew twice the number of orbits as Glenn and Carpenter and landed with fuel to spare within sight of the primary recovery ship, the carrier USS *Kearsarge.* Things were so nonchalant by this point that he turned down the helicopter flight from the capsule and opted to be towed by a small Navy vessel back to the *Kearsarge.* "A textbook flight," announced Schirra.

But there is something else people should know about—the process used to send pictures to Cape Canaveral and the public. The Navy would provide a jet or as big a plane as soon as possible, usually from the primary recovery ship. The photos were normally processed at Cape Canaveral. However, toward the end of the Mercury flight series we transmitted the pictures directly from the carrier. I even made a 4x5 Polaroid picture, which was transmitted that way by a professional, not by me. The NASA people pooled all of the pictures. They provided a specialist who developed the film and then transmitted it to Cape Canaveral by radio. The marvel of transmitting pictures directly to the mainland from the carrier for distribution was that it was instantaneous.

The public had become almost blasé about the Mercury flights until Gordon Cooper entered the cockpit. He set a record by piloting his spacecraft for twenty-one orbits. But to those of us who watched, this was also an extraordinary display of technical know-how. On the final orbit things began to go haywire. First the electrical system acted up, then the automatic control system shut down. Cooper had to reenter from space by manual controls.

This flight was the test of a true pilot. Cooper not only brought the spacecraft down successfully but also splashed down closer to the target than any of the previous capsules. Again the primary recovery ship was the USS *Kearsarge.* The crew went wild as the ethereal scene developed: spacecraft and parachute breaking through the clouds so close to the carrier. Gordon Cooper had been in that small capsule for thirty-four hours. What a feat! He was honored across the country as a national hero, second only to John Glenn.

June 1963 was the end of Project Mercury. It was a resounding success for NASA and a great pleasure for me for having played a small part in this magnificent endeavor.

In the fall of 1962 our U-2 surveillance flights confirmed that the Soviet Union was building a medium-range missile base in Cuba. President Kennedy told us about it in a speech broadcast to the nation and the world when he also announced the U.S. blockade of Cuba to turn back ships hauling offensive weapons to the island.

I was sent to the U.S. Navy base on Guantanamo Bay in Cuba. I flew in and set up shop but none of us in the press contingent knew what was going to happen and we were all pretty tense about the situation. The Cubans had troops on the other side of the fence.

I made a lot of pictures as our Marines dug slit trenches near the border and the Navy's golf course. I guess a missile crisis means nothing to a true golfer. I snapped a picture of one looking for his ball while the sweating Marines on duty were hard at work building defenses a few feet away.

I had no idea at the time that we had come so close to World War III and a nuclear holocaust. I got the Navy to fly me over one of the Soviet frigates, which was steaming toward Cuba, ready to deliver the missiles strapped on its deck. The frigates were being escorted by Soviet submarines. Each also had a U.S. destroyer tracking their every movement.*

* This is the USS *Dahlgren* named after Admiral Dahlgren. There is a large hall at the Naval Academy in Annapolis named for him as well as the naval testing range on the Potomac.

I took some pictures and sent the film off to Florida. I guess they were useful because I was sent some of the prints. But then the situation suddenly changed. On October 28, the Soviets backed down and their frigates and submarines turned back. Our U.S. diplomats had won in the negotiations.

Fifteen years later I learned of a strange coincidence during my time at Guantanamo. My wife, Peg, and I took the intracoastal route south from Maryland on our sailboat, stopping in Fort Lauderdale to visit Peg's college classmate, Barbara Sullivan, and her family. In the getting-to-know-you conversation, Barbara told of having been at the Naval Hospital in Guantanamo with her infant son, who underwent an emergency operation for a bilateral hernia on October 28, 1962. I had heard of a mother and son at the hospital and had made a pitch to take their picture. The base commander had turned me down. That afternoon, Barbara and her son were evacuated from the area, under tight security, to Haiti where the family was stationed.

■ JACKIE IN THE SUBCONTINENT

In 1962 the United States was worried about the Soviets' interest in the Asian subcontinent. I was assigned to cover the tour of India and Pakistan with Jackie Kennedy and her sister, Princess Lee Radziwill. It was a deluxe trip of three weeks, a superb way to see these countries. Of course, the vis-

At the height of the Cuban Missile Crisis, U.S. Marines were setting up bivouacs in the middle of a golf course along the border of Guantanamo and Cuba. Missile crisis or not, a true golfer must find his ball.

The U.S. Navy guided missile ship *Dahlgren* trails the Soviet freighter *Leninsky Komsomal* as the Russian vessel heads from Casilda, Cuba, through the Windward Passage between Haiti and Cuba. The freighter was loaded with military equipment, men, and missile-like objects covered with canvas.

it was billed as a sightseeing tour. But it was much more than that. It was a semi-official occasion; the first lady doesn't go anywhere without an official agenda and this looked to me like a goodwill tour.

Ours was a small press group, two wire service photographers and six women reporters, who thought this was their big chance to get an inside story on the first lady. But none of them could get around the princess, who was a buffer and who stuck to Jackie like glue, and nobody was allowed to delve for information beyond the official report of the trip. The reporters were certainly frustrated.

With only eight members of the press, we rode in the Air India jet with Jackie Kennedy from Rome to New Delhi. The Indian government was really putting it on for Jackie. I never flew in such luxury. We traveled on a 707, the largest jet of that time, and it was configured so that each person had an ottoman. You could lie down and sleep if you wanted. Each stewardess wore a different-colored sari—those gorgeous, long-flowing outfits. First they delivered hot towels and hand-painted menus, then came the fabulous food, served as though we were guests at a state dinner.

The pampering continued throughout the trip. Jackie entertained us at several cocktail parties and we were all wined and dined at the American Embassy by Ambassador John Kenneth Galbraith. It was Galbraith who pronounced the trip wonderfully useful to the United States. It was also a photographer's dream.

We boarded a cruise vessel at Varanasi in northern India for a scenic trip on the sacred River Ganges. We visited a castle on a lake at Udaipur, a fantastic place.

We saw the pink city of Jaipur in the foothills of the majestic Himalayan Mountains, and the magical, inspirational Taj Mahal palace at Agra not far from Delhi. The Taj Mahal is perhaps the greatest tribute to love of a woman ever built anywhere—glistening like marble, carved like lace. It can be viewed at any time of the day in different lighting. Breathtaking!

So was the pace of the trip. India's Prime Minister Jawaharlal Nehru and the Galbraiths came to the New Delhi airport to say farewell. Jackie was beginning to tire after the vigorous trip in India, but smilingly went aboard the private plane of the president of Pakistan, Mohammed Ayub Khan. He and the governor of West Pakistan greeted Jackie Kennedy and Lee Radziwill a short time later when they arrived at the Lahore airport.

That was March 21, and the next five short days were filled with exotic events. A highlight of the trip was the private dinner and visit to the Shahnian Gardens, forty acres of terraces and walled gardens with pavilions and canals built in 1642.

There were horse shows and visits to significant tombs, mosques, bazaars, and, by contrast, to forts and a children's hospital. There were state dinners, receptions, and luncheons, and even a torchlight tattoo complete with bagpipes. The first lady and her party were flown to Peshawar, then

Jackie Kennedy and her sister, Princess Radziwill, are properly dressed, including white gloves, as they enjoy an elephant ride during the first lady's diplomatic trip to India.

driven to the Khyber Pass where they had lunch at Torkham with the leaders of the Khyber Rifles, one of a dozen detachments assigned to guard the fifteen-hundred-mile-long frontier between Pakistan and Afghanistan.

Exhausting, but thrilling. To top it off, the president of Pakistan presented the first lady with a magnificent bay gelding, Sadar, as a farewell gift. Jackie was visibly delighted. Sadar became a favorite, stabled at Fort Myers, Virginia, and ridden often by Jackie.

Obviously both the leaders and the people of India and Pakistan felt privileged to have the First Lady of the United States visit their countries.

When I got home I was asked how Jackie had performed on this whirlwind tour. Actually, she wasn't performing. She was herself, moving calmly with no great animation, appreciating every minute. And she made splendid photocopy. She was always dressed simply and exquisitely, even for a ride on an elephant.

DALLAS

President Kennedy had been in Texas for a couple of days mending political fences. The trip had been billed as nonpolitical but was really aimed at securing the state's twenty-five electoral votes.

I was in the press pool, arriving at Love Field in Dallas at 11:37 a.m. aboard Air Force One, which was carrying the first lady. President Kennedy met the plane and escorted her out to greet the enthusiastic well-wishers, who were packed behind fences in the cordoned-off area. Jackie in her pink suit and matching hat and Jack, looking every bit a young, vigorous president in suit and tie, stepped out of the plane and waved to the crowd. Crowds inspired him, and this crowd let out a roar of welcome in return. At the plane-side reception someone gave Jackie a bouquet of blood-red roses. The schedule then called for President and Mrs. Kennedy to follow the Secret Service to the motorcade.

Instead, in his usual charismatic style, the president walked over to shake hands with the crowd for about eight minutes. I made a picture of Jack's last handshake and one of him entering the presidential limousine. That was the last time I saw the president alive.

This was the first campaign-style trip since 1960 in which Jackie joined Jack. It was also one of their first outings together since the death of their newborn son, Patrick. It was a providential decision.

After a rainy morning the clouds dissipated and the day turned gloriously sunny. Perfect for photographers. The bubble top on the presidential limousine would be down.

As the Kennedys' limousine pulled away we ran for the photo car, number eleven in the motorcade lineup. Normally we would have been close to the "Queen Mary," as we called the Secret Service car, which was always behind the

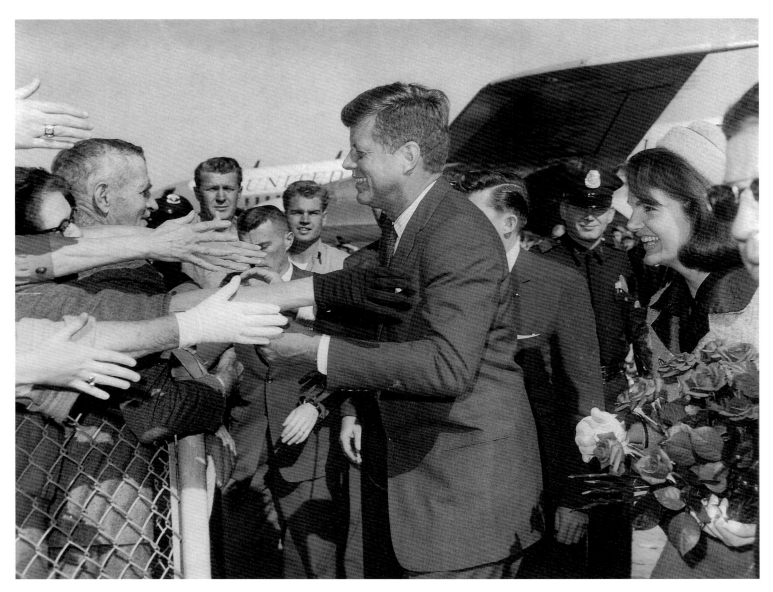

The last handshake. The crowds at the Dallas Airport inspired their charismatic
president to walk over to the fence to shake hands with his well-wishers.

president. This time, the cars in front of us were filled with local politicians so we knew that photographers did not have priority on this trip. Kennedy had come to learn about problems in Texas and to offer his support.

We complained, of course, but it was no use. The motorcade took off with five of us photographers stuffed in an open convertible: me, Frank Cancellare of UPI, Art Rickerby of *Life,* a local photographer from the *Dallas Times Herald,* and Major Cecil Stoughton, the official White House photographer.

The crowds were larger than expected, strung out all along the parade route. The few protesters were lost in the exuberant cheers for the president.

The president's car had turned the corner at the Book Depository and was completely out of our sight when we heard the first shot. "Must be a Texas salute," somebody said. Then we heard an ominous succession of shots. I thought I heard three more in a fast sequence and it sounded to me like gunshots that, I feared, were purposely aimed at someone.

It was 12:30 p.m. when we reached the corner and realized that something serious had happened. Our fears were confirmed when we looked across the park. In the distance, we saw the presidential limousine take off at seventy miles an hour, the "Queen Mary" right behind, with an agent standing up inside brandishing an automatic weapon. We knew the Secret Service car was armed but weapons were never displayed. We did not yet know the enormity of the situation.

We had no idea what was happening. The motorcade had come to a halt. We urged and prodded our driver to get us out of the motorcade and go find out what happened. He was a stubborn guy, a sheriff's deputy, and he was determined to keep us in line. Finally Major Stoughton pulled out his official White House credentials and ordered our driver to pull out of line and head for the Trade Mart where the Kennedys were supposed to have lunch. That did it. We took off in a hurry.

We were stopped briefly at the grassy knoll below the School Book Depository. People were running in all directions. A police contingent was charging up the hill toward the depository. UPI's Frank Cancellare jumped out and ran after the police. The rest of us stayed in the car and sped away from the scene. Finding the president was my top priority.

There was no sign of the limousine at the Trade Mart. The *Dallas Times Herald* photographer knew the motorcycle cop standing by and yelled, "Where did they go?" The cop just shrugged his shoulders. "Parkland?" shouted our photographer. The cop nodded with a wink, and we took off for Parkland Hospital.

The emergency entrance was chaos. Motorcade cars were scattered around. The president's limousine was up near the entrance and a Secret Service agent with a stainless steel hospital bucket in hand was cleaning up the bloodstains in the rear seat. People were crying. The roses that had been presented to Jackie and Lady Bird Johnson, the vice president's wife, were strewn on the seats of their limos.

I took a series of pictures and sent the film by courier to the AP bureau in downtown Dallas. A teenage boy with a camera over his shoulder caught me by the arm at Parkland Hospital. He said he took a picture when the Kennedy car left the motorcade and it was speeding by him along the route. He asked if I wanted to buy the film. I was standing with my competition from UPI, who offered the chap fifty dollars, all the cash he had. I said, "I'll give you one hundred dollars." So sight unseen I bought the roll and sent it into the AP Dallas office. The picture was blurry and out of focus, but you could see the forms of JFK and Jackie in the back seat of the car. A darkroom staff member on his way to work also made a picture from about the same location. It too was blurry, but it was the better of the two pictures. It was the only picture on the scene at the critical moment that day, and it was published. Two weeks later the Zapruder film came to light.

After buying the boy's film, I dashed into the hospital. I spotted Malcolm Kilduff, the White House assistant press secretary, who was filling in for Pierre Salinger. He told me the president had been shot and it looked pretty bad. There had been rumors from the priest, who gave the president his last rites. At 1:33 p.m., Kilduff called a press conference in one of the hospital's classrooms. I didn't see anybody from the AP in the crowd so I stayed for the briefing. I think I might have anyway.

Red-eyed and trying to keep a steady voice, Kilduff read out the official White House announcement:

"President Kennedy died at approximately 1 p.m. Central Standard Time today, here in Dallas. He died of a gunshot wound in the brain."

I took rapid notes and ran out of the room looking for a telephone or an AP reporter. Down the corridor I spotted Jack Bell, AP's top political writer, behind a glass door. He was already on the phone. I rushed in and said loudly, "Jack, I've got the official announcement." He calmly turned and handed me the phone. "Dictate it," he said.

I did, than ran out into the hospital corridor to find out where Jackie and Vice President Johnson were. I found Frank Cancellare instead and we joined up for a search of the hospital. Together we spotted a limousine departing from the side door, a pink pillbox hat framed in the rear window. We ran out, grabbed a cab, and headed for the only place we could think that the first lady might be going—Love Field and, hopefully, Air Force One.

Everyone was there ahead of us. Air Force One was still on the tarmac, revving up—with a cordon of soldiers surrounding it. The ramp was still in place, however, and in a few minutes Major Stoughton appeared at the door. When he saw us he ran down the steps, sidestepped the military cordon, and came over to us holding out a roll of 120-millimeter film and said, "These are pictures of Johnson being sworn in as president. Hank, would you have AP process them and pool them with UPI?"

Of course, I said "yes," and Frank agreed. We hopped back into the taxi and Stoughton convinced a motorcycle policeman to escort us to the AP bureau in the *Times Herald* building. The film was never out of our sight.

We rushed into the AP darkroom and developed the film—good clean negatives. My God! There was Jackie, standing next to Vice President Johnson as he was being sworn in by Sarah Hughes, the district judge in Dallas, who had been appointed by Kennedy in 1961. Jackie was wearing her blood-covered suit.

The word we got was that Lyndon Johnson had arrived at Love Field just ahead of the hearse carrying the body of President John F. Kennedy. The casket was taken aboard Air Force One almost precisely at 2 p.m. Lady Bird Johnson arrived half an hour later with Judge Hughes.

With the jet engines warming up, Mrs. Kennedy joined the vice president in the main cabin. Judge Hughes read the oath of office and was barely audible above the whine of the engines. At 2:38 p.m. Lyndon Baines Johnson was sworn in as the thirty-sixth president of the United States. LBJ had moved swiftly to arrange the transfer of power of the presidency. There would be no appearance of our nation drifting leaderless for even a short period of time.

Back in the AP darkroom, Frank and I picked the best two pictures and made duplicate prints. Time was of the essence. I had already called Al Resch, AP's executive photo editor in the New York headquarters. He had opened photo lines to points throughout the world and was waiting for the picture. He was really on me: "Why are you taking so long?"

I had to explain the pooling arrangement. Cancellare had gone to the UPI bureau just a few blocks away, and I had to wait for his call when he got there giving the OK for simultaneous release. The call came within a couple of minutes. Stoughton's famous picture was already wrapped around the transmitter cylinder, caption in place. I pushed the button and away she went—all over the world. Thanks to Al Resch's network management, AP's version was the most widely used.

By the time I got back to Love Field, both Air Force One and the press plane had taken off. I managed to talk my way onto a commercial flight and landed in Washington late that night.

And, oh, yes, about the roll of film from outside Parkland Hospital that I had rushed to the AP bureau in Dallas. The story I got was that the film did indeed arrive at the bureau but was somehow lost in the newsroom chaos.

The Toughest Part

As I was wending my way home from that fatal day in Dallas, Jackie Kennedy was in the White House trying to make sure that her husband would be remembered as a national hero. This would be a hero's funeral.

She asked that a certain book be brought to her from the White House library that contained information and sketches of Abraham Lincoln lying in state. She sent to the Library of Congress for more information on the rites and tributes to Lincoln. The Pentagon's funeral expert brought Jackie a copy of "State, Official and Special Military Funeral Policies and Plans." Every detail in the ceremonies of the next three days was carried out with the majesty and dignity accorded a world leader and a beloved president.

As for me, I managed a few short hours of sleep before going down to the White House the next morning to begin work covering the new president, Johnson, known to everybody as simply "LBJ." He arrived about 9 a.m. and was briefed by Bobby Kennedy, the president's brother and attorney general; John McCone, head of the Central Intelligence Agency; and McGeorge Bundy, one of Kennedy's closest advisers. Then Johnson walked over to his old office in the Old Executive Office Building next door, where he met with Secretaries Dean Rusk and Robert McNamara. All of this in two hours!

Frank Cancellare and I were the only news people camped outside President Johnson's office. With its ancient marble floor and dark-paneled doors, it was not the most inviting place to wait. Luckily, we didn't have to wait long.

The office door suddenly opened wide and out came LBJ. He greeted Frank and me warmly and spread his arms around our shoulders as he walked us down the hall. Lowering his voice in a very serious tone, he drawled, "Fellows, I'm gonna need your help. I'm gonna need all the help I can get."

We walked in silence and went with him on the elevator down to street level, where a limousine was waiting. The Secret Service was taking him to pick up Lady Bird from their home and they didn't waste any time. It was only a short time later when the Johnsons returned to pay their official respects to the dead president and the Kennedy family.

The Johnsons spent the first twenty minutes with Jackie in the family quarters, then came down to lead the procession of mourners past the flag-draped bier in the East Room. The circular driveway off Pennsylvania Avenue was already lined with limousines bringing congressmen, cabinet members, diplomats, and Supreme Court justices to view the casket on the catafalque in the East Room. Johnson and Eisenhower led the mournful procession.

Shortly before noon Lady Bird Johnson went across LaFayette Square to attend a memorial service for the late president at the old Saint John's Episcopal Church, often called the "Church of the Presidents." Later that afternoon, Johnson issued his first proclamation as president, declaring Monday, the day set for Kennedy's funeral, as a day of national mourning.

The next day, Sunday, I was assigned to cover special sections of the pre-funeral ceremonies. This included the departure of the casket and Kennedy family as they left the White

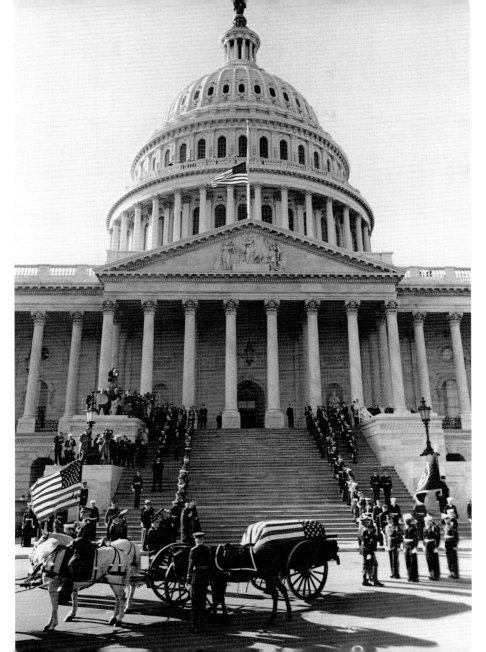

The caisson holding Kennedy's coffin leaves the Capitol after the president had lain in state in the rotunda for the nation.

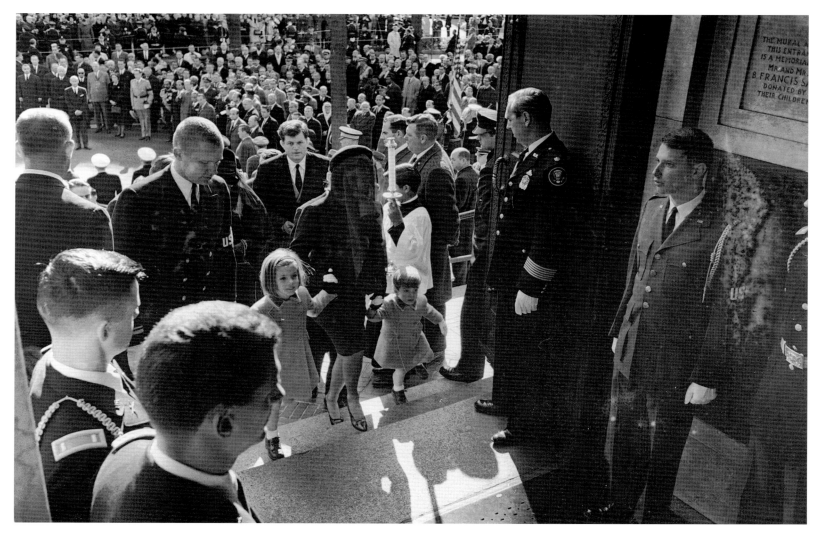

Jacqueline Kennedy is seen entering St. Matthews Catholic Church with her children Caroline and John-John. Ted Kennedy is in the background.

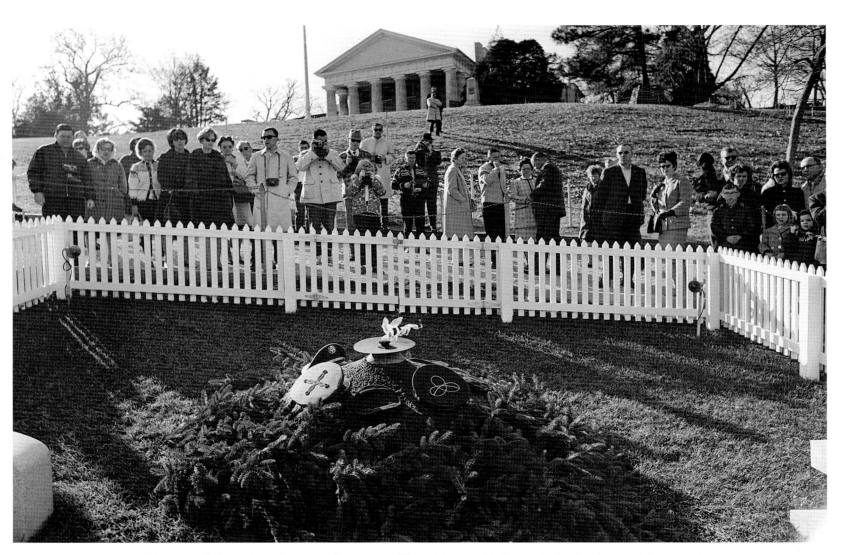

The eternal flame burning atop the grave of John Fitzgerald Kennedy. Truly, the torch is passed.

House for the Capitol. I was not assigned to cover the cortege down Constitution Avenue. My job was to photograph the White House departure, get to the Capitol in time to photograph ceremonies in the rotunda, and ensure that captioned pictures were ready at the Washington bureau for AP distribution to the world. The entire Senate, House of Representatives, and the White House staff were crammed into the magnificent rotunda as the president's widow and Caroline knelt and kissed the casket. This was all such a whirlwind of confusion and challenges. At one point I rode on the back of the AP courier's motorcycle. It was the only way I could get through downtown Washington, where streets were cordoned off from vehicles and the seemingly millions of people who had come to witness events.

After the ceremonies Jackie and the Kennedy family returned to the White House and the patient public was invited into the rotunda to pass by the catafalque and pay their respects. Private citizens from everywhere had been waiting hours in long lines for a chance to say good-bye. They came into the rotunda in double endless lines. Officials had planned to close the great gold doors by 9 p.m., but even at that late hour, the waiting line stretched a couple of miles across the Capitol Plaza and up Constitution Avenue. And the people kept coming all through the night. When the doors finally closed in mid-morning the next day, the unofficial count was that 250,000 people had passed through in homage to this once vital and inspiring president.

Jacqueline Kennedy had orchestrated the arrangements for this funeral and it was a thoughtful, tasteful, really elegant tribute to the former president. The funeral day was a masterpiece.

The horse-drawn caisson holding the coffin left the White House for the funeral services with Jacqueline and all the Kennedys following on foot. They walked down Connecticut Avenue to the cadence of muffled drums and the clip-clop of the hooves of seven matched grays and the riderless horse. Then came the most incredible assemblage of foreign presidents, prime ministers, and royalty that had ever been seen together, all walking in the solemn procession. Following along behind them were members of the Supreme Court, Congress, and the White House staff, also on foot.

I was at St. Matthews Cathedral waiting to photograph the Mass and ceremonies. In order to take my position inside the church I was required to wear a rented black morning suit. Jackie had thought of everything. I stood in the church doorway in my formal outfit and watched the approach of the procession.

I photographed Mrs. Kennedy tightly holding the hands of little Caroline and John-John as she entered the cathedral, followed by Bobby and Ted Kennedy.

Everyone settled down in their pews waiting for the Mass to begin, except John-John, who became restless and escaped into the aisle, where he was corralled and persuaded to rejoin the family.

Having made that last-minute picture, I focused on Cardinal Cushing of Boston, who said Mass in Latin. Mass ended and the casket was again placed on the black-draped caisson for the procession to Arlington Cemetery three miles away. I had to be there in advance, so again I traveled via the AP courier's motorcycle in my morning suit.

Of all the scores of pictures I made of this glorious but all too brief period of the U.S. presidency, the ones in Arlington Cemetery were the most humbling. Like the eternal flame burning atop John Fitzgerald Kennedy's grave, we shall long remember what happened here.

"Truly, the torch is passed."

CHAPTER VII *The Great Society*
 Lyndon B. Johnson, 1963-1969

The Great Society rests on abundance and liberty for all. It demands the end to poverty and racial injustice to which we are totally committed in our time. But that is just the beginning.

—Lyndon Baines Johnson, May 22, 1964, at the University of Michigan

The morning of his second day as president, LBJ was at work in his office in the Old Executive Office Building. He had not yet moved into the White House. I was one of the two wire service photographers waiting outside for anything significant to photograph. LBJ came out of his office, walked over to us, and said he needed our help. I believed he was sincere. He had just taken over an enormous job. But how we could help him I was not sure, except to cover all of his actions for everyone to see. We did just that.

The Johnson White House was as different from Kennedy's Camelot as Texas is from Massachusetts. The style of coverage changed to match the president's governing style.

The Johnson White House was a vibrant household. The entire Johnson family was in residence: LBJ, his wife, Lady Bird, and daughters Lynda Bird and Luci. There was no patter of little feet, but the comings and goings of two teenagers set a lively pace. The press, much to their frustration, reported their every move. Lady Bird had great charm.

Lady Bird Johnson, the mistress of the White House.

Lyndon B. Johnson was selected as the vice presidential candidate on the Kennedy ticket at the convention in Los Angeles on the first ballot. This was a strong political choice by John F. Kennedy. Texas, at the time, was a Democratic state. The reality of twenty-four votes in the Electoral College and twenty-two congressional representatives from Texas were strong reasons to select LBJ. Lady Bird may have urged LBJ to accept the nomination. She was concerned that his leadership in the Senate had been too strenuous for him after his heart attack.

Johnson was a formidable partner. He had been a congressman and a senator, and had risen to top leadership in the Senate. His history of "Hill" politics ran long and deep. He knew where all the skeletons were buried. His powers of persuasion and deal making were legendary.

Johnson's transition to the presidency was immediate and difficult. The nation was in mourning, but Johnson knew he had to move it forward. He was faced with a tremendous job of administration. Cabinet loyalties, of course, were to Kennedy. Initially he kept most of the key members of the cabinet because he respected them. Robert F. Kennedy had a key post in the government. Unfortunately, there was no love lost between him and Johnson. They both were aware of each other's great political talents. Therein was the problem. They were on a collision course of ambition for the presidency. As president, LBJ was in charge and could keep things from happening for Bobby Kennedy, which added to Bobby's resentment.

■ LEGISLATIVE AGENDA

Johnson gave his first major address on November 27, 1963, from the podium of the House before the joint session of Congress. He urged the country to move on. He outlined his resolve to implement the priorities of his predecessor. His address was well received.

JFK had proposed many bills: civil rights, help for the poor, and help for the old and infirm. Many have conjectured that without LBJ these bills and many more may not have become law.

Johnson jumped right in, getting his legislative agenda through Congress. He started immediately on his first priority, the Civil Rights Bill. He knew civil rights would bring the country politically, morally, and economically together. However, there was the fear that the South would be delivered to the Republicans. The Civil Rights Bill was passed on July 2, 1964. The Senate vote was 71 to 29. This incredible success was achieved because of his leadership, talent, persuasive powers, political skills, and desire to be a great president.

President Johnson signed the Civil Rights Bill in the East Room of the White House. It was an impressive ceremony. All of the cabinet and the key players who were instrumental in pushing the legislation through were on hand. Johnson had many pens on his desk. He used each briefly and then gave them as souvenirs to all congressional members who had anything to do with the Civil Rights Bill.

Lyndon Johnson was not relaxed with television at first. He was the first president to use teleprompters.

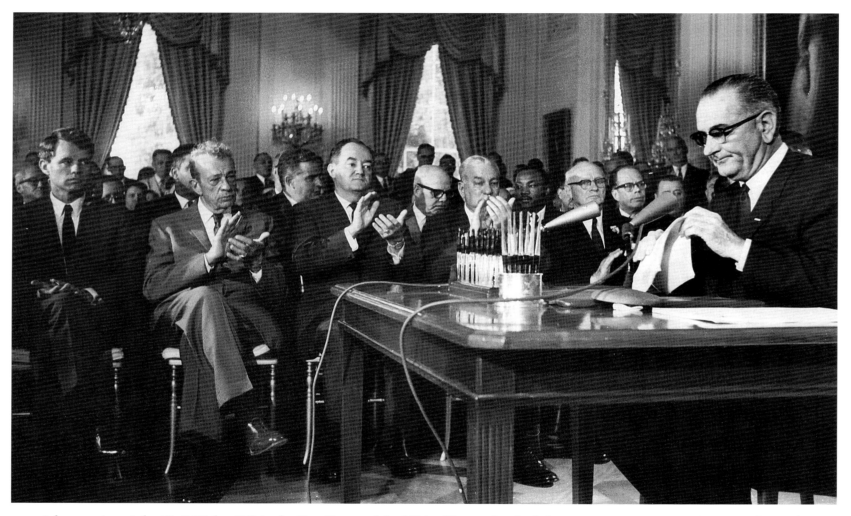

Johnson signed the Civil Rights Bill in the East Room of the White House. On the left is a very unresponsive Attorney General Robert Kennedy; next to him is Everett Dirkson, the leader of the Republicans in the Senate, Hubert Humphrey, the vice president, and Charlie Halleck, Republican leader in the House. In the next row between Humphrey and Halleck is George Meany, the president of AFL-CIO; next to him is Martin Luther King. Note the pens on the table. Johnson gave out many souvenir pens.

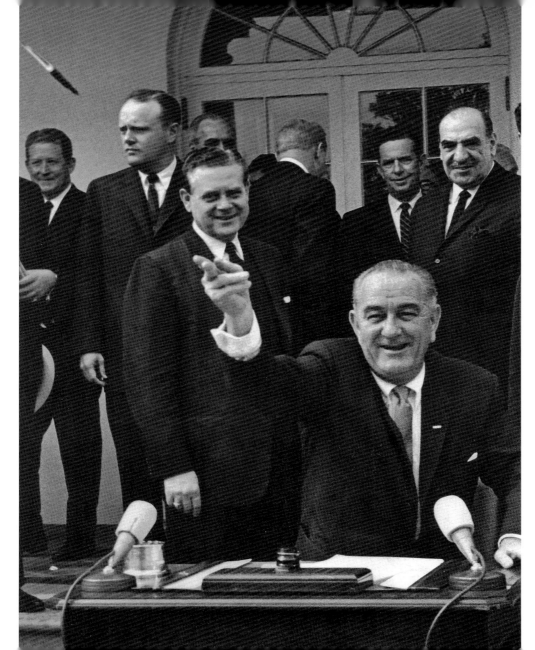

At a signing in the Rose Garden, Johnson saw a friend standing behind Burroughs somewhere, said, "Joe, you need a pen," and threw it to Joe.

The next piece of major legislation Johnson put forward was the Economic Opportunity Act. (This bill would provide a multifaceted approach to helping citizens break the grinding cycle of poverty through job training, help in finding work, and mentoring programs with local businessmen for budding entrepreneurs.) He chose to call the program aimed at helping through training and opportunity the War on Poverty, which would enhance the "Great Society."

His legislative agenda included voting rights, aid to education, Medicare, and many other items. Each bill signing was a special ceremony, always with the handing out of pens. In the Rose Garden he saw a friend standing behind me somewhere. He said, "Hey Joe, you need a pen?" and threw it to Joe who was just behind me. Johnson sent me a felt tip missile in the Rose Garden on that day. It was summertime and I was wearing a new seersucker suit. I said, "Thank you, Mr. President." I stuck the pen into my breast pocket and went on shooting. As I was walking back to the pressroom after the event I looked down at my jacket. There was a huge indelible ink stain that never came out. Thank you, Mr. President.

■ COVERING PRESIDENT JOHNSON

As a photographer, covering President Johnson was both interesting and unpredictable. He kept us all off balance. I always carried a packed bag, because we didn't know when he might want to fly to another city on a moment's notice. The Secret Service often was not alerted ahead of time either.

LBJ was not at ease with constant coverage at first. He was very picky about the pictures he didn't like. Bob Daugherty, one of the photojournalists on AP's Washington staff, told me a story about Johnson's vanity. I had been off for several days and Bob was covering the White House in my place. When I returned he told me that after the photo opportunity in the Oval Office was finished and Cleve Ryan, the lighting expert, turned off the lights, the president paused for a moment and asked who was the AP man on duty. Daugherty spoke up. Johnson shot back, "Were you the person who made the picture of me in the Baltimore Civic Center yesterday?" President Johnson had been in the civic center to promote the Democratic candidates in 1968. "It made me look like some sort of a ghoul." Bob, happy to escape the ire of LBJ, said, "No sir, Mr. President, that was Henry Burroughs and he is off today." The president's retort as he exited the room was, "You mess up one day, make a bad picture and they give you the next day off!" Actually it was a rather dramatic shot made from above—while making a point, LBJ had extended both of his arms.

Early in his career someone told him his left profile was his best side. He remembered this when he came to the White House. He would always have us on one side of the East Room when he held a press conference so we could only

shoot his left profile. During my first days covering Johnson at a press conference, I used to get into a fairly centered position. I shot a series of pictures of him raising his arms, gesturing with his hands, and there were facial grimaces, smiles, and so forth. He was very animated. The AP picked out what we call a combo of pictures showing both profiles and transmitted them. Papers all across the country used them. He discovered, well, maybe my right profile is not so bad after all. The mold was broken; we were now allowed to set up in any part of the room. In time he became very relaxed and was one of our most photographed presidents.

Many people thought that photographers were not respectful of the office of the presidency. Many objected to the picture that was published with Johnson's scar on his stomach exposed to the world after major abdominal surgery. This was not a "grabbed" shot of a paparazzi. Johnson actually wanted the picture taken. It happened on the lawn of the Bethesda Naval Hospital, as he was pushed in a wheelchair to his car. Suddenly, he whipped up his shirt to display his scar to the stunned photographers who made the picture. Then there are the pictures with his dogs. He picked up one dog by its ears, angering countless pet lovers. Another shot was with his two little beagles that usually rode in the front seat of his limousine. Johnson could order a lot of people around, but not these dogs. He was also having trouble getting them into the presidential helicopter. The famed Johnson treatment worked much better with people in his administration than with his dogs.

Lyndon Johnson, in his inimitable style, talked Arthur Goldberg out of his seat on the bench of the Supreme Court. He asked Goldberg to resign so he could be appointed as ambassador to the United Nations.* Goldberg did it out of duty to his country and loyalty to the president. Johnson's pitch was really hard-sell. "This is for the good of the nation. Your country needs you." Although Goldberg was ambassador for most of Johnson's time in the White House, he gave up being a judge for life on the Supreme Court.

There were always situations where the press photographers were not allowed anywhere near LBJ in the White House or on Air Force One. But pictures were taken by the official White House photographer, who just about lived with LBJ and took marvelous pictures. White House photographer Yoichi Okamoto would provide 11x14 prints every day to the president. Johnson himself would go through them and pick out the ones he wanted released, but many never saw the light of day. He was editing his pictures that were handed out by the White House as official pictures. LBJ learned the power of a good picture. For example, Jimmy Durante, an entertainer, made a rare visit to the White House with a little Korean orphan, a poster child. The cute little boy was obviously intrigued with Durante's famous "schnazola." In the old days there was no such thing as a White House photo handout. We took the pictures and we chose which pictures to use.

* Adlai Stevenson, our former United Nations ambassador, died in 1965, leaving a vacancy at the UN.

President Johnson took his pet beagles with him everywhere. He is encouraging one of the dogs to get in his helicopter. The dogs hated to ride in the noisy machine.

President and Mrs. Johnson at the memorial service for Adlai Stevenson at the Washington National Cathedral, July 16, 1965.

Button-nosed four-year-old Alan Nagao, the National Easter Seal child, reaches for the obvious, famous nose of comedian Jimmy Durante. The nose-clutching episode took place at the White House where Alan, of Honolulu, presented a sheet of 1966 seals to the president. Durante was the national chairman of the Society for Crippled Children and Adults.

But when LBJ got his own photographer, Okamoto, who took and released the pictures to the wire services, the ball game changed on photo coverage.

Johnson was not as comfortable with TV as JFK. But TV was a fact of life. He was the first president to use the newly devised glass teleprompter. There was one on each side of the podium when he gave a speech. It was all a part of a learning process and he quickly became very professional.

One of the biggest international news stories in 1964 was Pope Paul VI's visit to the Holy Land. It was the first trip for a pope outside of Italy since 1809, and the first time a pope had traveled by air. Covering the two-day visit from January 4 to 6 sticks in my mind as one of the most incredible events I covered from a logistical point of view. There was a near hysterical crowd surging around the pope every moment; there were hundreds of media people, probably three times as many police, Arab bodyguards, and army personnel. The Palestinians and Israelis were at war. Hal Buell of the AP New York staff had been sent before Christmas to make the complicated arrangements for coverage by AP photographers, their movements from place to place, and dispatching their pictures to the world. I arrived at the old city of Jerusalem and was supposed to follow the Pope through the city. I took one picture of him coming through the Damascus Gate and then an overzealous Arab bodyguard chunked me in the chest with his rifle butt and I went sprawling. That was the last picture I made of the Pope in the city of Jerusalem. My next assignment was to go to Galilee and be in place before the Pope's arrival. The arrangements were like a Hollywood movie. I caught a small plane similar to a Piper Cub outside of Jerusalem to Galilee. I had all of my gear and had to beat the Pope to his very short stop. The plane was to fly me to a small farm with a barn, and a car would be waiting at the barn to take me to an appointed spot. I thought this would never work. But the car was there and I rushed over, jumped inside, and drove to the Sea of Galilee to see the Pope arrive. Mission accomplished.

Sergeant Shriver, en route to India as the Peace Corps director, stopped in Jerusalem to deliver a letter from President Johnson to the Pope. LBJ invited the Pope to come to the United States and proposed a future meeting with him. The next year on October 4, 1965, Pope Paul VI visited New York. He was the first pontiff to visit the Western Hemisphere. In the morning he addressed the United Nations and made an urgent appeal for peace. In the afternoon he had an historic meeting with President Johnson at the Waldorf Astoria Hotel. The day ended with a Mass at Yankee Stadium with ninety thousand spectators.

President Johnson Continued the Space Program Started by President Kennedy

My last space odyssey while Kennedy was still president was with *Gemini 6.* I was on the aircraft carrier USS *Wasp,* the primary recovery ship for the splashdown of the historic

President Lyndon B. Johnson escorts Pope Paul VI outside the Waldorf Towers in New York on October 4, 1965, following their historic meeting. The spiritual and temporal leaders conferred for fifty minutes in the presidential suite.

The Pope celebrated Mass at Yankee Stadium in the evening with more than ninety thousand spectators.

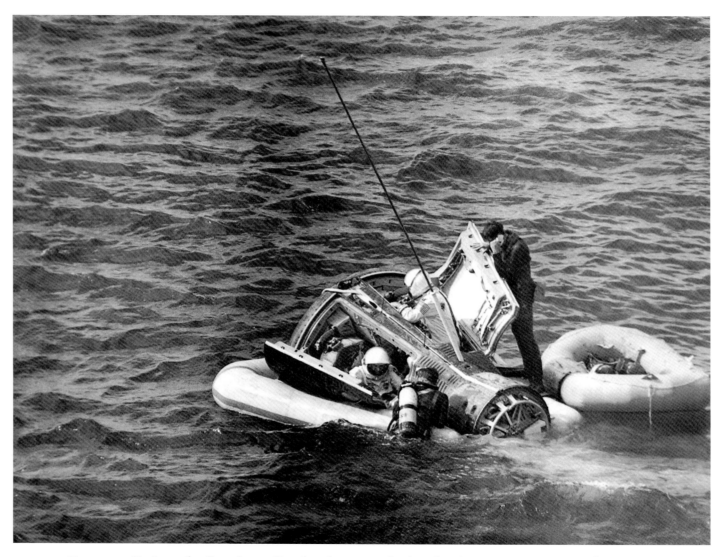

Frogmen climb on the flotation collar they have attached to the *Gemini 6* spacecraft in the Atlantic after it splashed down about twelve miles from the carrier *Wasp* in a perfect reentry after the historic rendezvous with *Gemini 7*. Walter Schirra and Thomas Stafford were in the capsule.

flight of *Gemini 6* after its rendezvous in space with *Gemini 7* on December 16, 1965. I had my longest lens ready to record the breakthrough in the clouds and the splashdown into the Atlantic. Unfortunately, it came down at 10:29 a.m. about fifteen miles from the *WASP*, but we overtook the capsule and hoisted it aboard one hour and three minutes later. My only role was to give one of the frogmen my underwater camera to get a picture at the watery landing site with the astronauts emerging. The crew—Walter Schirra, who was on the Mercury's sixth flight, and Thomas Stafford—were treated royally aboard the aircraft carrier that evening. They slept in the captain's cabin and departed the next day for Cape Kennedy via Bermuda.

Working Style

LBJ could be blustery or gentle in personal dealings with everyone from photographers to cabinet members. He was often very earthy in his comments. At a press conference early in his presidency he was asked when he was going to fire J. Edgar Hoover, director of the Federal Bureau of Investigation, since he said it was one of the first things he was going to do as president. "Well," he responded, "I think it is better to have him on the inside of the tent pissing out, than on the outside of the tent pissing in."

Daily briefings with his press secretary, George Reedy, were often interesting, and it became evident that the president was listening in on the briefings, as well as the questions and answers. The phone on the press secretary's desk often rang after a particularly difficult topic or policy statement. The briefing would then continue right after the press secretary delivered the comments he received from LBJ's phone call.

Johnson ate up press secretaries and other advisers. He could be vindictive if displeased. Frank Cormier, the senior reporter for the AP who covered the White House, wrote a piece to which the president took umbrage. Johnson held a grudge, but felt he knew a way to get even with this upstart reporter. At Christmas, Johnson had gold tie pins packaged and delivered by a White House limousine to each of the reporters and photographers who covered the White House and those who covered his campaign.

Frank's beautifully decorated box was delivered to his home. But his was different from the rest—there was no tie pin enclosed. Everyone began wearing his Christmas gift to the White House. George Reedy, who knew about the omission, asked Frank why he didn't wear his pin. Frank hadn't complained, and that had upset the president's small plot. Frank simply said he hadn't gotten one. So the press secretary took his pin off and gave it to Cormier.

President Johnson would periodically go on the wagon. One particular hot day Air Force One was returning from a series of stops and speeches. He settled down and invited some of the press up to his compartment. Any drink was available. The president asked for diet root beer, drank it

down without a pause and asked for another that was delivered. Then came his call for a third. The steward arrived to announce that there was no more diet root beer, but listed all of the other diet drinks available. LBJ roared, "Sergeant, this is an order from your president: I want there to be diet root beer on Air Force One at all times and that it be stocked in military airfields around the world!" The root beer may still be there to the bewilderment of current commanders.

On another day, when LBJ was off the wagon, he relaxed with several bourbons during a long trip back to Washington. Landing at Andrews Air Force Base there were the usual three helicopters waiting for Air Force One: the president's helicopter was first, the second was for staff, and the third for the press. It was dark when he deplaned to be flown back to the White House. In his mellow state, the president passed the first chopper and climbed the stairs of the second. A Marine sergeant saluted his commander-in-chief and said, "I beg your pardon, Mr. President, this is not your helicopter." The president indignantly reminded the Marine with a sweeping gesture, "Son, they are ALL my helicopters."

Johnson won his party's nomination for president at the convention in Atlantic City in 1964. He chose Hubert Humphrey, a liberal senator from Minnesota, as his running mate. Johnson had achieved great popularity in less than a year because he continued Kennedy's programs and was supported by the vast majority of Americans. He had made sure significant legislation was passed. The Republicans nominated Senator Barry Goldwater from Arizona, an ultraconservative. His running mate was William E. Miller, a congressman from upstate New York.

Minutes before Goldwater was nominated as the Republican candidate, Governor William Scranton of Pennsylvania lost his bid as presidential candidate. I took a picture of his children crying when they heard the news at the convention—a heartbreaking moment for his family. The Associated Press Managing Editors selected this picture for the first annual staff award for excellence.

The Associated Press president, Wes Gallagher, had recently issued an order that staff could no longer fly first class. Apparently, the Washington office had not yet received the directive, so I flew first class both ways to the Managing Editors' meeting at the University of Missouri School of Journalism to accept my award. On the way back, I was seated next to Ambassador John Kenneth Galbraith, who had spoken at the convention. I met him when he was ambassador to India while Jackie Kennedy toured the country. We had a lively and fascinating conversation flying back to Washington. Wes Gallagher, properly abiding by his new rules, was sitting in the coach section. For a moment, I thought it might be the right thing to offer to exchange seats, but my personal enjoyment won out. I was having too good a time talking with Ambassador Galbraith.

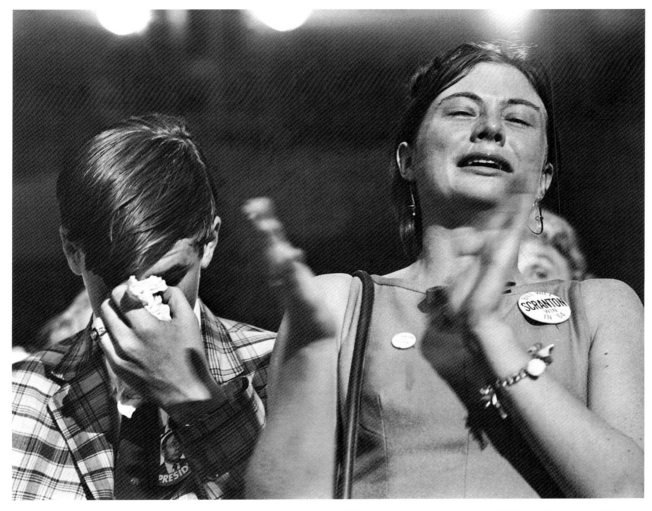

It was a heartbreaking night for the son and daughter of Pennsylvania Governor William Scranton. Minutes before Barry Goldwater was nominated as Republican candidate in 1964, Governor Scranton lost his bid.

Some people called it a political campaign, but Washington news photographers called it an endurance contest. It might have been tough on the candidates, but it was tougher on the newsmen who tagged along.

Once I overheard a lady asking a photographer about all the interesting mementos he must have collected on the campaign. "You call 'em mementos, I call 'em grim reminders," he replied.

There are bureau drawers full of these mementos—silver and gold pins, badges, and buttons. If you kept score, Goldwater won hands down. It was more like a jewelers' convention the way the Goldwater staff handed out gold and silver lapel pins used for identification for access to the Goldwater Special Boeing 727.

The frugal LBJ camp used the usual White House baggage tag for identification. But the president made up for that after the election by presenting campaigning newsmen with a solid gold tie clasp at Christmas.

A photographer had to work in a political campaign to get the full flavor of the challenges involved, which included crowds, police, too many other photographers, too cold at the one stop, too hot at the next, or pouring rain when you don't have your raincoat.

With all the battles there were plenty of laughs too. In Springfield, Illinois, AP's Bill Smith found himself restrained rather forcefully by an adamant policeman. Bill reasoned with him to no avail. Finally, in desperation, he said, "Turn around will ya', the president wants to talk to you." "OK buddy, that's enough of that, get back now," replied the officer. Bill persisted, "Look, the president of the United States wants you."

The policeman turned three shades of red when he turned to discover President Johnson pointing at him. The president was shouting, "Leave him alone, I brought him along to make pictures. That's not a gun he's carrying—it's a camera." The officer swallowed hard, the president smiled, and Bill Smith was released for the Great Society.

There was another first in Hartford, Connecticut, when President Johnson invited photographers to ride the Secret Service car, the "Queen Mary," to get better pictures. At one point in the motorcade, an impartial observer counted twenty-seven people riding the "Queen." Some of them must have been Secret Service.

The president, who was always very picture-conscious, became even more so during the campaign. In Providence, Rhode Island, the photographers rode in the car of Rear Admiral George G. Berkley, the president's personal physician, to get better shooting positions. The car caught fire and photographers jumped out while others photographed them jumping out. The pictures got wide play, overshadowing photos of the president, who that day had drawn some of the largest crowds of the campaign. LBJ caught the photogra-

phers the next day and scolded them good-naturedly. "If you want to take pictures of each other you ought to have a family picnic," he said.

The stories about the Goldwater campaign plane listing to starboard are true. The gag caught on early in the game when a photographer hung his forgotten hotel key on the starboard bulkhead with a paper clip. Other newsmen began adding to the collection. At every overnight stop a few more keys would appear until there were hundreds, all on the now-listing starboard side. At the end of the campaign, UPI's Frank Cancellare, who didn't miss a single day of the tour, gathered the keys and dropped them in the mailbox.

Photographers traveling with LBJ did take pictures of each other, but the lens men traveling with Goldwater were surprised one day to discover themselves on the receiving end of the candidate's camera. At every turn in the motorcade, the senator would lean out of the door of his car with a telephoto lens and shoot a couple of pictures of the overloaded photo car. Naturally, the photographers retaliated with a battery of shots at the candidate.

Out in San Francisco, Frank Cancellare had a run-in with Christopher Columbus. It happened at a Columbus Day observance with Goldwater as the main speaker. Frank was leading a group of traveling photographers onto the speakers' platform when he reached an impasse. "Come on, Frank, let's get through." Frank whispered back, "but this guy in front of me won't move." Then he discovered who the guy was. It was the life-size statue of Christopher Columbus from the local wax museum. The logjam was broken as the press rushed past Christopher.

HUBERT HUMPHREY'S TRIP TO SOUTHEAST ASIA

Vice President Hubert H. Humphrey was sent on an extensive trip to visit nine countries in Southeast Asia in February 1966. There was just a handful of press on the trip. Jack Valenti, a special assistant to the president, was in charge of all arrangements for the vice president on this trip. The president had just concluded a conference in Honolulu with President Nguyen Cao Ky of South Vietnam, and most of the press corps accompanied LBJ back to the mainland. We were finishing our packing, trying to get some last-minute shopping done, caught in that pre–press plane departure bind. Before taking off for Washington a few of us got the word that we would go with Humphrey on a trip to Southeast Asia. The dirty clothes in our suitcase were only part of the problem. We had no passports, and many needed shots. Temporary passports were issued and a five-man medical team started a production line for shots in a suite at the Royal Hawaiian Hotel in Honolulu. It looked like induction day at Fort Meade.

The next morning we were on our way to Saigon. We made a short stop at Guam for fuel, tea, cookies, and more shots. My biggest thrill on this trip was our first stop, which was at

an Air Force base in Udorn, Thailand. I knew my brother, Dave, a captain in the Air Force, was stationed there. I told the vice president and he had Jack Valenti handle logistics for this stop. We had to stop at Udorn to change to a smaller plane. Air Force Two was too large to land at the next airport in Vietnam; the airstrip wasn't long enough. The Udorn stop would be a brief one of twenty minutes. Valenti called ahead to the base with orders for my brother to be on the tarmac at a certain time. I'm forever grateful that Dave was not flying a mission that day. As our plane came to a stop, I could see a lone figure, my brother, standing there with no idea why. Everyone on the plane insisted that I deplane first. Dave was stunned when he saw me. We had a brief but wonderful twenty-minute visit. Dave flew RF-101 jets. Humphrey was very interested in his reconnaissance flights. Dave wrote me right after our short meeting and said the base commander called him on the carpet as soon as we took off. He wanted to know why Dave was out visiting with the vice president and he wasn't invited. Dave said, "Well, I didn't go out there to see the vice president. I was there to visit my brother who was traveling with Mr. Humphrey." The poor base commander thought someone was undercutting him and that he might be replaced. On July 31, 1966, my brother was shot down and captured by the North Vietnamese. He spent six and a half years as a prisoner of war. Dave died in March 1999 at age sixty-six. His health had deteriorated in the POW camp, which may have led to his early death.

We were in Saigon three days and worked under some of the strangest conditions I've ever seen. We toured all over, seeing U.S. installations, chatting with GIs, and getting a fill-in on the war. We did most of our traveling by helicopter, never knowing where we were headed when we took off. The security was that tight.

Actually, we felt a lot safer in the choppers flown by Americans than we did riding in Saigon taxis. Traffic there was some of the worst I'd ever seen. They didn't bother with traffic rules or laws, and the longer you rode the less your odds of survival were. Aside from the wild car driving you had to contend with an incredible number of bicycles and carts. Most seemed totally unaware of the vehicles around them.

Next we went to Bangkok, Thailand, the city of Buddhist temples. We took an early morning boat ride on the Chao Phraya River, which carried us through the famous floating market and ended at one of the magnificent temples for a tour. "Boat ride" is hardly the proper description. It was more like a flotilla of motorboats on maneuvers with the vice president's boat leading the pack. One of the pursuing boats, top-heavy with photographers perched on the roof, almost capsized. But everyone got pictures. Even the vice president took shots of the press boat with a Kodak. Later in the trip when we saw his pictures, I said, "Don't worry, men, your jobs are secure."

The visit to the temple made an exciting game. The object was to get a picture of the vice president without another

On a trip to Southeast Asia, Vice President Hubert Humphrey stopped at Udorn Air Base in Thailand for twenty minutes to change planes because the airport at Vietnam's runway was too short for Air Force Two. Henry Burroughs' brother, Dave Burroughs, was stationed at Udorn. Humphrey arranged for the brothers to meet when the plane landed.

photographer in it. Nobody won. From Bangkok we headed for Vientiane, the capital of Laos. The vice president was greeted by beautiful girls offering baskets of flowers. We were there just four hours.

All in all we flew some forty-three thousand miles on the trip. The picture opportunities were good and everyone got his share of top ones. We were kept hopping all the way but even so there was time for a swim in Karachi, Pakistan, to clean off two bushels of Punjab farm dirt from India; to get lost in New Delhi; to drink the finest draught beer in Canberra, Australia; to drive two hours through magnificent New Zealand scenery; to smoke Philippine cigars and attend a final lavish press party in Seoul, South Korea.

THE WHITE HOUSE WEDDINGS

The White House provided a regal backdrop for two joyous events in the Johnson household. President and Mrs. Johnson's two lovely daughters, Lynda Bird and Luci, were married. These were the first weddings in the White House of an incumbent president's family since Eleanor Wilson in 1914. Luci married Patrick Nugent in 1966, at Washington's Shrine of the Immaculate Conception, followed by a reception at the White House with seven hundred guests. One news report said no one was invited but the immediate coun-try. She presented her parents with their first grandson, Patrick Lyndon Nugent, in 1967. Lynda was married in December 1967 to Captain Charles S. Robb, a U.S. Marine officer assigned as a social aide to the White House. The wedding and reception were at the White House. They had a daughter, Lucinda Desha Robb, just three months before the Johnsons left Washington. These events were probably the most delightful memories Lady Bird has of the White House.

LBJ IN SOUTHEAST ASIA

LBJ and Mrs. Johnson traveled to Southeast Asia in the fall of 1966. It was a whirlwind trip with state visits to Australia, New Zealand, Thailand, the Philippines, Malaysia, Korea, and a visit to the armed forces in Vietnam. A summit conference in the Philippines was attended by leaders from all of these Southeast Asian nations. The president and Imelda Marcos, wife of Philippines President Ferdinand E. Marcos, were cordial hosts to this prestigious gathering. Saturday night they entertained at a grand banquet. LBJ was enjoying the company of his dinner partner, Imelda Marcos, and he asked her to dance. He was considered the best dancer in Washington. He held her very close and moved his hand up and down her back. Lady Bird partnered with President Marcos for the dance. She whispered into his ear and shortly

thereafter President Marcos cut in on LBJ. The Marcoses danced off together and Lyndon waltzed around the room very sedately with his wife for the rest of the evening.

When my wife, Peg, and I were on a personal trip to Southeast Asia in 1995, we stopped in Kuala Lumpur, Malaysia. We visited friends, Colonel and Mrs. Patrick Caldwell and their children, Nicholas and Alison. He was the U.S. Air attaché to Malaysia.

The Caldwells asked me if I would bring my slide show, Moments In History. They had seen the show before they left for Malaysia. It covers my career in news photography. I was happy to oblige. They had been out of the country for several years and I thought they might invite a few friends before dinner one evening to see the pictures. Instead, it became a gala event at the embassy and the entire international community in Kuala Lumpur was invited. It was an extremely receptive audience and I enjoyed their questions and enthusiasm.

I was stunned at the difference less than thirty years could make to the city. I don't know why I should have been though. Southeast Asia had been growing and prospering, like many European cities, and I could not even find the core or the old character of colonial Kuala Lumpur. The building and expansion were mind-boggling. Office buildings and apartments were new, all skyscrapers and innovative in design. The highest building in the world was there. The city swarmed with people walking and riding many different types of bikes—some motorized and some propelled by manpower. There were many automobiles and traffic jams were everywhere. If someone had given me a car I would have refused. In countries settled by the British, motorists drive on the left side of the street, and every driver is overly aggressive, almost suicidal. Pat Caldwell, trained as a fighter pilot, handled the driving with great gusto.

LBJ's Ranch

Every president has a favorite White House "getaway" . . . Lyndon Johnson went to Camp David occasionally, but his real getaway was the LBJ ranch. His roots were in the Texas hill country and he went there as often as he could. It had always been a great family gathering place. The LBJ ranch was a real working ranch, where he raised white-faced Hereford cattle. When he flew down to Texas he took several secretaries and they worked all the way down on the plane. All of his administrative problems followed him, but few of the interruptions did. In Washington, there was always a parade of ambassadors, college presidents, constituents, legislators, and multiple requests for pictures with the president, from the crippled poster child to a winning ball team from a small town in the Midwest. Johnson said he could do four days'

worth of work at the ranch in two days. The Johnsons also entertained there. LBJ was a cordial and affable host and often included the press. I remember on one afternoon he took a few young ladies for a ride in his new toy, an amphibious car, to the Pedernales River on the ranch. This car was developed as a novelty to drive on land and cruise on water like a small powerboat. I don't know where else they were popular, but a few were seen cruising the Potomac River near the Washington airport. LBJ had to have one for his ranch. He and his passengers slowly drove down the incline to the river's edge and into the Pedernales. There was lots of squealing and excitement. It was well called for because the president, who was driving, had forgotten to close the seacocks on the car to make it seaworthy. It began to take on water and appeared to be sinking. The passengers were hysterical, shouting to be rescued, and the Secret Service men were wild with concern for the president. Luckily the river was not very deep and the president, the guests, and the car were saved. This was a not-to-be-forgotten cruise. I never saw the amphibious car again!

LADY BIRD'S BEAUTIFICATION PROGRAM

A very important cause taken up by Lady Bird Johnson was the beautification of America's parks, cities, and highways. Her husband supported her totally. A highway beautification act was passed in September 1965. Following this, Stewart Udall, secretary of the interior, escorted the first lady on a trip to the western part of the country later in September. There was a dedication of Port Reyes National Seashore, Big Sur Scenic Highway, and a visit to the Hearst Castle in California. The Glen Canyon Dam in Page, Arizona, was dedicated, and finally there was a tour of San Ildefonso Pueblo in New Mexico.

The Hearst Castle was the most memorable for me. The organizers of the trip planned an elegant dinner for our small party—Lady Bird, the officials, and the press—after all of the hundreds of tourists left for the day. It was a revelation to see and enjoy briefly famous publisher William Hearst's lifestyle. The setting was stunning. The table was positioned by a shimmering pool surrounded by columns. It was set with linens, china, and silver. The whole area was lit with candles. I don't recall what was served, but it was presented in a grand fashion.

In Washington, D.C., Lady Bird dedicated many parks, and there were special tree plantings as well as flowering bushes and seasonal flowers. One day I joined a very small group on a tour of these beautification projects. It was a lovely day. We had a picnic lunch sitting on the shore of the Potomac River. There were three photographers and one reporter, Liz Carpenter, Lady Bird's press secretary, the chief of the U.S. Park Service, and Nash Castro. Lady Bird was absolutely ebullient. We wondered why she was so upbeat. Well, we found out later that this was the day that she had gotten the word from LBJ

Mrs. Lyndon Johnson sits on the lawn between the Potomac River and a field of daffodils during a break on a tour of blooming flowers in parks in Washington, D.C. Nash Castro of the National Park Service is with her.

Solicitor General Thurgood Marshall stands behind President Johnson at the White House on June 13, 1967, as the chief executive announces he is nominating Marshall to serve on the U.S. Supreme Court.

that he would not run for another term. She was delighted. She had been trying to convince him to bow out. Of course she was the only one who knew that day. He made the announcement himself later on television. Lady Bird knew the war had had a corrosive effect on LBJ. She also knew that he knew he could not win this war.

Protests against the war in Vietnam were building. They were originally led by students, liberal activists, and religious groups who were morally opposed to the war. The demonstrations were peaceful in the beginning but they became very large and unruly in many cities and on college campuses. Young men were burning their draft cards. Some went to jail, others went to Canada or Sweden, or to grad school, to escape the draft. As the war escalated, so too did the antiwar marches. There were big demonstrations, rioting, and much civil disobedience. Burgeoning race riots were causing much havoc and unrest also. The country was unhappily divided.

LBJ enjoyed being president, but bad advice, his own stubbornness, and mounting national unrest caused by Vietnam finally destroyed him as president. It was a tragedy. He knew he could not run again.

President and Mrs. Lyndon Baines Johnson left Washington, D.C., right after Richard Nixon was sworn in as the new president of the United States on January 20, 1969. The Johnsons flew back to Texas and led a quiet life at their ranch.

I shall not seek, and I will not accept, the nomination of my party for another term as your president.

–*Lyndon Baines Johnson, March 31, 1968*

Chapter VIII *Vietnam and a Nation's Agony*
Richard M. Nixon, 1969-1974

Peace does not come through wishing for it. There is no substitution for days and even years of patient and prolonged diplomacy.

—Richard Milhous Nixon, Inaugural Address, January 20, 1969

Nixon as Vice President

I first covered Richard Nixon when he was the vice president during President Eisenhower's first term. He was delegated to represent the White House on trips overseas where the mission was goodwill rather than high-level diplomacy.

I made a fascinating and extensive trip with Nixon to Africa in 1957. We visited nine countries: Morocco, Ghana, Liberia, Uganda, Ethiopia, Sudan, Libya, Rome, and Tunisia. The most newsworthy story of the entire trip was the celebration of the newly independent nation of Ghana, formerly called the Gold Coast or Togo land, on the west coast of Africa. It had been a part of the British Empire. On March 6, 1957, it became a self-governing country and a member of the British Commonwealth. My office requested, by wire, certain pictures in particular—the Duchess of Kent, who represented the Queen, and Kwane

Nkrumah, the leader of the new nation of Ghana. I was pleased when a wire came saying, "New York advised we were ahead competitively."

The trip to Africa lasted three and a half weeks. Logistics were complicated because we were on the move constantly. I could get radio prints out of a few cities; they had to be sent either to Rome or London, where they were relayed to New York. The bulk of the negatives were sent by air freight. I was given a detailed schedule of the flights from each country we visited. I usually had a backup person, a local stringer, to help with filing the film and to fill in when necessary.

We were off to a grand start in Casablanca, Morocco, with a welcoming banquet in honor of the vice president hosted by Governor Ahmed Bargash. A national honor guard greeted us at many airports. The colorful local tribes' dress added a festive note, business attire was worn at most ceremonies, and some events in Ethiopia, Ghana, and Liberia were white tie.

The agenda each day was full: visiting schools, hospitals, and local industries and laying wreaths at memorials. In two countries Nixon presented naval ships to his hosts. Two Coast Guard cutters were given to President William U. S. Tubman in Liberia. It was announced that a new naval patrol ship would be delivered to Ethiopia in the spring of 1957 and another one the following year.

The vice president gave everyone in the press who accompanied him and Mrs. Nixon a framed citation that read:

The Vice President's Safari
To
Africa—1957
To Whom It May Concern
Henry Burroughs
Accompanied Mrs. Nixon and me on our
Safari to Africa, February 29 to March 21, 1957.
He displayed great stamina in traveling 20,000 miles by air, 1,700 kilometers by surface and the distance it takes to wear out two pair of shoes by foot. He revealed a joyous liking for such delectable dishes as cous cous, banded pigeons, small chop, and brik; demonstrated impounding patience over misplaced luggage, lost laundry, engine trouble, strange languages, frequent encounters with African practitioners of American "hot rod" tactics, and responded with true American friendliness to the tribal honors of numerous Paramount Chieftains. Although not greatly adept at carrying heavy loads (physical, that is), he showed commendable ingenuity in dangling from his frame varied luggage containers, attaché case, typewriter cases, camera equipment and gadgets, and additional articles of African memorabilia. Throughout this arduous Safari, he maintained himself in the peak of physical condition and returned with a glow, not all of which resulted from frequent exposures to flash bulbs, unscratched and undaunted, he is thereby saluted, cited, certified, and authorized to talk, lecture, write, and indulge in appropriate hyperbole about any and all subjects in the vaguest way connected with this African Safari: and to collect there from any and all perquisites, kudos and emoluments. I recommend him for future service on a similar Safari, or for such more menial employment as a diplomat, newspaperman, or a vice president.
Richard Nixon
(With the seal of the vice president affixed)

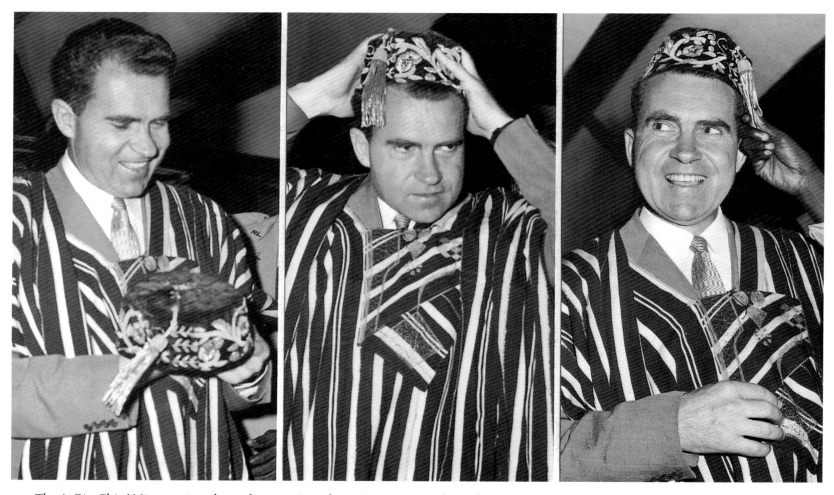

That's Big Chief Nixon going through a tassel on the left or tassel on the right routine in Monrovia, capital city of Liberia. The vice president donned the colorful robes of office after being named an honorary chief of the tribe in Liberia during a visit on a tour of Africa.

The Duchess of Kent represented the Queen of England when Ghana, a part of the British Empire, became self-governing on March 6, 1957. She is with Kwane Nkrumah, the leader of the new nation.

Cuba's Fidel Castro reaches over the heads of well-wishers to shake the hands extended to him after his arrival at National Airport in Washington, D.C., on April 15, 1959. The thirty-two-year-old Cuban prime minister was given an ovation by about two hundred sympathizers who crowded around the plane. It was an unofficial visit to the United States.

Nixon earned respect when he stepped in to carry on during Ike's illnesses—a heart attack in 1955, an ileitis attack in 1956, and a minor stroke in 1957. With the concurrence of the cabinet and the security council the government under Nixon during these days ran smoothly.

In April 1959, Nixon met with Fidel Castro in Washington. This was just three months before Castro led a successful revolution in Cuba ousting the cruel, corrupt dictator, Fulgencio Batista y Zaldívar. Castro asked to meet Eisenhower, but Ike went out of town and assigned the task to Nixon. It was a three-hour meeting. Castro did not ask for money even though everyone knew Batista had looted the Cuban treasury. The meeting ended and the pair emerged together with their arms around each other's shoulders. Nixon said, "We are going to work with this man." However, no funds were provided. Nixon suggested that Castro meet with him in six months. Eisenhower said to check the situation in a year. Cuba was desperate so Castro turned to the Soviet Union for monetary and technical help.

Nixon prided himself on his knowledge of international affairs. In July 1959, he was scheduled to go to Moscow on a cultural exchange representing the United States by opening the art exhibit displaying American products. He wanted to be properly prepared, so he studied all the reports and information available on Khrushchev and consulted allies, politicians, and those in the news media who had interviewed him. The State Department and the CIA briefed him. He took a crash course in everyday Russian. Nixon was not told until the eve of his departure that plans were under way for the premier's visit to the United States, but was told that when he was in Russia he was not to mention it. Ike never considered Nixon a close political adviser or a statesman and slighted him in many ways during both terms. He was often not briefed on state business or political plans. On Nixon's return from Russia, he wrote a report with recommendations on how to treat Khrushchev in America. The report was either ignored or countermanded.

BACKGROUND

Nixon studied hard. In college he joined the glee club, the drama club, and the debating team, was elected to the student council, and played freshman football. Richard Nixon and Lyndon B. Johnson had parallels in their political careers—both were congressmen, senators, vice president, and finally president. Nixon was determined to succeed and make his mark in the world.

Nixon met his wife, Pat, a schoolteacher, when trying out for a play. It was love at first sight for him, but she was cool at first. But, like other important things in his life, when he set his cap for something or someone, he would not be deterred until he reached his goal. Pat Nixon was a very sweet, charming, and long-suffering woman. I don't think she ever

enjoyed being a political wife, especially as first lady. But she was a good soldier, and through thick and thin she was always there in her supportive role.

From his early days Nixon was uncomfortable socializing. This lack of ease with people followed him throughout his life, but he worked hard to overcome his shyness. I watched him greeting people at a White House reception. He memorized an appropriate comment to make to each guest. The only time I saw him relax was when he visited his friend Bebe Rebozo in Key Biscayne, Florida. In a spontaneous burst of musical joy, he sat down at a piano and played with much spirit. He was a talented musician. He took music lessons and became skilled in the violin, saxophone, clarinet, and accordion. He, like Harry Truman, said that he had often thought of music as a career instead of politics.

POLITICAL DEFEATS AND RETURN

Nixon suffered two devastating political defeats. In 1960, with Henry Cabot Lodge as his running mate, he lost the presidential race to John Kennedy, and in 1962 he lost the California governor's race to Edmund (Pat) Brown. The presidential election was very close and there were concerns from the Republican Party that there were voting irregularities in several areas of the country. Nixon had a legitimate and compelling reason to ask for a recount. Kennedy received 49.71 percent of the vote, while Nixon got 49.55 percent. He did not bend to his party, who felt he should have asked for a recount. He knew that if he lost a recount, he would be considered a sore loser. Nixon also had the future in mind.

The swearing-in ceremony for Kennedy must have been a bitter pill for Nixon to swallow. He was sitting next to Eisenhower, who never cared for him nor helped him in his bid for the presidency, and Kennedy was the man who with Lyndon Johnson had defeated him.

After his defeat in California, Nixon moved to New York to practice law. John Mitchell was a law partner in the firm Mudge, Rose, Guthrie, and Alexander. Nixon later appointed Mitchell as his attorney general. Nixon continued to keep himself in the public eye. He campaigned for candidates and spoke at fund rallies. He traveled extensively overseas to educate himself in foreign affairs and developed international skills. He was putting himself in position to run for president again.

The 1968 Republican presidential convention was held in Miami Beach, Florida. There were several powerful men jockeying for the coveted prize of presidential nominee—Nelson Rockefeller of New York; George Romney of Michigan; and Richard M. Nixon. Nixon got the nod from his party; he selected Spiro T. Agnew, the governor of Maryland, as his vice presidential running mate over Rockefeller, a Republican liberal. Agnew was a far-right conservative.

Liberty City, a black ghetto in Miami, sent their community council to the Republican convention in Miami Beach to

Nixon at the piano in Bebe Rebozo's home in Key Biscayne, Florida. It was a spontaneous burst of musical joy.

plead their grievances and was forcibly turned back. Liberty City erupted into a bottle-throwing, shouting, shoving, and heckling mob. Buildings were burned. The police responded by gassing the rioters, arresting scores of people, and many were wounded. The press considered Miami a minor disturbance. At the Democratic convention in Chicago, demonstrators camped out around the convention hall protesting everything they considered wrong with the country: civil rights, Vietnam, poverty, the establishment, and the environment. The media reported that the throngs of protesting students trying to crash the gates were out of control. On my way to the convention hall to do my job covering the activities there, I was gassed along with everyone and anyone outside the building. Many were arrested and some were jailed.

Through it all the business of the convention proceeded. Hubert Humphrey, Johnson's vice president, was the heir apparent and was nominated for the presidency. He selected Edmund Muskie of Maine as the vice presidential nominee. George Wallace, governor of Alabama, ran as a third-party candidate with General Curtis LeMay as his vice presidential running mate. Wallace was a conservative Democrat who supported the Vietnam War.

It was a close election. Nixon won only 43.4 percent of the popular vote but received 301 electoral votes, to Humphrey's 191 and Wallace's 46.

The inaugural at noon on January 26, 1969, was a bitingly cold day in Washington. A temporary canopy was erected on the Capitol portico for the swearing-in ceremony. Pat Nixon wore a rose-red coat and fur hat. She held two family Bibles dating back to the nineteenth century. Chief Justice Earl Warren, who was no friend, administered the oath of office. Evangelist Billy Graham offered a prayer. Nixon was now officially the thirty-seventh president of the United States. His inaugural address was seventeen minutes long. He stressed winding up the war in Vietnam, ending the Cold War, and bringing a divided nation together. The Bibles were opened to Isaiah 2:4, " . . . beating swords to plowshares . . . " The keystone sentence was a Quaker sentiment he composed: "The greatest honor history can bestow is that of a peace maker." When he died twenty-four years later the words were chiseled onto his tombstone.

There were throngs of people at the inaugural balls, many from Nixon's California and Rebozo's Florida. Guy Lombardo's orchestra played. The Nixons had danced to his orchestra the night World War II ended. They went back to the White House and walked from room to room turning on all of the lights. On his first working day in office he invited a thousand campaign workers to the White House.

I covered President Nixon on a trip to Europe in the fall of 1970. It was a marathon that started at Andrews Air Force Base at 6 a.m. on September 27. We visited five countries, Italy, Yugoslavia, Spain, England, and Ireland, and nine cities, including the Vatican, several towns in Ireland, and the Sixth Fleet in the Mediterranean. We logged approximately 11,820

Evangelist Billy Graham offered the prayer at the inaugural of Richard Nixon, the thirty-seventh president of the United States.

Martha Mitchell upstages her husband, Attorney General John N. Mitchell, who is hidden by her umbrella as they arrive at the White House to attend the wedding of Tricia Nixon to Edward F. Cox.

air miles and several hundred more by helicopter. Schedules and logistics were very tight. Our hotels were the finest but four hours of sleep seemed to be the most I could snatch—barely enough for survival on such a demanding trip.

There were twenty-one people in the official party and 123 members of the media. AP sent two photographers, Harvey Georges and me.

The race began after an early-morning pickup at the hotel and we were off to parades, briefings, luncheons, banquets, greetings—meetings—and farewells with presidents of each country, and an audience with Pope Paul VI, and an overnight with the Sixth Fleet.

The trip was so hectic and fast-moving that few events stand out as memorable accept the extravaganza in Madrid, the farewell banquet given by Spain's President Francisco Franco at the Royal Palace.

The finish line was at Andrews, on October 5, at 9:45 p.m. We were all winners now.

The Nixon White House had only three residents, Richard and Pat Nixon and their younger daughter, Tricia. Their older daughter, Julie, had married David Eisenhower, the grandson of Dwight D. Eisenhower, in December 1968, just prior to Nixon's inaugural. It was a joyous time for the president. Tricia married Edward Cox, an attorney, on June 12, 1971, in the White House.

Moments of joy at this time were few and far between for Nixon. Revolts and demonstrations continued on college campuses. There were sit-ins, march-ins, and teach-ins. The country was badly divided. There were endless marches on Washington, D.C. After four students were killed and nine wounded at Kent State University in Ohio by National Guardsmen who were sent to break up a protest on the campus, even conservatives were shocked.

On September 30, 1971, I was with a small group in the pressroom at the White House. After the business of the day Nixon's press secretary, Ron Ziegler, invited us to join the president in his quarters for a drink. The occasion: Nixon scooped Helen Thomas of UPI by announcing her engagement to Doug Cornell, formerly of AP. I was due at the apartment of Peg, my fiancée, in midtown Washington for a prenuptial celebration. I was only half an hour late and everyone was impressed that the president himself mixed my martini.

■ Nixon Knew the Power of the Photograph

Nixon was a tough man to photograph because he was ill at ease with photographers and people in general, but he went along with us because he knew the value of pictures. The White House took advantage of the power of the photographer. If they had something they wanted to publicize they could control it pretty well. They set up the pictures. If the administration didn't want pictures or didn't want to be

One antiwar protester raises his fist, another the peace sign in the shadow of the Capitol.

The reelected President Nixon looks out the thick glass window of the Oval Office in the White House in 1973. After Nixon jokingly said that he would be seen as "brooding," Hank promised he would not use that word in his photo caption. But the photo appeared everywhere after Watergate.

associated with a person or group at the White House, press photographers were excluded. However, the official White House photographer, Ollie Atkins, would make the pictures that the president wanted published and release them to the press after they had been edited, just as LBJ had done.

The president had many visitors. He understood which ones would make good press. It might be hard to believe Nixon in a picture with Elvis Presley, but Presley had appealed directly to the president to allow him to be of service, and he and Nixon were photographed together. Presley wanted to use his influence on young people for his antidrug message, which the president applauded.

Nixon usually cooperated with the press on special requests. The Associated Press wanted to do a "Day with the President." Saul Pet, one of the top AP writers, came down from the New York office to interview Nixon, and I took a series of pictures in the White House. I asked Nixon to go to the window, stand next to the flag, and look out—a president in thoughtful pose. He replied, "Fine, as long as you don't say I'm brooding." We all laughed. He had been very obliging. I said, "I would never do that, Mr. President." I did not put that on the caption I sent back to the office. But by the time the story and the pictures were released, Watergate had broken, that picture played everywhere, and most editors captioned it "a brooding president." This picture still shows up in biographies of Nixon.

In February 1972, Nixon achieved what he considered the greatest accomplishment of his presidency, the normalization of relations with China on his historic visit there. Our country and the rest of the world were watching this drama. On his return, his White House staff greeted him on the stairway to his office. I did not go on this trip because I was taking an intensive series of chemotherapy treatments for lymphoma cancer.* I could not go without the treatments and the therapy was physically debilitating, making it impossible for me to take such a strenuous trip.

1972 CONVENTION AND ELECTION

The 1972 Republican convention, without reservation, nominated Richard M. Nixon and Spiro Agnew. George Wallace, the Governor of Alabama and third-party candidate, had planned to run again, but Arthur Bremer shot him in an assassination attempt in the spring. Wallace was left paralyzed. The Democratic convention selected George McGovern, senator from South Dakota, to run against Nixon. McGovern chose Thomas Eagleton, senator from Missouri, to run with him. The Democratic convention was chaotic; it lacked control and alienated many in the party as being too liberal. There were demands by women liberal advocates, homosexuals, black militants, those who favored abortion, and

* The treatment lasted eight months. I was in remission for twenty-four years. The cancer was behind my left eye.

President Nixon is greeted by his staff upon returning from a highly successful trip to China. He considered his China diplomacy to be the greatest achievement of his presidency.

Senator Henry M. Jackson talks in the ear of Governor George C. Wallace of Alabama. It was a private matter. The conversation was only for two Democratic presidential hopefuls.

George McGovern at Mount Rushmore. He poses with outstanding presidents.

George McGovern in Custer, South Dakota, where he found out that his running mate,
Senator Thomas Eagleton of Missouri, had taken electric shock treatment for depression.

those who favored the use of marijuana. Many felt McGovern was too far left to govern effectively with so many conflicting controversial, even radical, issues on his agenda.

Many of these questions are still not settled. McGovern was finally nominated by Senator Edward M. Kennedy at 2 a.m., hardly prime time. In contrast, the Republican convention was organized, well scheduled, and united.

George McGovern took a breather after the convention. He and his party and the ever-present press went to Mt. Rushmore State Park in South Dakota. Everyone stayed in the rustic cabins in the park. It was very relaxing. McGovern had become interested in tennis. He played a few times for a full gallery of photographers. But a specter was looming immediately over this idyllic scene. Rumors were rampant that Senator Eagleton had had electric shock treatments for depression.

Senator and Mrs. Eagleton and Mrs. McGovern flew out to South Dakota. The two candidates met in McGovern's cabin. When they came down the stairs, the facial expressions and body language told the whole story. The four walked over to the big lodge for a press conference. The press corps was doing what it does best, looking for unusual and descriptive pictures and asking penetrating questions. There was a helicopter standing by to fly out the TV footage of the event. McGovern defended his choice and told the assembled group he was backing Eagleton "one thousand percent." Two days later Eagleton was off the ticket. Sergeant Shriver, JFK's brother-in-law, a loyal Democrat, stepped in as the vice presidential candidate. He knew that there was not much hope of

victory, but he worked hard and enjoyed it. McGovern worked tirelessly as he did not want to let his party down. I was very impressed with his integrity; he was a fine man. I covered the entire campaign. After the election, McGovern was invited to visit friends in St. Thomas, Virgin Islands, to unwind. The Associated Press sent me to cover anything that might happen. I had a very casual visit with him, but he wanted no pictures, no publicity. We reminisced about the campaign, of course. McGovern said that when Wallace could not run, his constituency of right-wing southern Democrats would not vote for a candidate with an agenda as liberal as his and turned to the Republican Party. The death knell was Eagleton's revelation that he had suffered from depression and had electric shock treatments.

The election was a landslide for Nixon. He captured forty-nine of the fifty states. Massachusetts was the only state McGovern carried. Nixon earned 60.7 percent of the popular vote and McGovern 37.5 percent. Nixon must have felt vindicated.

Every four years all photographers covering national news were assigned to cover both political conventions. Since they were not held at the same time, I usually went to both events. I didn't have a choice as to which candidates I covered; I was assigned to one by AP. Conventions and campaigns were physically exhausting, but I was young enough to recuperate with little sleep. I enjoyed them as they were exciting and fun. But I seemed to have a penchant for covering losers. I've been jokingly asked if maybe it was the pictures I took of the can-

didates. Nixon lost to Kennedy in 1960. It was a difficult defeat for him. Barry Goldwater lost to Lyndon B. Johnson in 1964. He was a good sport about it. He knew he did not have a chance, but he was the standard-bearer for the party and he went through the motions. He was most fun to cover because he had a delightful sense of humor. He was an amateur photographer and he often took pictures of us. McGovern lost to Nixon in 1972 and took his loss pretty hard.

Nixon's inaugural day was typical in Washington in the winter: cold, damp, and dreary—much like the inaugural day four years before. His speech was upbeat and triumphal. "We shall answer to God, to history, and to our conscience for the way we use these years." There was a celebratory concert by the Philadelphia orchestra. It opened with Beethoven's Fifth Symphony, and the final number was Tchaikovsky's "1812" Overture with bells, kettledrums, and cannons. A special song was written for the occasion, "A Wonderful Day Coming for a Wonderful U.S.A." The inaugural balls were held at the Sheraton Park Hotel, the Shoreham Hotel, and the Smithsonian. The Nixons danced at each one to "People Will Say We're In Love."

■ FEATURE PICTURE STORIES

Occasionally AP assigned feature picture stories to the photographers. Two of my favorites were both taken on the Eastern Shore of the Chesapeake Bay in the same year.

I met and followed Dr. John W. Robertson, a country doctor in Onancock, Virginia, for several days. He was eighty-six years old at the time and had been practicing since 1910. He delivered about everyone in town and was affectionately called "Dr. John." Besides doctoring, his passion was photography. He privately published two books of his photographs of the creeks and beaches: spring, summer, fall, and winter, over several years. He asked if I ever saw the president. I told him, "Very often when I went to the White House." He handed me one of his books and asked me to give it to the president. The Watergate investigation was in full spring—Dr. John thought this might cheer up President Nixon. I delivered the book to Ron Ziegler.

I had an opportunity to go back to Onancock several weeks later. Dr. John invited me to join him at the Rotary Club luncheon. He proudly stood up and read a letter he had just received from the president of the United States, thanking Dr. John for the gift of his book and also praising him for his life of service to humanity. Dr. John W. Robertson was a very proud and pleased man that memorable day.

My favorite picture story was harvesting the Chesapeake Bay oysters by sailing vessel—the traditional skipjack. At the turn of the twentieth century, there were more than a thousand skipjacks working the Chesapeake Bay. A skipjack has a single raked mast, and the hull is sleek and low to the water. It sports a long clipper bow, with carved and brightly painted trail boards and transom. Skipjacks are working boats and were designed for speed as well as ease in bringing oysters

aboard. I contacted the marine police to find out the location of the fleet in mid February 1973. I asked if I could go aboard with them as they often followed the fleet. They very cordially allowed me to join them and said that would be fine. We left from a harbor on the Choptank River side of Tilghman Island about dawn. We went out to the mouth of the river and into the bay. It was blowing about 30 to 35 knots and very blustery. The skippers looking for their quota of 150 bushels tongued on a few known oyster bars before the weather worsened and it became too difficult and unproductive to continue.

As they turned back to port the skipper ordered shortening of the sails, and both the mainsail and jib were reefed down. I chose, among the series of pictures, one of a single reefed-down skipjack returning to port on a wintry, stormy morning to enter in the White House Press Photographers Association annual contest. It won first prize in the pictorial category.

I was assigned to travel to South America with Mrs. Nixon in March 1974. I should not have accepted the trip because I had a persistent virus, but optimistically, I was sure my health would improve. I hated to forgo a White House trip. We left Florida on March 11 for Caracas, Venezuela. Mrs. Nixon was to serve as the head of the U.S. delegation to the inaugural ceremony for the new president of Venezuela, Carlos Andrés Perez, and then the group would go on to Brasília for the inauguration of Brazil's new president, Ernesto Geisel.

Unfortunately, my health worsened and I was very sick on the way back. March 16 was Mrs. Nixon's birthday. Several members of the press produced a cake with candles. Mrs. Nixon walked through the plane proudly displaying her cake. It was a charming scene. I was asked once if I ever missed a good picture or did not achieve the shot that I wanted. My answer was "yes." This was the occasion—I failed miserably. Mrs. Nixon was out of focus and the cake and candles were a fuzzy blue. In my photojournalism career this was a disaster for me. Fortunately, the trip was finished and I was headed back to Andrews Air Force Base and home.

THE END OF NIXON'S PRESIDENCY

It appeared that Nixon had reached a zenith in his presidency. But this was far from true. The country was badly divided. Watergate investigations were ongoing. The antiwar demonstrations had reached a high pitch. Nixon had promised when he took office in 1969 to end the war, but the battle continued with its deadly toll on human lives.

Finally a cease-fire in Vietnam was signed in 1973. It was not the happiest way to end such a contentious war that consumed the United States for many years. The return of the prisoners of war triggered a national celebration and a particularly happy time for my family and me. My brother, Dave, was released as a POW from a Hanoi prison sardonically

A Chesapeake Bay skipjack coming back to port on a blustery morning of oystering. Both sails are reefed.

called "Hanoi Hilton." He came home in the spring of 1973 after six and a half years away from home. During these trying days Nixon acknowledged and desperately appeared to reach out to anyone he knew in the press. He asked about my brother several times. At difficult times in his presidency, like others before him, he got away to the Catoctin Mountains of Maryland. He frequented Camp David for short periods of time and bought a modest house in Key Biscayne, Florida, from Senator George Smathers, near Rebozo's house. He often visited Grand Cayman in the Bahamas, as a guest of Robert Abplanalp who had a house refurbished for the president. Mr. Abplanalp also lent Nixon money to buy twenty-nine acres in San Clemente for the Western White House, where he retired.

At the White House Press Photographers Association annual presidential dinner, winning photographers received awards for their pictures judged best in each category taken that year. Happily for me, I was named Photographer of the Year in 1973. I had received first place in the news category and first place in the pictorial category. The news award was for my picture taken in South Dakota of McGovern, right after he had heard from Eagleton about his electric shock treatments. The pictorial award was the picture of the skipjack coming back to port.

Henry Kissinger was doing the honors for the president and presented the awards. I thanked him for the awards and for negotiating to bring my brother home. Dave was seated at the head table that night next to Mr. Kissinger.

Within months the entire Nixon administration was close to the end. Vice President Agnew resigned in the face of corruption charges. The Watergate break-in and the subsequent lengthy and revealing trial brought Nixon to the realization that he must resign or be impeached. The country was beginning to think that there was so much corruption that the Nixon administration must be replaced. Richard Nixon resigned at noon on August 9, 1974. He was the first president in the history of our country to resign from office. He flew back to San Clemente on Air Force One—his last ride on the presidential plane.

Many books have been written about Nixon. Was he a scoundrel or a tragic figure? One thing is certain, he was always a fighter. He emerged in later years as an elder statesman—his final political comeback.

There's no question but that a person in politics is always hurt when he loses, because people like to play a winner. But one sure thing about politics is that what goes up comes down, and what goes down often comes up.

–*Richard M. Nixon*

CHAPTER IX *The Task of Healing*
Gerald R. Ford, 1974-1975

My fellow Americans, our long national nightmare is over.

–Gerald R. Ford, August 9, 1974, at the time of Nixon's resignation

I covered the Ford presidency for approximately fourteen months before I retired. A cancerous tumor had been removed from behind my left eye by radiation treatment, which virtually destroyed the vision in that eye. It was more difficult to make sharp images. I always remembered my first assignment with the AP was to go to the White House. The guard at the gate recognized me as new and warned me not to make any fuzzy pictures. This was certainly a criterion for AP and a career goal for me. But I knew the time was coming when I might make a fuzzy one. I did not want to be a photo editor. I had always been and loved being a shooter.

Vice President Spiro Agnew had resigned. Richard M. Nixon selected Congressman Gerald R. Ford to fill the vacancy. Ford was a popular member of the House and the minority whip, a congressman's congressman and a loyal Republican. The proper hearings were conducted. He was confirmed by the House and Senate and was sworn in by Chief Justice Warren Burger before a joint session of Congress on December 3, 1973, as Betty Ford held the Bible.

When Nixon resigned the presidency on August 9, 1974, Ford had served as vice president for only eight months. He was sworn in immediately by Chief Justice Burger as the thirty-eighth president of the United States in the East Room of the White House. Ford came to the office with limited administrative experience and in the shadow of a failed presidency. He assumed his duties with good grace; he was sincere, hardworking, and wanted to put the country back on track. He was not aggressive or flamboyant. He said, as he took office, that he would do the best possible job and with disarming good humor said he "was a Ford, not a Lincoln."

Ford nominated and Congress approved as his vice president Nelson Rockefeller. Men who had not been elected to either office held the nation's two top offices. This was a unique situation in the nation's history.

On September 8, 1974, a month after Ford assumed the presidency, he granted Nixon a pardon. Ford's short-lived honeymoon with Congress and the public was over. Many people believed that Nixon had made a deal with Ford to pardon him. Many wanted Nixon to be tried. There was much unhappiness about the pardon. The president's press secretary, Jerald terHorst, resigned in protest. Ford wanted to end the nightmare of a resigned president, put Watergate to rest, and heal the country. He believed and acted according to the decision of *Burdick v. United States* in 1915, which says that a pardon "carries an imputation of guilt, acceptance and a confession of it." Ford carried this verdict with him and referred to it when pressed for his reason for the pardon. Many people felt the pardon may have cost Ford his bid for election in 1976.

A week after the announcement of Nixon's pardon, Ford announced a limited amnesty program for Vietnam deserters and draft evaders. This seemed to anger the nation's political right, but the left felt it didn't go far enough.

I covered Ford in the Oval Office and at many press conferences. I accompanied him on short trips in the United States. I enjoyed a trip to Florida to the Jackie Gleason Inverrary Classic Golf Tournament. President Ford was with his Hollywood golfing friends, Jackie Gleason and Bob Hope. The three were following Jack Nicklaus on the course.

The Fords' daughter, Susan, was in high school at Holton Arms in Washington, D.C. She was the only one of the four Ford children who lived at the White House full-time. Son Jack spent some time there, and sons Steve and Mark lived elsewhere but visited often. Susan became very interested in photography and worked for the AP for a short time. AP's Bob Daugherty said she was treated the same as all the photographers, no special favors. She went out on assignment with another staff member and sometimes alone, except for her Secret Service agent.

To escape from the Washington pressure-cooker Ford occasionally went to Camp David or to Palm Springs, California, to golf. But his favorite place was Vail, Colorado, for skiing. He bought a condominium there.

Reactions to a long putt skillfully put in by Jack Nicklaus on the fourth green are captured on the faces of Bob Hope, President Gerald Ford, and Jackie Gleason during the Jackie Gleason Classic at Inverrary, Florida, in 1975.

President Ford puts his arm around Vice President Nelson Rockefeller as they chat prior to the Fords' departure for Europe. His six-day trip took him to Brussels, Madrid, Salzburg, and Rome.

Christmas morning 1974 was a beautiful, bright, and serenely calm day. I looked out my front window at the historic house, Norman's Retreat, across the narrow West River from my home in Maryland as it shimmered in the morning sun. Built in 1790, the house was perfectly reflected in the river. It was a lovely scene and I shot it.

Before I had a chance to finish breakfast I got a call from the AP in Washington. I signed up for duty on Christmas morning so that the younger men could be at home with their families. I was told to report to the White House where someone had driven a car through the fence. I grabbed my camera and bag and flew out the door. By the time I arrived the driver had jumped out of his car with what he said were explosives strapped to his legs. He was threatening to blow up the White House and everyone in it. President Ford was not in residence; he was taking a ski vacation in Vail. I sent my film to the office by courier. I made some pictures while I stood there for four hours before the man finally surrendered to the police. It was a tiresome standoff.

My shot of the house across the river was on the roll of film. Normally Christmas is a slow news day and editors are always looking for pictures of interest. Norman's Retreat was printed in thirty to forty newspapers across the country, captioned "A Peaceful Christmas Morning." The reflection of the house in the river was such a perfect mirror image that several papers printed the photo upside down. It was published in the *Washington Post* and when the owner of the house saw the picture in the paper he called the AP to see if he could get a copy. The staff put me on the line and I told him I'd bring him a copy. As a result, he and his wife became good friends of ours. Yes, the crazy bomber's picture made the paper too.

Ford's relationship with the Washington press corps was cordial because he had worked with the press for years in the Congress. Unfortunately there are always a few reporters and photographers who go for the jugular. Ford stumbled getting off Air Force One. Some of the press reported that he was clumsy. Nothing could have been further from the truth. He had been a college athlete and was still an active snow skier and golfer. He did not lack dexterity. This tale was reported often.

David Hume Kennerly was a photographer who had previously worked for UPI. He knew and had worked with many of the photographers who covered the president and the White House before he became the president's personal White House photographer. Dave felt that besides his primary job of covering the president, he should find as many ways as possible to give photographers access to the White House and to Ford. What better way to describe Ford's presidency to the public?

I first met Dave when he was a young photographer for UPI in California. He had just returned from Vietnam with a Pulitzer Prize. We were both covering Nixon on the West Coast. He had never covered a president, so I was kind of a mentor for a short time while showing him the ropes. We became good friends.

"Norman's Retreat," built in 1790 near the site of the colonial shipyard, on a serene, calm Christmas morning on West River, a tributary of the Chesapeake Bay.

Henry D. Burroughs and his wife, Peg, in the Oval Office with President Gerald Ford. The occasion was an official farewell from the president on Henry's retirement from the Associated Press.

FLIGHT CERTIFICATE

This is to certify that
Henry Burroughs
has flown in Air Force One as a guest of Gerald R. Ford,
President of the United States of America.
Presented this 10th day of December, 1974

Lester C. McClelland
Presidential Pilot

A certificate presented to Henry Burroughs by President Ford.

Just before Christmas in 1975, Dave Kennerly invited Peg and me for lunch at the White House mess, because I was retiring. This was a great treat. We went through the White House gate and our names were on the guard's list. We went directly to Dave's office in the West Wing. He said, "Hank, would you like to see the president's official schedule for the day?" and handed me a copy. There at 12:40 p.m. was . . . Mr. Henry Burroughs, the Oval Office. I just about flipped out. I think Peg did also; she ran to the ladies' room to fix her makeup and hair. When the door to the Oval Office opened for us to go in for my farewell visit, Peg was spellbound. I was taken aback, because my colleagues, who were covering the White House that day, took pictures of all the White House visitors, including my farewell handshake with the president of the United States. It was strange, but delightful, for me to be on the other side of the camera in the Oval Office.

On the same day that we had lunch at the White House we were invited to the press Christmas party in 1975. Each guest was assigned a parking place on the grounds; we entered on the ground floor through the handsome diplomatic reception room and were ushered up to the first floor. All the rooms were used—East Room, West Room, Red Room, Blue Room, Green Room, and even the entrance hallway. Everyone was treated like a state guest. There were many bars and buffet tables, and small tables and chairs. Mellow music of the Ford era was played by the U.S. Marine Band in the two large rooms and there was lots of room for dancing. The president was even persuaded to take a twirl or two around the room with several of the long stag line of ladies. Sweet, kind man. The party was scheduled to end at 11 p.m., but we had our last dance at 2 a.m.

In one day I was entertained for lunch and dinner at the White House and received a very special farewell from the president of the United States, Gerald Ford, in the Oval Office. I had covered history for thirty-three years with the AP, including seven presidents. I began my life as a news photographer in 1944 by making a picture of Franklin D. Roosevelt in the Oval Office. What a glorious day and way to end my career.

by Margaret Wohlgemuth Burroughs

Children are attracted to water—from walking through mud puddles to chasing waves at the seashore. Many never outgrow this affinity to water and for some it becomes a need, a hobby, relaxation, a passion, or an adventure. In Hank's case it was relaxation and adventure. His first boat was a folding canoe. He graduated shortly into a series of sailboats, the last of which was a Choey Lee sloop from Hong Kong with a cutter rig. It was a perfect boat for the Chesapeake Bay. It had a large cockpit and a retractable centerboard; it could go anywhere on the bay and its many rivers and creeks. We explored them all.

Hank retired from the AP in 1976. A dream that began years before was finally put into action. Hank and I left our dock on the West River in October 1976 with the good wishes of our neighbors, friends, and family, and headed south down the bay, down the Intracoastal Waterway, and over to the Bahamas. It was a dream come true. We returned in July 1977. It was a true adventure for both of us. We headed south again in 1980. This time we investigated the Florida Keys, out to Dry Tortuga, and up the west coast of Florida.

Although Hank had traveled extensively around the world on assignments covering presidents and vice presidents, he continued traveling in retirement for the discovery and joy of it. His cameras were important appendages and as important as his luggage. Then we decided to see the United States. We drove the northern route one way, traveled down

the West Coast, and returned via the southern tier of states. Outside of the United States we took trips to the British Isles, Scandinavia, Finland, Russia, Germany, France, Spain, Italy, Yugoslavia, Greece, Egypt, Turkey, Jordan, Israel, South Africa, Iceland, Greenland, Malta, China, Japan, Hong Kong, Thailand, Malaysia, Singapore, Bali, Australia, New Zealand, and Tonga. Hank produced slide shows with music and narrative for each trip.

Hank spoke to many clubs and organizations about his career—his "front row seat in history." He taught classes in photography at Calverton School, Elan College, and gave lectures at the local public high schools in photojournalism. He mentored many young people who showed an interest in photography. Through the generous contributions of friends, family, organizations, and businesses, the Henry D. Burroughs scholarship has been established at Anne Arundel Community College in photojournalism. His spirit continues to educate earnest students in photography.

All his life, Hank played the piano by ear. He played often just for his own enjoyment. He was sought after by hostesses to liven up parties with a sing-along. Even on the sailboat he had an extended harmonica with a three-octave keyboard that he enjoyed playing. He called it his boat piano. He was a music man.

Hank was the treasurer for our local county council chairman for many years. He organized the Great Books Discussion Group in Anne Arundel County at the local library. He was an enthusiastic board member of the trustees of the county library system. He enjoyed the graceful game of tennis, which he had played since he was a young. He continued to play up to a few months before he died.

As his career was highly successful, his postcareer life was eventful, interesting, intellectual, civic, hospitable, and generous. There were so many layers in this Renaissance man. He enjoyed and shared them all.

Index